LOUISE BOURGEOIS

THE LOCUS OF MEMORY

WORKS 1982–1993

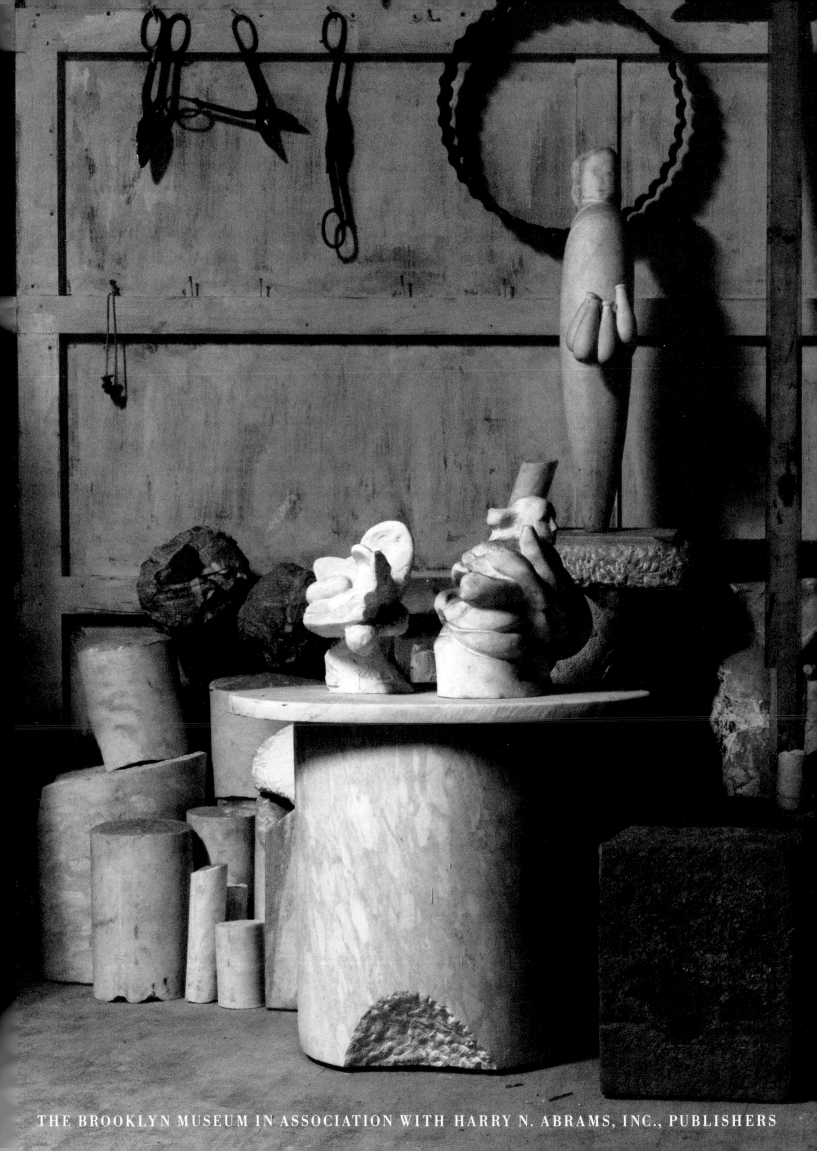

THE BROOKLYN MUSEUM IN ASSOCIATION WITH HARRY N. ABRAMS, INC., PUBLISHERS

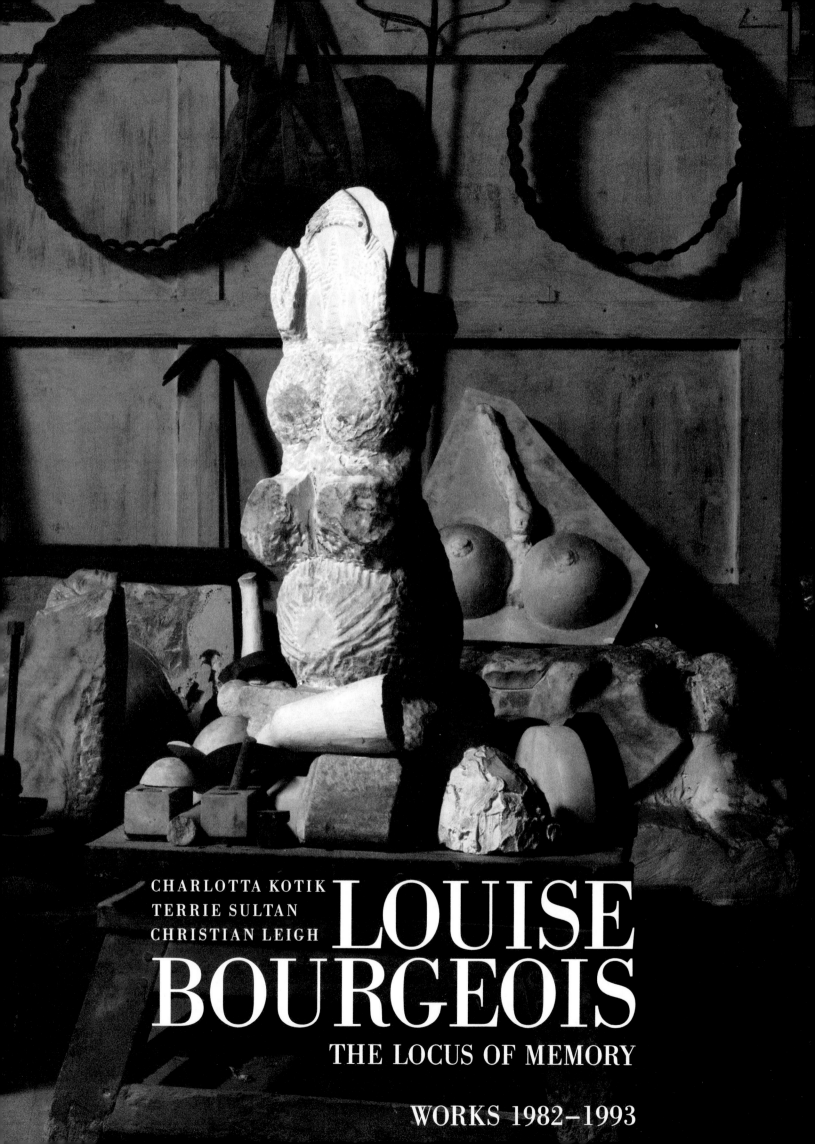

CHARLOTTA KOTIK
TERRIE SULTAN
CHRISTIAN LEIGH

LOUISE BOURGEOIS

THE LOCUS OF MEMORY

WORKS 1982–1993

Published on the occasion of the exhibition *Louise Bourgeois: The Locus of Memory, Works 1982–1993*, organized by The Brooklyn Museum in association with The Corcoran Gallery of Art, Washington, D.C.

The exhibition is sponsored by Philip Morris Companies Inc.

Additional support was provided by the National Endowment for the Arts, a federal agency, Maureen and Marshall Cogan and the '21' International Holding, Inc. Foundation, and the New York State Council on the Arts.

This publication was organized at
The Brooklyn Museum by Elaine Koss, Editor-in-Chief
Editor: Joanna Ekman
Project Coordinator: Pamela Johnson

For Harry N. Abrams, Inc.:
Project Manager: Margaret Kaplan
Editor: Diana Murphy
Designer: Judith Michael

Franz Kafka's "Letter to His Father" is excerpted from *Dearest Father: Stories and Other Writings* by Franz Kafka, trans. Ernst Kaiser and Eithne Wilkins, 27. English trans. copyright 1954 and renewed 1982 by Schocken Books Inc. Reprinted by permission of Schocken Books, published by Pantheon Books, a division of Random House, Inc.

LIBRARY OF CONGRESS CATALOGING-IN-PUBLICATION DATA

Bourgeois, Louise, 1911–
Louise Bourgeois: the locus of memory, works 1982–1993/
Charlotta Kotik, Terrie Sultan, Christian Leigh.
p. cm.
"In association with the Brooklyn Museum."
Exhibition catalog.
Includes bibliographical references.
ISBN 0–8109–3127–3 (Abrams: hardcover).—ISBN 0–87273–130–8
(Museum: paperback)
1. Bourgeois, Louise, 1911– —Exhibitions. 2. Bourgeois,
Louise, 1911– —Criticism and interpretation. I. Kotik,
Charlotta, 1940– . II. Sultan, Terrie, 1952– . III. Leigh,
Christian. IV. Brooklyn Museum. V. Title. VI. Title: Locus of
memory, works 1982–1993.
NB237.B65A4 1994
709'.2—dc20 93–28375

CONTENTS

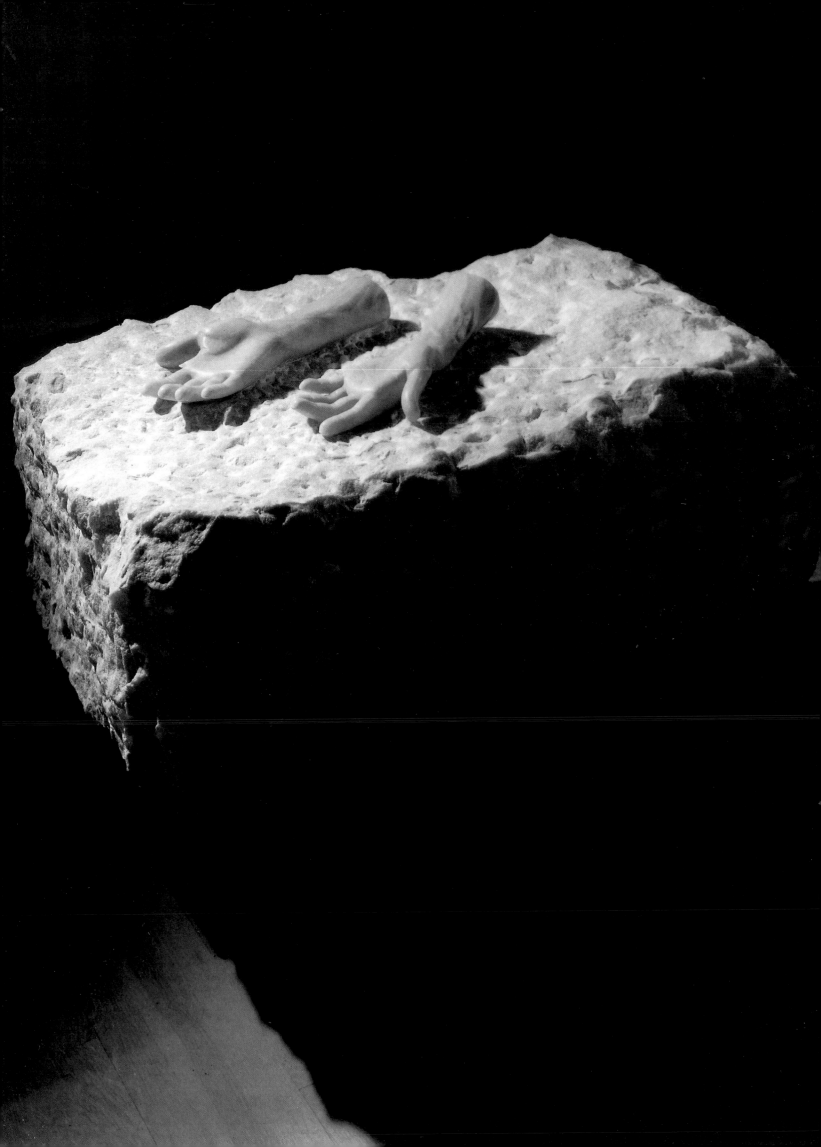

We at Philip Morris are pleased to continue our long-standing support of the arts by sponsoring *Louise Bourgeois: The Locus of Memory, Works 1982–1993*, an exhibition imbued with a spirit of hope and new possibilities.

Louise Bourgeois has had a long and accomplished career, yet is only now receiving the recognition she deserves. She has consistently followed her own vision without conceding to stylistic trends, applying her absorption in personal and social conflicts to the exploration of the mysteries of the human form. The extraordinary results are passionate and often disquieting.

An artist of international stature and appeal, Bourgeois, and the presentation of her work organized by The Brooklyn Museum, enjoyed wide acclaim at the 45th Venice Biennale last year. This expanded version of the Venice exhibition, visiting The Brooklyn Museum and other venues, should confirm her role as one of today's most important artists.

We thank The Brooklyn Museum for making this vital exhibition possible, and for offering us this opportunity to bring the unique achievements of Louise Bourgeois to audiences around the world.

STEPHANIE FRENCH
Vice President
Corporate Contributions and Cultural Affairs
Philip Morris Companies Inc.

Décontractée. 1990
(see plate 21)

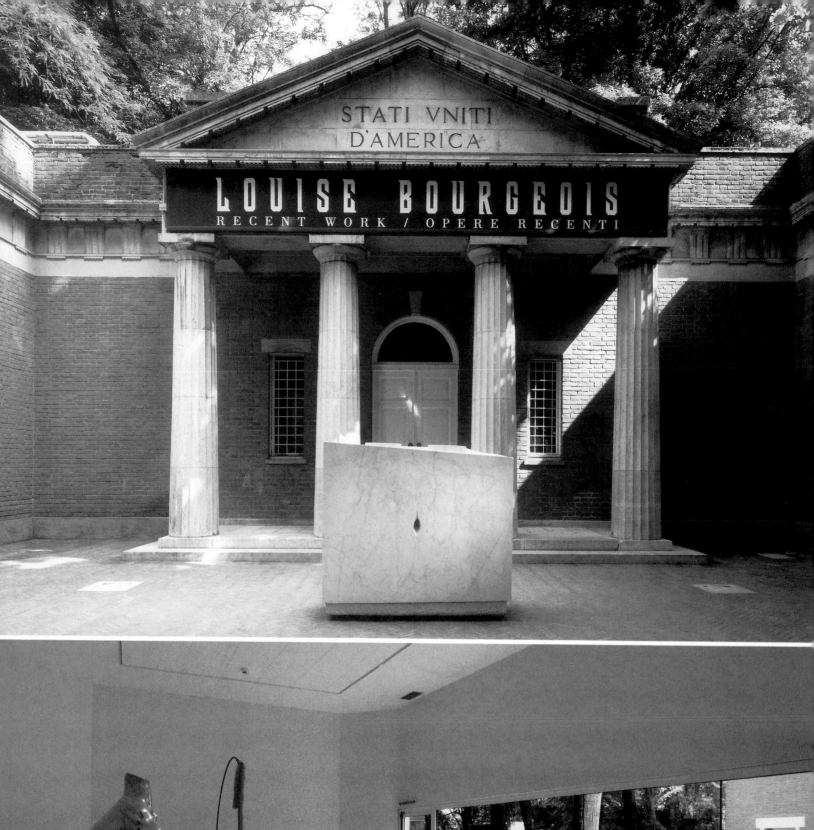

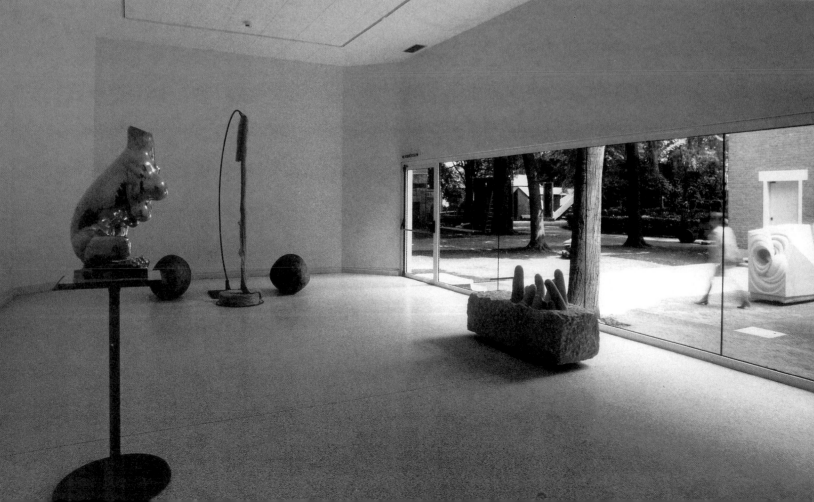

FOREWORD AND ACKNOWLEDGMENTS

I t is an honor for The Brooklyn Museum to present the recent work of Louise Bourgeois both in the United States and abroad. The past decade has been a period of extraordinary achievement in the artist's career, a culmination of her creative pursuits of more than forty years, during which time Bourgeois's sculptures have borne witness to the international development of the art of this century. Bourgeois received her early training in her native France during the height of Modernism and was exposed to such sources of inspiration as Brancusi, Giacometti, and Léger, with whom she had the opportunity to study. Moving to New York in 1938, during the difficult years preceding the Second World War, she befriended artists of the Surrealist movement and encountered the energy and vitality of the New York art world as it contemplated the nature of abstraction. From her experiences in Europe and the United States, she has created an extraordinary body of work.

Throughout the years Louise Bourgeois has maintained a unique and independent vision, synthesizing the spirit of two continents and cultures. In the summer of 1993, The Brooklyn Museum was privileged to organize an exhibition of her work for the 45th Venice Biennale, in which Bourgeois was the sole artist to represent contemporary art from the United States in the U.S. Pavilion (fig. 1a-c). The current exhibition is an expanded version of the Venice presentation. For the exhibition, we proudly join with our colleagues at The Corcoran Gallery of Art in Washington, D.C., and the Musée d'Art Moderne de la Ville de Paris in celebrating the achievements of this remarkable woman, whose work offers affirmation that the enduring power of the spirit can transcend borders imposed by geography and state.

We at The Brooklyn Museum are honored to present this exhibition and grateful to the many individuals and institutions who have made it possible. The staff members of The Brooklyn Museum have together realized this remarkable project headed by Charlotta Kotik, Chair, Department of Painting and Sculpture, and Curator of Contemporary Art; without her limitless devotion to the project and singular perception of Bourgeois's artwork, the exhibition would not have been possible. Ms. Kotik was assisted by Elizabeth Reynolds, Registrar, Larry Clark, Curatorial Administrator, and Pamela Johnson, Project Coordinator, whose combined careful attention to the complex demands of organizing this international presentation have made it a success.

Fig. 1a, b. *Louise Bourgeois,
Recent Work/Opere Recenti,*
United States Pavilion, 45th
Venice Biennale, 1993

This publication, which grew out of the handsome brochure produced for the Venice Biennale, was expertly overseen by Elaine Koss, Editor-in-Chief, Joanna Ekman, Editorial Associate, and Rena Zurofsky, Vice Director for Marketing, with assistance from Karen Tates, Rights and Reproductions. Special acknowledgment is due to the staff of Harry N. Abrams, Inc., who handled this publication with care and expertise: Margaret Kaplan, Project Manager; Diana Murphy, Editor; Judith Michael, Designer; and Shun Yamamoto, Production. The exhibition has been beautifully designed by Jeffrey Strean, Chief Exhibition Designer, with the sensitive guidance of Jerry Gorovoy, the artist's assistant. It was skillfully installed under the supervision of Kenneth Moser, Chief Conservator, and his staff. Sally Williams, Public Information Officer, has impressively met the challenges of promoting the show both here and overseas. In the Development Office, former Vice Director Karen Putnam, former Manager Kristen DeLaMater, and Acting Director Sarah Himmelfarb have worked with the curatorial staff to secure funding for this project. I also wish to thank Roy Eddey, Deputy Director, and Linda Ferber, Chief Curator, who have offered their kind support and counsel throughout the organization of the exhibition.

At The Corcoran Gallery of Art, David Levy, President and Director, Jack Cowart, Deputy Director/Chief Curator, and Terrie Sultan, Curator of Contemporary Art, have been most generous in their cooperation on this project. We especially want to thank Terrie Sultan for contributing a most illuminating essay to the catalogue.

We gratefully acknowledge Christian Leigh's challenging essay, "The Earrings of Madame B . . .," as well, and the appreciations of Louise Bourgeois's work contributed by her colleagues and admirers.

At the Musée d'Art Moderne de la Ville de Paris, Chief Curator Suzanne Pagé and Curator Béatrice Parent have contributed immeasurably to the development of this exhibition.

The Museum deeply appreciates the support of the Robert Miller Gallery in New York. We are grateful for Mr. Miller's enthusiasm for the project from its inception and the dedication of his staff—John Cheim, Director, Wendy Williams, Registrar, and Diana Bulman, Archivist—who have each been instrumental in the development of the catalogue and the touring exhibition.

The kind assistance of the Arts America Office of the United States Information Agency, particularly Robert McLaughlin, Director, Susan Flynt Stirn, Manager of Visual Arts Programs, and Rex Moser, Coordinator of Festival Projects, throughout the initial stages of the project is warmly acknowledged as well. Its staff members provided guidance and support essential to the achievement of the presentation in Venice, which was the core of the current exhibition. We wish to express our gratitude for the financial support generously provided by the Fund for U.S. Artists at International Festivals and Exhibitions, a public/private partnership of the National Endowment for the Arts, the United States Information Agency, The Rockefeller Foundation, and The Pew Charitable Trusts, with administrative support from Arts International, a division of the Institute of International Education. We salute their unique partnership and commitment to cultural presentations abroad.

As the corporate sponsor of the Venice presentation and the expanded

touring version of the exhibition, Philip Morris Companies Inc. has been most generous. We have been particularly proud to partake in the celebration of the corporation's thirty-fifth anniversary of support to the arts in 1993, which included sponsorship of the American presentation at the 45th Venice Biennale, and are delighted that they share our highest esteem for the work of Louise Bourgeois. The Philip Morris staff—particularly Stephanie French, Vice President of Corporate Contributions and Cultural Affairs, Karen Brosius, Manager of Cultural Affairs and Special Programs, and Jennifer Goodale, Specialist of Cultural Affairs—have been a great pleasure to work with and have provided marvelous assistance. Additional support for the expanded touring version of the exhibition was provided by the National Endowment for the Arts, a federal agency, Maureen and Marshall Cogan and the '21' International Holding, Inc. Foundation, and the New York State Council on the Arts.

Working with Louise Bourgeois has been a rare privilege for all of us at The Brooklyn Museum. The involvement and support of the artist and her assistant, Jerry Gorovoy, have enriched the exhibition beyond measure. We are grateful to Ms. Bourgeois not merely for her cooperation on the project but also for her energy and her genius, to which this exhibition is a tribute.

ROBERT T. BUCK
Director
The Brooklyn Museum

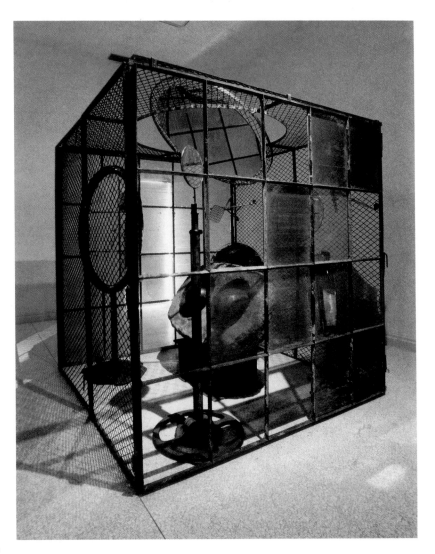

Fig. 1c. Installation view, *Louise Bourgeois, Recent Work/ Opere Recenti*, Venice Biennale, 1993, with *Cell (Eyes and Mirrors)*

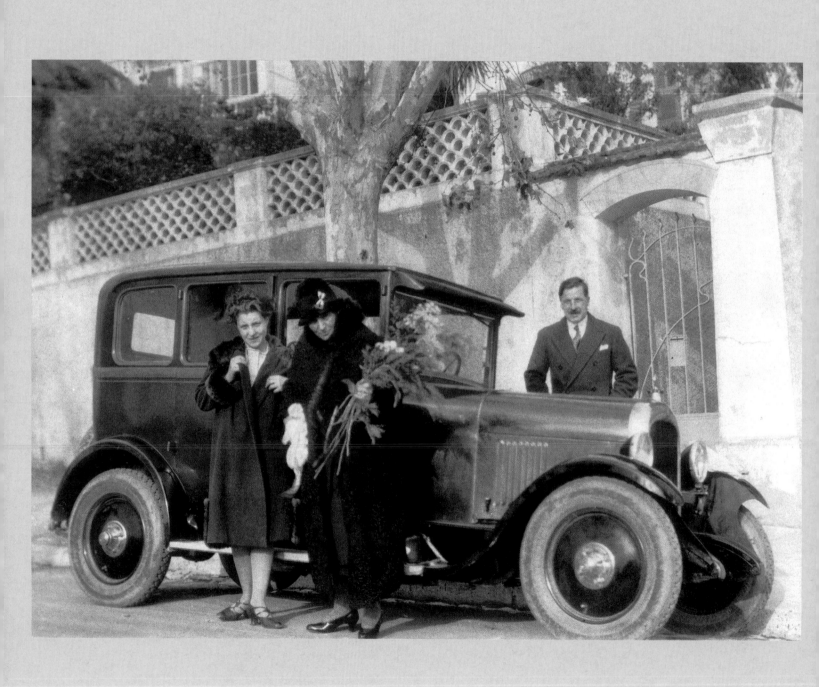

CHARLOTTA KOTIK

THE LOCUS OF MEMORY: AN INTRODUCTION TO THE WORK OF LOUISE BOURGEOIS

For me, sculpture is the body. My body is my sculpture.
—LOUISE BOURGEOIS[1]

However intricate the elaborate construct of the art world may be at any given moment, its existence and renewal depend on a select number of sources. These sources, sometimes obscured by extraneous concerns, often take a long time to be identified. Yet, once recognized, their creative energy penetrates our consciousness and permanently marks our perception of the times. For those artists who have turned to spatial enclosures and/or to the image of the body—in all its permutations and fragmented forms—as a vehicle for expressing ideas about universal questions and as a means not only of connecting with the outside world, but also of reaching deep into their own psyches, the enigmatic oeuvre of Louise Bourgeois is a profound force.

The 1980s and early 1990s have been a period of unprecedented accomplishment in Bourgeois's career, leading to her most challenging and monumental work as yet. The examples selected for this exhibition bring together for the first time the full range of media, techniques, and thematic content of the past decade, including individual pieces and installations alike. In them we see Bourgeois's explorations of both natural and architectonic form and her development of a body of work unique among artists today.

Louise Bourgeois has emerged as an artist of intense individuality with her integrity and vitality intact. Her recent work represents a culmination of forms and ideas she has pursued for over half a century. The universal themes that have long obsessed Bourgeois—anxiety, alienation, love, identity, sex, and death—dovetail with and illuminate the contemporary issues of gender, sexuality, and the right to freedom and individuality. No longer a peripheral figure in the art world, but an exemplary model for artists who came of age in the 1980s, Bourgeois is now considered one of the foremost living artists, whose legacy is central to our understanding of twentieth-century art.

Trained in Europe as well as in the United States, and witness to this century's vital art movements, Bourgeois is a truly international artist whose career spans both continents and cultures. Since her arrival in New York in 1938, Louise Bourgeois has become an integral part of the intellectual and artistic life of the city. Befriending a number of expatriate Sur-

Fig. 2. Louise Bourgeois with her mother and father in France, ca. 1929

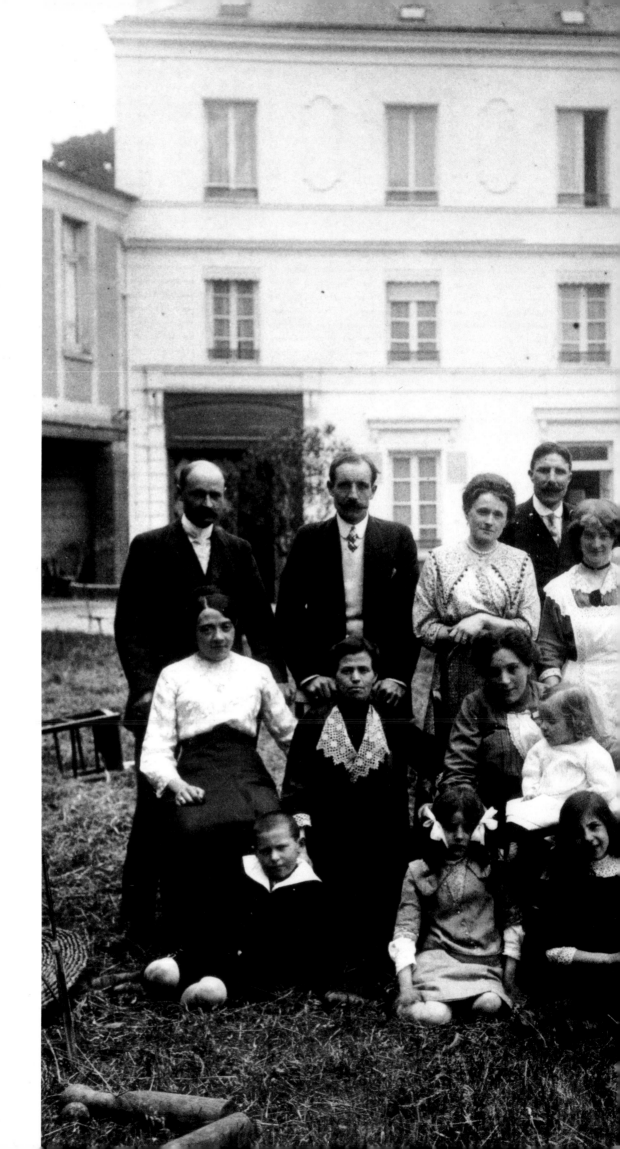

Fig. 3. A Bourgeois family gathering in Choisy-le-Roi, France, ca. 1913. Louise is sitting on her mother's lap, to the left of the table.

realist artists during the Second World War, she participated in the rise of Abstract Expressionism, shared the legacy of the New York School, and through her early working methods anticipated the practices of Process Art and the discipline of Minimalism. She readily comprehended all, but accepted none. Fiercely independent, she charted her own territory instead, traveling a solitary path and sustaining the isolation that so frequently attends such a road.

Motivated to express deeply autobiographical content, Bourgeois followed her own rhythm. Although her work explores abstraction, allusion to organic form permeates most of her pieces, naturally strengthened by the suggestion of fragments of human anatomy. Since there is no single mode to which she subscribed for any length of time, Bourgeois subverted established notions of the development of a style. In the process, she superbly mastered numerous techniques such as carving, assembling, modeling, and casting—using and discarding them at will—and media as varied as wood, plaster, latex, bronze, marble, and an array of found objects ("*objets trouvés*," as she calls them). Noble or mundane, all of these methods and materials were subjected to her wishes and used to express her innermost feelings.

Although the work was exhibited intermittently and known to artists and scholars, it remained in effect the art world's best-kept secret. This limited recognition had a positive effect, as Bourgeois has explained:

This . . . has been the story of my career. For many years, fortunately, my works were not sold for profit or for any other reason. And I was very productive because nobody tried to copy my alphabet. They knew about it, because I had some shows over the years. But it was not sold. And in America, selling is equated with success. My image remained my own, and I am very grateful for that. I worked in peace for forty years. The production of my work had nothing to do with the selling of it.[2]

Rejecting the rules and regulations of the art world since her essentially antiauthoritarian nature was unable to accept any established doctrine, Bourgeois instead chose to experiment, to make up her own rules, and to select her own narrative imagery. In doing so, she addressed questions of gender and sexuality and foreshadowed the premises of early feminism in accepting and exploring what was then considered marginal or ephemeral. The ever-present, subversive impulse that permeated her art from the beginning of the 1940s became increasingly recognized by proponents of change in the late 1970s. She became an example for those with the courage to draw inspiration from their innermost feelings and to turn away from the spent Modernist tradition toward the darkly subjective and elaborately eclectic realm of Postmodernism.

As Bourgeois's work was exhibited with increasing frequency throughout the 1970s, it effectively influenced both the work of other artists and public taste. The turning point in this process was the retrospective exhibition of Bourgeois's work at The Museum of Modern Art in New York in 1982. Surveying four decades, from the early forties to the early eighties, this exhibition was a milestone in the broad recognition of the artist's work. At the time of The Museum of Modern Art's critical reappraisal, Bourgeois was seventy-one years old. For many artists, an exhibition of such summarizing intent could have been the climax of a life's work. For Bourgeois,

however, it heralded a new era during which her productivity surged.

In order to appreciate fully the work of this past decade, which is so rich with autobiographical and emotional reference, it is helpful to consider the artist's background. Louise Bourgeois was born on December 25, 1911, on the Left Bank of Paris, where her parents ran a gallery dealing primarily in historical tapestries. She spent her early years there and her later childhood in the nearby suburbs of Choisy-le-Roi and later Antony, where the family opened a tapestry restoration studio in 1919, right after the war (figs. 2, 3). It was in this workshop that Bourgeois first learned to draw, in order to help with the restoration work. The family was polarized between a wise and practical mother, who provided stability and affection although she was frequently ill, having suffered from the Spanish flu in 1919, and a charming but philandering father, whose flamboyance the young Louise at once admired and detested. While she studied mathematics for a short time at the Sorbonne beginning in 1932, she soon decided to pursue an artistic career and attended several art academies and studios in Paris for the following six years. In 1938 Bourgeois married Robert Goldwater, an American art historian, and moved to New York City.

While Bourgeois studied painting throughout the 1930s, it was largely her study of mathematics and geometry at the Sorbonne that pointed her to sculpture. She was fascinated by the rules of solid geometry and by the intricate relationships created by the positioning of elements in space. Bourgeois was attracted to mathematics and geometry largely because she found in these disciplines the stability and continuity that had been missing in her life at home. She explains, "In mathematics the rules are eternal, and the points of reference do not change from day to day."[3] However, as her knowledge of the subject deepened, she became increasingly aware that

Fig. 4. Louise Bourgeois in her New York studio, 1940s

mathematics was not necessarily fixed and that Euclidean geometry was but one theoretical construct. "The day I understood that there were other geometries besides Euclidean, I experienced a sharp disappointment," Bourgeois has said. "It was for me the death of a symbol. Mathematics was no longer a safe symbol. . . . So I was in search of a new symbol, a new equation. The new equation was art."[4]

In her artwork, Bourgeois increasingly turned away from the rigid, rational rules of Euclidean geometry toward the more fluid, intuitive formulations of topology, the branch of mathematics concerned with the relationships of figures in space. While she began to investigate such formal correspondences in her paintings of the early 1940s (fig. 4), she soon turned to sculpture, which, as a medium that is labor-intensive and by nature confrontational, challenging the viewer through its physical proximity, was better suited to express the complexities of human interplay and the autobiographical drama that was to unfold in her work.

By the late 1940s, Bourgeois had abandoned painting and focused on sculpture, drawing, and printmaking. Her earliest sculptures were carved, assembled, and stacked; they were made of wooden segments, sometimes with a painted and sometimes with a natural surface. The resulting tall figures symbolically represented members of the artist's family and circle of friends. "Even though the shapes are abstract," Bourgeois explains, "they represent people. They are delicate as relationships are delicate. They look on each other and they lean on each other."[5] In these early pieces, the artist summoned forth significant individuals in her life in France to help her fill the void she felt after leaving her homeland during the particularly difficult time on the eve of the Second World War. These missed and remembered personages, which were first displayed in 1949 in New York's Peridot Gallery, exuded an air of isolation and evoked the torment of life (fig. 5). Bourgeois has said, "My sculpture allows me to re-experience the fear, to give it a physicality so I am able to hack away at it. Fear becomes a manageable reality. Sculpture allows me to re-experience the past, to see the past in its objective, realistic proportion."[6]

From this early stage in the artist's career, she discovered that her sculpture had the power and the presence to represent the experiences of her life and, in doing so, to create new experiences, which she could share with those who viewed her work. The 1949 exhibition may be considered Bourgeois's very first installation piece, in which she exhibited the sculptures in a manner that suggested interaction, in emotional as well as spatial terms. In these early sculptures, Bourgeois created a special brand of animism that continues in her work to this day. The figures or objects represent personages close to her not in appearance, but in spirit; they constitute, in fact, a surrogate family. Bourgeois's approach to her art at this time displayed an unprecedented fusion of the rational and the intuitive. She concentrated on the spiritual function of her sculpture, using form, materials, techniques, and scale to give tangible expression to the traumatizing experiences of her own life in a heroic attempt to exorcise them.

Bourgeois's work is largely derived from her personal history and experience as a woman—daughter, wife, and mother. The artist herself frequently speaks about her adolescence amid a family with one member too many, and one should not underestimate the far-reaching effects on her life caused by the presence of the English tutor, Sadie, who was her father's

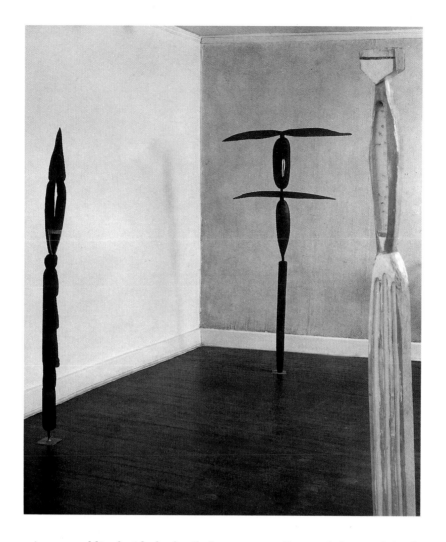

mistress and lived with the family for ten years. Bourgeois has explained, "My father betrayed me by not being what he was supposed to be. First of all, by abandoning us to go to war, and then by finding another woman and introducing her into our house."[7] Having three parental figures involved in complex and confusing relationships forced all three children to negotiate unusual alliances in a painfully uncertain world of pretending adults. The very notion of authority was forever undermined, leaving a young Bourgeois with the resolve to create her own universe, one in which there were constants she could define and control.

As the architect of her own imaginary world, Bourgeois was able to represent her emotions and memories in terms relevant to her experiences. Throughout her career, Bourgeois has been drawn to imagery of the body and the home to express themes of life, death, sex, isolation and alienation, and care and tenderness. In her prints, drawings, and paintings of the early and mid-1940s, Bourgeois frequently depicts women in fantastic domestic situations. One recurring image is of a female figure carrying a house on her shoulders: the universe the woman created to protect herself and her family has betrayed her and confined her as a prisoner of her own invention. In these early works, many of which are entitled *Femme Maison* (figs. 6, 7, 19), the figure and the building are fused, and it is difficult to determine whether the woman is metamorphosing into the house or the house into the woman. The poignant clarity of such statements about a woman's status— one that was accepted not only by the larger society, but also by an art world with truly reactionary sexual politics—was far ahead of its time. This feminist vision signaled the emotional intensity and narrative content that

Fig. 5. Installation view, Peridot Gallery, New York, 1949

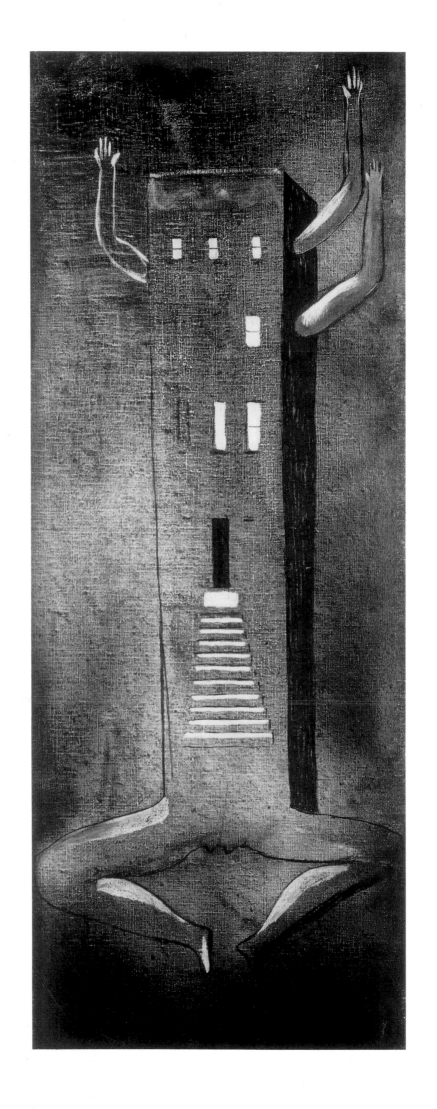

Fig. 6. *Femme Maison.*
ca. 1946–47. Oil and ink
on linen, 36×14 in.
(91.4×35.6 cm). Private
collection, California

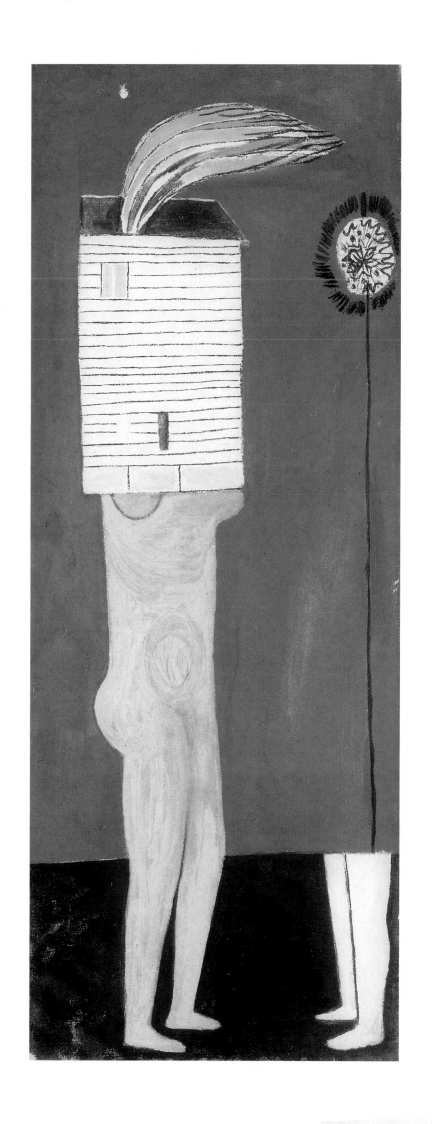

Fig. 7. *Femme Maison.*
ca. 1946–47. Oil and ink
on linen, 36 × 14 in.
(91.4 × 35.6 cm). Private
collection, New York

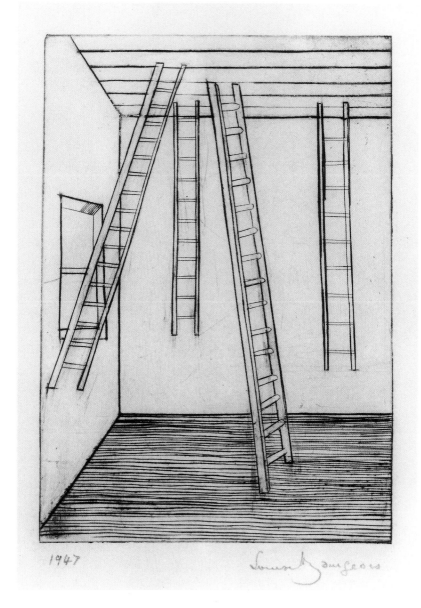

1947 Louise Bourgeois

was to become the hallmark of Bourgeois's art. It also provided the foundation for imagery that would recur in her work throughout her career.

Images related to the house or dwelling—from the Femme Maison paintings of the forties and the eerily empty rooms of the published set of etchings *He Disappeared into Complete Silence* (1947), to the series of Lairs, to the Cells with their fusion of body parts with architectural constructs—are persistent themes in Bourgeois's work. This recurrence is understandable in view of the artist's concentration on the psychological drama evolving in her oeuvre for the past five decades; this drama takes place in the spaces of familial, social gathering or in solitary, isolated realms provided by man's habitat. The house becomes a major catalyst for memory, for it is in this certain and defined locale that the range of human relationships and feelings—from the most primary to the most complex—take place.

The image of the house represents the topography of our most intimate selves and relates to a spectrum of experiences connected with the universe of our first domicile. Humble or grand, tragic or nurturing, the impressions acquired in these first rooms, hallways, and staircases of our early years live forever within our imagination. In her artwork, Bourgeois has provided the means to give these memories and feelings a tangible reality:

Fig. 8. *He Disappeared into Complete Silence*, Plate 8. 1947. Engraving, 10 × 7 in. (24.5 × 17.8 cm). Courtesy Robert Miller Gallery, New York

I need my memories. They are my documents. I keep watch over them. They are my privacy and I am intensely jealous of them. Cézanne said, "I am jealous of my little sensations."

To reminisce and woolgather is negative. You have to differentiate between memories. Are you going to them or are they coming to you. If you are going to them, you are wasting time. Nostalgia is not productive. If they come to you, they are the seeds for sculpture.[8]

Bourgeois's memories become departures for an undertaking that is quite personal yet often recalls a sense of space that belongs to our shared experience of the home. In Bourgeois's imagery, the enclosure of the house, a room, or a staircase may either provide protective refuge or become a trap. In her early works, houses, rooms, and steps appear in self-contradictory constructs. One of the prints of the series *He Disappeared into Complete Silence* (fig. 8), for example, depicts a number of ladders floating in a room, leading upward toward the floor-ceiling. Similarly, in works such as *No Escape* and *No Exit*, both 1989 (pls. 16, 17), monumental staircases lead toward nothing. These steps are another dead end. Yet the stairs of *No Exit* house beneath them, like the ribs of the chest cavity, a hidden chamber with two suspended hearts. This work again alludes to Bourgeois's perception of her childhood home:

There was a grenier, *an attic with exposed beams. It was very large and very beautiful. My father had a passion for fine furniture. All the* sièges de bois *were hanging up there. It was very pure. No tapestries, just the wood itself. You would look up and see these armchairs in very good order. The floor was bare. It was quite impressive. This is the origin of a lot of hanging pieces.*[9]

Similarly, in a work entitled *Articulated Lair* of 1986 (pl. 9), another unlikely room constructed entirely of corners houses a series of hanging rubber forms. The Lairs (figs. 17, 24), unlike *No Escape* and *No Exit*, do have both entrances and exits. They represent a place of refuge, nurturing, and regeneration.

Bourgeois's ability to infuse her sculpture with emotive and psychological expression, together with her understanding of the mathematics of topology, has allowed her to pursue the study of form with a unique and unprecedented approach. Throughout her career, she has explored spatial relationships and developed a personal lexicon of figures that she initiated in her early work and has continued to build upon over the course of five decades. Combining both constructive and reductive approaches to making sculpture, she has employed the organizing principles of geometry and architecture to give foundation to her pieces, yet she has allowed for more fluid formations and organic compositions.

In her drawings and her three-dimensional work, Bourgeois recognized the human body as a unit composed of independent parts, which could be used as the elements of new and evocative configurations. In her early work Bourgeois composed some of her tall standing sculptural personages by stacking cut pieces of wood, literally building the figures. Increasingly, she used elements of the anatomy—cells, tissues, and organs—as the building blocks of her sculptures. The manner in which Bourgeois has fragmented and reconfigured the body is not unlike that in which life is segmented and

reexperienced through our memories. "Since the fears of the past were connected with the functions of the body, they reappear through the body,"[10] Bourgeois has said.

Throughout her career, Bourgeois has experimented with various methods of composing the fragmented parts of the body in her sculptures, yet none are more brilliant than those employed in the past decade. *Nature Study*, 1984 (pl. 6), demonstrates her unique approach. Though reminiscent of ancient representations of mythical winged demigods, this bronze figure appears to have been fractured and reconstructed from its disparate parts. While the individual features of the sphinxlike figure correspond to natural shapes, the compounded effect of this imposing composition of both human and animal body parts suggests a supernatural creature, an anthropomorphic goddess. The polarities between man and beast, male and female, are well in keeping with the inherent contradictions of the artist's approach. The placement of the figure at eye level on a stemlike base both forces the viewer to confront the creature's genitalia and adds an element of precarious balance, rendering it at once aggressive and vulnerable.

While some works comprise numerous organic elements, others feature a single part isolated and decontextualized. *Nature Study (Velvet Eyes)*, also from 1984 (pl. 7), demonstrates the latter approach. In the marble block are two deeply carved holes, half-spherical in shape. Out of these craters emerge two eyes fully rendered with a definite stare. These "velvet eyes" are eternal, imploring, and doubtful, and suggest flirtation and seduction. *Legs*, 1986 (pl. 11), consists of pliable cast rubber. Linear and almost immaterial, two strips that appear to be the skin of two limbs are suspended in the air, hanging loose without any controlling force. With one "leg" slightly longer than the other, they allude to the rhythm of walking. Two hands carved in marble in *Décontractée*, 1990 (pl. 21), masterfully suggest not only the arrested tension of pain and exaltation, but also total relaxation and release.

Cast rubber is used for a wall relief entitled *Mamelles*, 1991 (pl. 32), which displays a series of female breasts. Although the work has a classical architectural construct, *Mamelles* does not unfold a procession of hardened warriors or gods, but rather one of soft, nurturing, female forms. The use of the ancient configuration of the frieze evokes a classical narrative, yet there is a typically subversive twist in this story. According to the artist, *Mamelles* "portrays a man who lives off the women he courts, making his way from one to the next. Feeding from them but returning nothing, he loves only in a consumptive and selfish manner."[11]

While bronze, steel, and rubber have been used in numerous works, it was marble that most captivated Bourgeois in the 1980s, particularly in her large-scale work. The artist explores the range of effects this material offers, sometimes roughly chipping its surface and at others highly polishing it. The weight, mass, and density of the stone are underscored in *Ventouse*, 1990 (pl. 26), wherein a large piece of coarse black marble serves as a base for delicate, clear glass medical vessels of the type Bourgeois had used to treat her mother during her frequent illnesses. The noble beauty of this venerable material is nowhere more apparent than in the brilliantly carved *The Sail*, 1988 (pl. 15). Competing with masters of classical and Baroque drapery alike, Bourgeois accentuates the play of light and shadow by illuminating the hollow interior of the carved marble block and allowing

light to emanate from the core of the exquisite stone through the windowlike openings in the work.

Untitled (with Growth), 1989 (pl. 19), addresses the artist's most challenging recurrent themes. From the roughly hewn marble block grows a superbly polished cluster of organic forms. Although they consist of the hardest stone, their fragile beauty is exposed and vulnerable. Suggesting life and regeneration, they represent the span of the biological spectrum. They grow from the formative matter of their own unarticulated universe, the burgeoning forms both of nature and of sculpture. It is a story of creation, wherein the artist gives inanimate material a spark of life and shapes start to emerge.

In her recent works, Bourgeois has focused her creative microscope on organic matter and objects related to her early memories. In *Gathering Wool*, 1990 (pl. 23), she monumentalizes the balls of yarn that surrounded the young Bourgeois in her family's tapestry restoration studio. *Needle (Fuseau)*, 1992 (pl. 33), is part of a larger series of sculptures of that title created to commemorate the mending power of this instrument. The needle is given epic proportions to signify that it is a prominent object of the artist's memory, again reminiscent of her parents' livelihood. Bourgeois explains her feelings about the needle as follows: "When I was growing up, all the women in my house used needles. I've always had a fascination with the needle, the magic power of the needle. The needle is used to repair the damage. It's a claim to forgiveness. It is never aggressive, it's not a pin."[12] Focusing on this object of personal significance from her childhood is perhaps an act of self-reparation and reconciliation with the past.

Bourgeois's desire to give physical presence to memories, or to re-create the experiences of her life, was manifest as early as 1949, in her already-mentioned exhibition of sculptural personages, and has continued throughout her career in such projects as *The Destruction of the Father*, 1974 (fig. 9), and *The Confrontation*, 1978 (fig. 10). In the late 1980s, Bourgeois once again turned to large installation pieces and began to concentrate on a series of works called Cells (figs. 25–27; pls. 27–29). The title alludes both to cells that form living organisms — the most basic body unit — and to cells that impose desired or enforced solitude. Bourgeois's Cells are places of contemplation, with veritable prison walls of found steel or of glass doors or windows and containing objects used as memorial documents. Every item has significance for the artist and for the viewer, who is often invited to enter the Cell's chamber. Where one may find solace behind the protective walls of heavy steel, another might suffocate within the oppressive barriers of doors that do not open. Bourgeois explains:

The Cells *represent different types of pain: the physical, the emotional and the psychological, and the mental and intellectual. When does the emotional become physical? When does the physical become emotional? It's a circle going round and round. Pain can begin at any point and turn in either direction.*

Each Cell *deals with fear. Fear is pain. Often it is not perceived as pain, because it is always disguising itself. . . .*

The Cell *with the figure or arch of hysteria deals with emotional and psychological pain. Here in the arch of hysteria, pleasure and pain are merged in a state of happiness. Her arch — the mounting of tension and the release of tension — is sexual. It is a substitute for orgasm with no access to sex. She creates her own world and is*

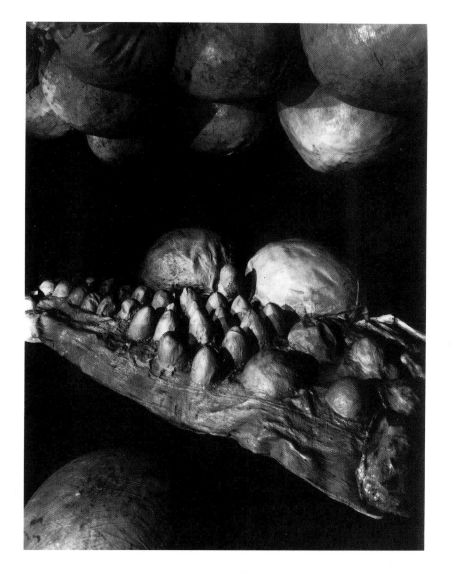

very happy. Nowhere is it written that a person in these states is suffering. She functions in a self-made cell where the rules of happiness and stress are unknown to us.[13]

The most recent group of Cells, created in late 1992 and 1993, presents the dichotomy between the impersonal, strictly geometric enclosures and the highly evocative objects they contain (pls. 35–40). While a bed in *Cell (Arch of Hysteria)* suggests a bedroom, a table with chairs in *Cell (Glass Spheres and Hands)* alludes not only to a dining room in a home, but also to a classroom in which disciples are gathered around a teacher. The installation of the Cells in close proximity to one another with little or no passage between them brings to mind the ground plan of a house. *Cell (Choisy)* shelters a small replica of Bourgeois's childhood home carved in flesh-toned marble, reinforcing the house-body metaphor. The Cells also contain the fragmented body parts from which many of her sculptures are built: severed arms rest on the table of *Cell (Glass Spheres and Hands)* in a gesture of anguished prayer, while a pair of enormous eyes guards the entrance of *Cell (Eyes and Mirrors)*. These and a seemingly decapitated, distended figure in *Cell (Arch of Hysteria)* are accompanied by instruments of dismemberment—a band saw and a guillotine, which looms large above the house of Choisy. In her recent Cells, Bourgeois has synthesized the forms, methods, and themes that have prevailed in her art throughout her career. Once again fusing the body with the home as she had in those early Femme Maison

Fig. 9. *The Destruction of the Father*. 1974. Latex, plaster, and mixed media, 93⅝ × 142⅝ × 97⅞ in. (237.8 × 363.3 × 248.7 cm). Courtesy Robert Miller Gallery, New York

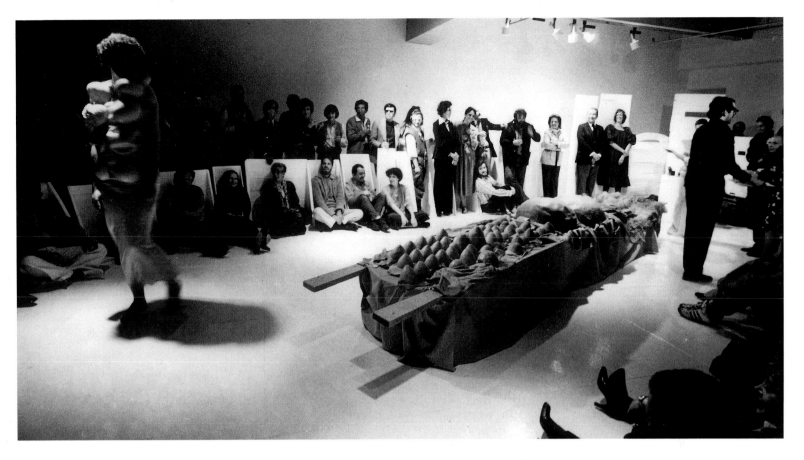

paintings, she has developed works of unprecedented scale and energy. These sculptures are both a result of and a departure from Bourgeois's achievements of the past.

Louise Bourgeois is endlessly resourceful. In the universe of her creation, the feeling of loneliness can be turned into celebration, humiliation into victory, and despair into assurance. Much as our experiences inform the landscape of our dreams, Bourgeois's memories provide her with the vocabulary of figures within her sculptural world. As the architect of that environment, she uses locales of her past and present and the cells, organs, and tissues of her own making as her building blocks, delving deeper and deeper into her own psyche. Her courage to share with us her anxieties and obsessions has produced a body of bold and monumental work unique in the history of sculpture. It is said that we bring our Lares with us—that these gods and guardians of the household from classical mythology accompany us in our journey through life. It would seem that Louise Bourgeois has not only brought her Lares with her, but has engaged them in a constant and creative discourse.

[1] Louise Bourgeois, "Self-Expression Is Sacred and Fatal: Statements," in Christiane Meyer-Thoss, *Louise Bourgeois: Designing for Free Fall* (Zurich: Ammann Verlag, 1992), 195.

[2] Louise Bourgeois, "In Conversation with Christiane Meyer-Thoss," in ibid., 139.

[3] Christiane Meyer-Thoss, "Designing for Free Fall," in ibid., 53.

[4] Ibid., 53–54.

[5] Bourgeois, "Self-Expression Is Sacred and Fatal," 179.

[6] Ibid., 195.

[7] Ibid., 182.

[8] Ibid., 184.

[9] Ibid., 185.

[10] Ibid., 195.

[11] Conversation with the artist, December 1992.

[12] Bourgeois, "Self-Expression Is Sacred and Fatal," 178.

[13] Louise Bourgeois, "Louise Bourgeois," *Balcon* (Madrid), issue 8–9 (1992): 44, 47.

Fig. 10. *The Confrontation* (a banquet/fashion show of body parts). 1978; performed at Hamilton Gallery of Contemporary Art, New York. Painted wood, latex, and fabric, ca. 37 × 20 ft. (11.3 × 6.1 m). Solomon R. Guggenheim Museum, New York

TERRIE SULTAN

REDEFINING THE TERMS OF ENGAGEMENT: THE ART OF LOUISE BOURGEOIS

Tenacity and acumen are privileged spectators of this inhuman show in which absurdity, hope, and death carry on their dialogue. The mind can then analyze the figures of that elementary yet subtle dance before illustrating them and reliving them itself.
—ALBERT CAMUS[1]

People misunderstand my work. I am not a surrealist; I am an existentialist.
—LOUISE BOURGEOIS[2]

Louise Bourgeois's aesthetic stands as a counterproposal to the optimistic and nihilistic approaches that remain the hallmarks of Modernism at the end of the twentieth century. In place of the pseudoscientific, primarily materialistic understanding of spatial relationships formulated by Cubism, the misogynistic antihumanism implicit in Surrealism's literary motifs and free associations, the reductive geometries of Minimalism, or the appropriational attitudes of current artistic approaches, what Bourgeois espouses is the validity of the self, in all its frailty and strength. Her work has been relentlessly dissected for autobiographical, psychosexual, and formal meaning and has been linked to both Modernism and the Postmodernist movement. The works in the present exhibition illustrate the increasing clarity of vision in her stylistic process over the last decade; this clarity underscores the essential content that remains the basis of her art. Bourgeois has considerably enlarged the scale and scope of her sculpture over the last decade, and her creative presence has had a significant impact on the art of the 1980s. However, it is important to remember that her art did not arrive or even coincide with the zeitgeist of the time but operated independently of it, like a preexisting condition. Insistently roaming through myriad sculptural materials and techniques while traveling a digressive, even transgressive path of ideas and meanings, Bourgeois has produced a rich body of work that remains singular in its ability to challenge accepted definitions of the structure and meaning of art. At once ingenuously forthright and disturbingly enigmatic, hers is an art of compelling cyphers that, while strangely unknowable, pull

us into what seems to be an extremely personal relationship with their maker. I say seemingly because although we enter her work through her open invitation to interpretation, there resides in the sculpture of Louise Bourgeois the sense of two mysteries—one personal, the other expressed in larger terms—that we cannot fully resolve.

My work is a very specific fight against specific fears, one at a time. It comes close to a defining, an understanding and accepting, of fear.
—LOUISE BOURGEOIS[3]

Bourgeois expressed her ideas in a wide variety of materials during the 1980s, from soft, pliant rubber to crystalline, fragile marble and glass, from the myriad associative possibilities of highly personalized objects that she sometimes refers to as *"objets trouvés"* (found objects) to the resolute immediacy of welded and cast metal. However, the central themes of her sculpture—nature studies, lairs and cells, and figurative tableaux—have remained remarkably constant, from the seminal *The Destruction of the Father*, 1974 (fig. 9), through her most recent Cells. For Bourgeois, the basic human condition is fear, and it is the will to overcome fear that fundamentally defines us as sentient beings. Each time the artist approaches her materials to convey an emotion, her resolution evolves from a process of overcoming an outside invasion: for example, a fear of intimacy, the inability to communicate, or love. However, it would be a mistake to reduce her work to any single psychological impetus. Rather, her will, which at the age of eighty-three mirrors the shape of her life, is one of mastery over resistance. Sculpturally, this is stated through her ability to make her materials subservient to the ideas enunciated by her forms. In this sense, her approach is the same whether expressed subtractively, through carving, or additively, through ensemble combinations of intimate, domestic objects she culls from her daily routine. The repetition of Bourgeois's creative process—the continual making and refashioning that has marked her long, determined, and productive career—has been enlarged, over the last decade, to accommodate the willful revisitation of some of her foremost concerns through a series of theme and variation.

Bourgeois builds each of her works from the inside out. Working in parallels and series, she moves easily from one sculptural format to the next, claiming, "I am not interested in materials as such; I'm interested in finding an order out of chaos."[4] Bourgeois quite purposefully structures her materials to mirror her content: her organic contradictions range from overt associations of found objects, to the contrasts between vigorous roughness and refined artisanship in her marble carving, to the stacked construction of her early wood figures. Increasingly architectural in their structure, her newest installations directly challenge the primacy of traditional subject-object relationships, denying a linear hierarchy of materials such as stone-to-stone or metal-to-metal in favor of amalgams that expand the role of the pedestal to include the position and posture of the viewer. By delineating the base as an essential aspect of her marble sculptures, she gives the impression of an emergent subject that floats to the top of the material while remaining at one with it. The refusal or sublimation of the pedestal is, in

fact, Bourgeois's way of redefining the function of sculpture—and, by implication, the nature of the viewer's relationship to the artist's world.

Bourgeois has taken on, mastered, and put aside the full panoply of modern materials and sculptural approaches. Her earliest student works, produced while she lived in Paris, were paintings in a "Cubist-based abstractionist style."[5] She continued to paint and draw after coming to the United States in 1938, studying with Vaclav Vytlacil at the Art Students League; in 1949 she made her exhibition debut as a sculptor, conceiving a room-sized installation of freestanding, human-scaled wood sculptures. Throughout the 1950s her work referenced the figure, involving constructions of stained and painted wooden forms focused around a vertical axis and created mainly through additive processes, as in *Spiral Woman*, 1951–52 (fig. 11). The strong verticality of these works has its roots in Bourgeois's desire to abstract the figure in relation to architecture and in her personalization of the act of construction as a revolt against the developing Modernist canon of welded steel epitomized in the United States by David Smith.[6]

Beginning around 1960, Bourgeois began to favor plaster, combining the additive and subtractive processes intrinsic to this material to shift her work away from the strong verticality of the abstracted body in an architectural environment and toward horizontal arrangements of piled or knotted forms suggestive of natural terrains or internal organs that can be more easily related to psychological territories. Many of these works emphasize interiority, creating cavelike recesses that can be seen as anticipating the installations that the artist began to construct in the 1980s. Toward the end of the 1960s, in works like *Janus Fleuri* and *Fillette* (see fig. 23), both 1968, Bourgeois's imagery began to include aggressively explicit depictions of sexuality, particularly through references to male and female genitalia that are presented as trophies cut away from the body. Hanging in mute isolation, these objects strongly contrast the antipodal male-female relationship established by Modernist masters as divergent as Pablo Picasso, in such works as his monument to Apollinaire (fig. 12), and Alberto Giacometti. Marble entered Bourgeois's vernacular as a more permanent complement to plaster in the late 1960s. Works such as *Colonnata*, 1968, sprout colonies of vertical nodules whose open-ended shapes are suggestive of spores, mushrooms, or phalli, excretions or growths that emerge organically from a marble base.

Throughout the 1970s Bourgeois alternated carving and collaging in marble with latex casts of objects from life that served as precursors of finished sculptures in bronze. The latter technique introduced a vigorous naturalism that is proclaimed most evidently in works such as *Rabbit*, ca. 1970 (fig. 13). The 1970s were a decade of expansion for Bourgeois, not only in her command of diverse media, but also in her increasing confidence in her content. This personal recognition of her strengths propelled the artist into the 1980s, a decade when her work began to take on a sense of monumentality only previously implied in her objects. It was during this time that Bourgeois expanded the vocabulary of her large-scale installations, combining objects from life and works of sculpture within structural arenas as a means of displaying her increasingly codified themes.

Regardless of medium, Bourgeois's work has remained grounded in the senses, and it is not coincidental that she has chosen body fragments— eyes, ears, hands, feet—to concretize aspects of the body associated with

Fig. 11. *Spiral Woman*, view and detail. 1951–52. Wood and steel, height 62½ in. (158.8 cm). Courtesy Robert Miller Gallery, New York

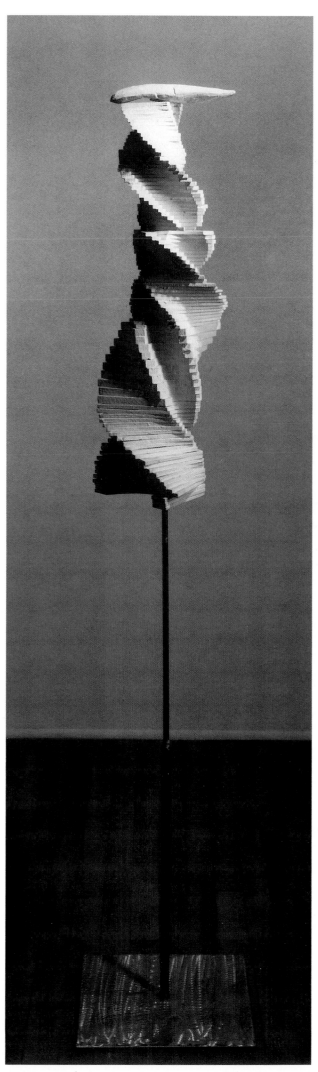

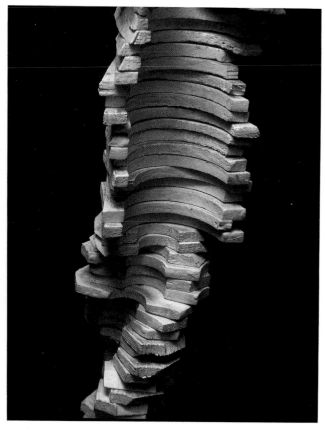

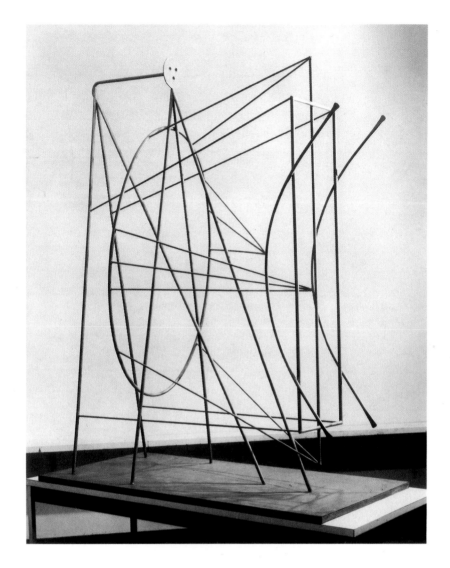

sensate experience. For example, the eyes that Bourgeois employs in *Nature Study (Velvet Eyes)*, 1984 (pl. 7), challenge our claim to the privacy of viewership by blurring the relationship between the viewer and the object viewed. Sunk between two stone slabs, the eyes peer out, alternately seductive and flirtatious. They also present a monolithic stone gaze that acknowledges the social implications of the act of seeing without allowing the engagement of a directed gaze. This play on the eye as a window to the soul is expressed much more intimately in *Bald Eagle*, 1986 (pl. 10). This small pedestal-based object of white alabaster is immediately compelling, like a fetishized ideal. However, because it is detached from a useful function and presented as a fragment instead of part of an integral whole, the hooded orb, nestled in its socket like an egg in a nest, is more passively iconic than aggressively probing. Whether monumental or intimate in scale, directly or abstractly expressed, the eye as an object and the gaze as an action of inquisition or possession remain central metaphors in Bourgeois's oeuvre.

Hands and arms reaching out from or resting on top of stone blocks became another signature of Bourgeois's work in the 1980s. Conjoining supplicative gestures and tactile, geometric forms, these hands, whether presented singly or in groups, are integers that help Bourgeois stage her dramatic emotional content. In *Untitled (with Foot)* and *Untitled (with Hand)*, both 1989 (pls. 18, 20), a smoothly polished marble sphere, disturbed only by a protruding limb, is perched atop a roughly hewn base.

Fig. 12. Pablo Picasso. *Project for a Monument to Guillaume Apollinaire* (intermediate model). 1962; enlarged version after 1929 original maquette. Painted steel rods, 6 ft. 6 in. × 62⅞ in. × 29½ in. (198.1 × 159.7 × 74.9 cm). The Museum of Modern Art, New York. Gift of the artist

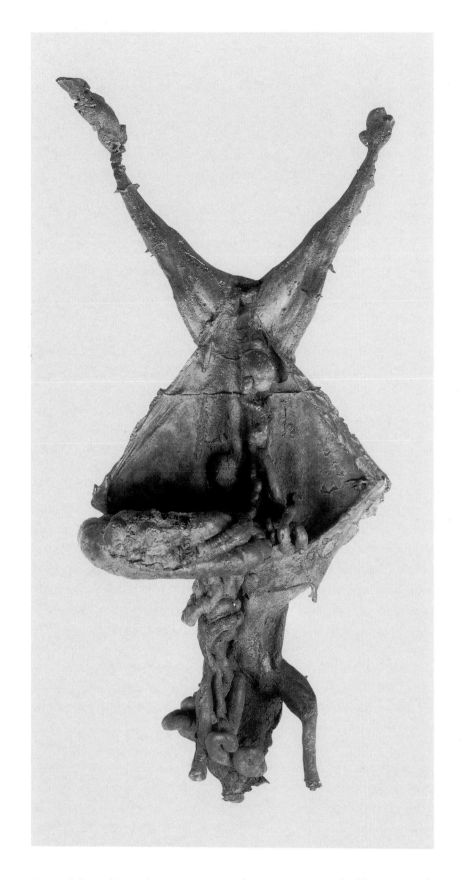

We read this odd combination as natural, an organic growth. The emotional tension created by this double entendre of emergence and dependence, ideal geometry and fleshly proportion, is reinforced by the inscription carved around the rectangular base. Like the unseeing gaze in *Nature Study (Velvet Eyes)*, the repeated phrase "I love you, I love you" creates a social dynamic between object and viewer, an emotional attachment that is as succinct in its direction as it is unclear in its intent. Is the artist declaring her love for the emergent child implied by her form, or is she addressing us

Fig. 13. *Rabbit.* ca. 1970. Bronze, 23 × 11⅜ × 5⅞ in. (58.4 × 28.9 × 14.9 cm). Solomon R. Guggenheim Museum, New York

33

Fig. 14. *Je t'aime*. 1977. Red ink on grid paper, 8¼ × 12¾ in. (21 × 32.4 cm). Private collection, The Netherlands

rhetorically, saying, for example, "I love you, but I am out of reach"? Conversely, the inscription carved in *Untitled (with Foot)* is "Do you love me?"; that in the third work in the trilogy, *Untitled*, reads "We love you." This tense ambiguity is obsessively foreshadowed in the 1977 drawing *Je t'aime* (fig. 14), an exercise in expiation that reinforces the repetition of an after-school punishment or a confidence-building mantra. In each work, both the statement and the object it inscribes mirror the uncertain nature of the social entanglements Bourgeois perceives as dominating life.

As she began to state definitively her love-hate relationship with the tradition of pedestal sculpture, marble began to supersede plaster or bronze as Bourgeois's medium of choice. Her use of such a traditional material as marble was largely determined by the figurative impetus of her imagery, where hands, feet, breasts, and eyes described with supple naturalism emerge from, or are bound to, the rough-hewn rawness of a stone base. This is a strategy pioneered by Auguste Rodin, whose vigorously modeled expressive figures can be seen as important precedents for Bourgeois. But if Bourgeois's approach to carving marble is deeply rooted in the Rodinesque tradition, she alludes to traditional figurative sculpture in order to break down the concept of representation as an allegory of beauty that Rodin's work stated explicitly. While emphasizing the fragmentation of the figure through a whittling away of arms and legs, Rodin produced a figural ideal that refined raw matter into a gesture of heroic individuality, as in *The Evil Spirits* (fig. 15). Although she retains Rodin's preoccupation with representation, Bourgeois refrains from explicit portrayal of individuality, preferring to address the fragmented nature of the very extremities that Rodin forsook. In addition, Bourgeois's figurative fragments are rendered in a high realism that conveys intensity of emotion through an authentic description instead of a Platonic ideal: because of her insistence on authenticity, the models for her hands and feet are always very specific and personal.

In contrast to the careful depictions of her marble pieces, Bourgeois also creates much more abstract body references, using rubber or other pliable materials and freely adopting mannerist tactics of distortion in scale and perspective. For example, the rubber limbs in *Legs*, 1986 (pl. 11), seem, like the branches of an etiolated plant, to be functional members grown

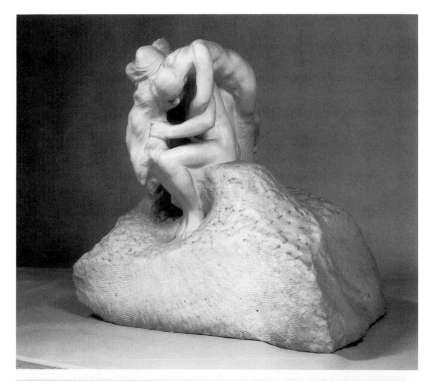

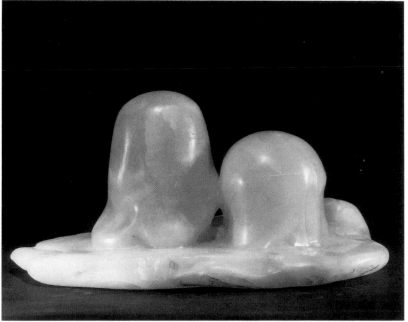

Fig. 15. Auguste Rodin. *The Evil Spirits.* 1899. Marble, 28 × 29¾ × 23¼ in. (71.2 × 75.7 × 59 cm). National Gallery of Art, Washington, D.C. Gift of Mrs. John W. Simpson

Fig. 16. *Soft Landscape II.* 1967. Alabaster, 7 × 14⅝ × 9⅝ in. (17.8 × 37.2 × 24.5 cm). Kunstmuseum Bern

useless through repeated attempts at adaptation to conditions of deprivation. *Legs* offers the antithesis of our expectations for the usefulness and attractiveness of our lower limbs; denied their traditional context by their detachment from the whole, they hang lifelessly, even menacingly. But whether situated in vertical or horizontal positions, Bourgeois's body fragments command the landscape. Her definition of forms in terms of axial relationships expresses a specific symbolism: "Horizontality is a desire to give up, to sleep and be passive, to retreat. Verticality is affirmation, an attempt at a peaceful compromise and a desire for acceptance. Hanging and floating are states of ambivalence and doubt."[7] The pliable forms in *Mamelles*, 1991 (pl. 32), are positioned horizontally, aligned with our field of vision. In their multiplicity these lurid pink pods of breast forms almost appear to be socialized individuals attuned to the same purpose, like a moiling colony of ants or bees. Instead of the singular isolation of *Legs*,

Mamelles uses human fragments to express metaphorically the group dynamic of social interaction as a fusion of the topologies of landscape and body. Her choice of the breast lucidly expresses what I believe to be Bourgeois's inexorable need to feminize sensuality as a means of blurring what she perceives as the passive-aggressive dynamic of human intimacy. Through this comprehensive practice, which can be seen in other enigmatic landscapes such as *Soft Landscape II*, 1967 (fig. 16), and *Untitled (with Growth)*, 1989 (pl. 19), Bourgeois obtains insistent forms that prod us to respond to an erotic sensuality that is as palpable as it is ultimately abstract.

Nature Study, 1984 (pl. 6), expresses Bourgeois's continued fascination with the manipulation of the recognizable landscape of our bodies. Extending her mannerist strategy of elongation and distortion, this sculpture is complex and unpredictable in its sudden shifts of anatomy. Neither completely human nor totally animal in its physiognomy, it displays forms that are concerned with the physicality of flesh. Bourgeois first exaggerates and then conjoins sharply differing sculptural contours, combining male and female attributes to declaim an intricate allegory about raw, unfettered sexual attraction. In addition, *Nature Study* projects the distanced presence of a sentient being, or rather, a powerful being, since this is a body without a head. Unlike many of Bourgeois's earlier sculptures on this theme, which convey sexuality through an abundance of orifices, this embodiment of sensation without the imposition of a mediating intellect is devoid of any opening that would allow for the suggestion of an inside-outside interaction between object and viewer, or between the object and its surrounding environment.[8] Self-contained, *Nature Study* is a body that acts like a fragment. Nevertheless, the sexual energy it projects is easily discernible through the powerful articulation of its limbs and claws; this is also indicated through the distortions of the viewer's own image that are reflected in its impermeable, utterly traditional surfaces of highly polished bronze. While carved of stone, *Blind Man's Buff*, 1984 (pl. 5), offers a similar disconnection from intimacy. Perched atop a marble slab, and displaying not a head but a column of hacked marble, this form is rounded by breastlike nodules that at times verge on becoming subtly phallic. Bourgeois presents a persona that has sprouted a virus of sexuality, as if expressing a disease, an abundance of breasts only a blind man could love. If *Nature Study* projects sexuality as an attribute of raw power, *Blind Man's Buff* can be seen as an outgrowth of Bourgeois's 1978 performance of *The Confrontation* (fig. 10), in which the art historian Gert Schiff wore a latex costume affixed with numerous breastlike nodules.

The 1986 Nature Study series (pls. 12, 13) restates Bourgeois's refusal to accept the dichotomy between figuration and abstraction so clearly set forth in sexual terms in *Nature Study* of 1984. In these marble works, twisted, ropy, or knotted biomorphic forms are monumentalized by their placement on pedestals that suggest small boulders. These forms evoke highly threatening invertebrate echinoderms trapped in a carnivorous death struggle or, more innocently, carnal abstractions in vegetational disguise. If, as has been noted, Bourgeois's sculpture "is organic representation of convoluted psychic mechanisms which guide and motivate her work," then the forms in the Nature Study series provide analogies for the shapes of the forms of the unconscious mind.[9] With the directness of a psychologically primitive

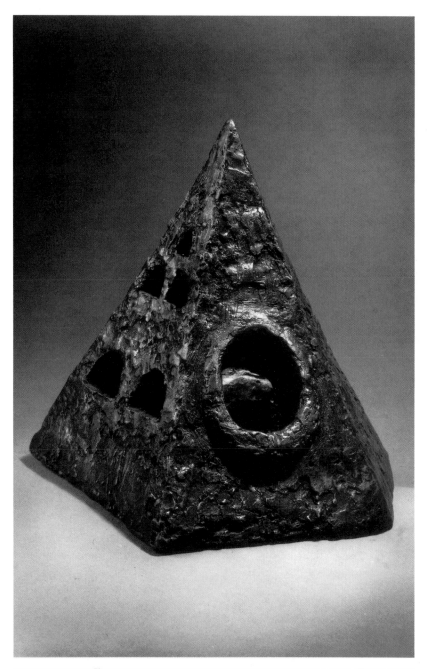

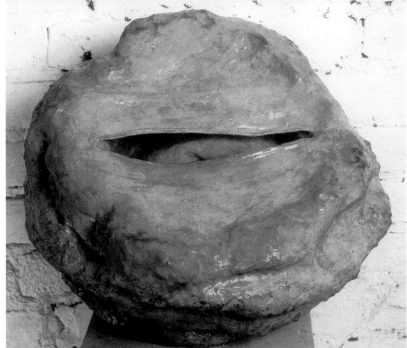

Fig. 17. *Lair*. 1962. Bronze, height 14 in. (35.6 cm). Courtesy Robert Miller Gallery, New York

Fig. 18. *Le Regard*. 1966. Latex and cloth, 5 × 15½ × 14½ in. (12.7 × 39.4 × 36.8 cm). Collection of the artist; courtesy Robert Miller Gallery, New York

anima, the Nature Study series operates somewhere between anxiety and tenderness. Both the central cylinders and the spirals that entwine them bear attributes that, while clearly linked in mutual dependency, are also subtly oppositional. However, whether interpreted as animal or vegetable, male or female, these forms, seemingly extruded from the same substance, are locked in a suffocating duet of self-gratification. Significantly, in *Nature Study*, 1986 (pl. 12), the entwining coil around the central object ends in the articulation of a human hand, injecting a recognizable human gesture as a clarifying addendum to an otherwise abstract depiction. Such abrupt transitions further emphasize Bourgeois's contention that even the most abstract form can vividly convey a human reality. The enigmatic sculptures of the Nature Study series and the more explicit 1984 *Nature Study* and *Blind Man's Buff* present the body through a confluence of abstract and figurative form; through their ambiguous intersections of shape and intention, they present humanness as a shifting admixture of male and female characteristics. Bourgeois seems to be saying that a fluid state of being that is perhaps best thought of as a presexual body remains a natural part of our makeup, certainly in terms of our psyches even if not specifically in terms of our genitalia.

If Bourgeois's body fragments are surrogates for senses, the openings that appear in many of her works perform another function. Often, they act as gateways between exterior and interior surfaces, which themselves evoke similar distinctions between emotion and intellect. These dichotomies have appeared consistently throughout her work, in such early examples as *Lair*, 1962 (fig. 17), and *Le Regard*, 1966 (fig. 18). In the monumental *Cleavage*, 1991 (pl. 30), this theme is expressed in both human and topographical terms. There is no question that this is a highly charged image, but typically, Bourgeois is purposefully vague in revealing any single connection or sentiment. The undulating folds that she arrays could be either earth or flesh; similarly, the openings that beckon us to come closer and metaphorically enter the work suggest both excavations and orifices. *Cleavage* exemplifies one of the defining characteristics of Bourgeois's work: the great care the artist takes to ensure that as viewers we are left to make our own attachments to her forms. While the 1984 *Nature Study* and *Blind Man's Buff* present vertical presences, the division in *Cleavage* operates on both vertical and horizontal axes, contrasting huge fleshy confines that suggest warm, nonthreatening envelopment with mouthlike or vaginal orifices that seemingly want to devour everything in their path. *The Sail*, 1988 (pl. 15), is also permeated with passageways that refer both to the human body and to the physical world, but in a much cooler, less erotically explicit way. This interweaving of interior and exterior is achieved through rich transitions between hard architectural planes and soft, almost pulpy folds. A long passageway like a tunnel or birth canal runs the length of the piece, which is pierced twice from above and twice again on one side. The mystery of the work is the conundrum it presents: a symbolic land- or seascape possessing decidedly earthy attributes, it nevertheless accepts metaphysicality as a reality. But Bourgeois also readily acknowledges that such a manifold and open-ended identity remains difficult to grasp. Speaking about *The Sail*, she said, "The passage here refers to the Biblical quotation about a camel passing through the eye of the needle. André Gide calls it '*la porte étroite*'—the narrow door."[10]

Concurrent with Bourgeois's terminology of body fragments and passageways is her concept of the lair. This theme is an outgrowth of the Femme Maison series, which, beginning in the mid-1940s, used the house form to encapsulate a balance between enclosure and escape, security and isolation. In the 1980s Bourgeois developed from this idea a desire to create physical spaces capable of signifying memory, time, and recognition. Bourgeois exploits the ideal of home as a pivotal metaphor for femininity; for her, the house structure provides a means of fetishizing memory by making it safe, either by conquering fear or by rehabilitating the dynamic of the intimate events that can take place within it. *Femme Maison*, 1983 (pl. 3), is the culmination of paintings and drawings on the subject that Bourgeois made, beginning in the early 1940s, which depict a female form with a simple house placed over her head (figs. 6, 7, 19). By the time Bourgeois created this sculptural

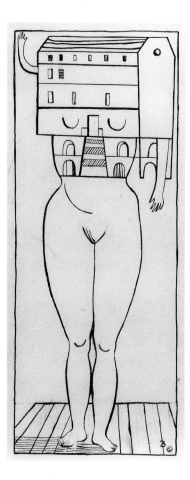

version, however, the house had evolved into a small hat that rests comfortably atop a draped figure in repose; it is as if the house resides as a distant memory that can no longer threaten, confine, or even contain female identity. Surmounting amorphous, almost labial folds and swirls of drapery, the idea of home emanates from this piece as if from the peak of a mountainous form. *Femme Maison* also reflects Bourgeois's interest in how

Fig. 19. *Femme Maison*. 1947. Ink on paper, 9⅛ × 3⅝ in. (23.2 × 9.2 cm). Solomon R. Guggenheim Museum, New York

the fusion of the architecture of the body and that of the house can be used to create an analogy of body and spirit. Concurrent with the Femme Maison sculptures, Bourgeois also separated the psychological home from the geometric house, positing home as an architectural abstraction. *The Curved House*, 1983 (pl. 4), is a minimally enunciated marble whose distorted facade displays only a small doorway: no other openings or architectural details are evidenced in its decorous arch. *The Curved House* presents an edifice that is almost like a sealed tomb, as self-contained and impenetrable as it is imposing.

Having established these sculptural forms as the embodiment of an ideal of home, Bourgeois returned to the broader scale of sculptural installation that had marked her first exhibition, with a dramatic expansion of scope and scale. One of her earliest efforts at heightening this sense of interior space occurred in *Articulated Lair*, 1986 (pl. 9). The outer boundary of this work is circumscribed by dozens of tall black-and-white metal shutters. Slotted together in a fan-fold arrangement that allows the space to be contracted or expanded to suit different configurations, the variable articulation of this piece always creates a series of conflicting conditions. A small stool, positioned across from the entry, proffers the possibility of limited repose and safety. However, a regular rhythm of vertical slats, created by the hinges that connect each partition, encourages an easy voyeurism that suggests vulnerability for the occupant. Any aspect of safe haven is further contradicted by bundles of pendulous rubber objects suspended along the walls of the lair. Is this captured prey, foodstuffs stocked in preparation for a long siege, or sacrifices readied for the person Bourgeois has described as "the invading, frightening, visitor"?[12] *Articulated Lair* is a place that is precisely defined and clearly enunciated (or articulated, as the work's punning title states) as a refuge and a site for seduction. Bourgeois made her first Lair in 1962 (fig. 17) and has revisited the theme consistently throughout her career. Lair forms articulate architectural structures but also involve primarily horizontal arrangements of organic or biomorphic shapes that are permeated with hollows, cavities, and other small openings. Bourgeois has rendered Lairs in materials ranging from plaster to latex, from bronze to the large mixed-media installation *Articulated Lair*, where the scale, suddenly larger than the viewer, allows physical penetration as well as metaphorical entry. Not coincidentally, *Articulated Lair* also provides a vivid metaphor for Bourgeois's Brooklyn studio, where labyrinthine piles and stacks of old and new works are separated only at the junctures of narrow pathways that allow the artist to navigate her sanctuary-like workplace (fig. 20). Expanding the inside-outside terminology outlined in the Femme Maison series to accommodate the viewer as physical participant, Bourgeois has raised the stakes, challenging the viewer to enter her space on her terms, to become, so to speak, part of the dynamic of her work.

No Escape and *No Exit*, both 1989 (pls. 16, 17), simplify the arrangement of *Articulated Lair* into a further permutation of the artist's definition of house and lair. Both works use stairs as a central metaphor, placing the viewer directly in the route of entry or egress. If stairs can symbolize the possibility of flight to a better place, as in the expression "stairway to heaven," the repetitive motion they require can also seem endlessly nihilistic, even futile. Bourgeois's use of stairs metaphorically mirrors the existen-

tialist philosophy of Albert Camus, which articulates the absurdity of the human condition:

All great deeds and all great thoughts have a ridiculous beginning. Great works are often born on a street-corner or in a restaurant's revolving door. So it is with absurdity. The absurd world more than others derives its nobility from that abject birth. In certain situations, replying "nothing" when asked what one is thinking about may be pretense in a man. Those who are loved are well aware of this. But if that reply is sincere, if it symbolizes that odd state of soul in which the void becomes eloquent, in which the chain of daily gestures is broken, in which the heart vainly seeks the link that will connect it again, then it is as it were the first sign of absurdity.[13]

Bourgeois's concerns evoke Camus's emphasis on the ways in which "the chain of daily gestures is broken," with the difference that what Camus expresses as absurdity, Bourgeois states in terms of ambiguity.[14] This is the heart of Bourgeois's existentialist dilemma, as well as the source of her rage. She has noted: "When you reach the top of the stairs, there is nothing there, but still to succeed [to exist], you must proceed, even if this means starting completely anew."[15]

Each Cell deals with fear. Fear is pain. . . . Each Cell deals with the pleasure of the voyeur, the thrill of looking and being looked at. The Cells either attract or repulse each other. There is this urge to integrate, merge, or disintegrate.
—LOUISE BOURGEOIS[16]

Increasingly, Bourgeois has chosen to situate body fragments within the theatrical tableaux that have come to dominate her work. Combining these references to the physical body with found objects, the Cell series (figs. 25–27; pls. 27–29, 35–40) expands many of the repeated motifs and concerns outlined throughout the artist's career in the Femme Maison, Nature Study, and Lair series. Despite their materiality, she views these works mainly as metaphoric repositories for memory. Often the memories they confront relate to pain, which, like many of Bourgeois's personal fears, is firmly anchored in her psyche, specifically grounded in the details of her life.[17] Carved in marble, hands often embody extremely personal grief or rage, such as the pain of abandonment after her mother's death in 1932 or rage at her father's duplicities. In the Cells, the rage Bourgeois derives from such specific memories becomes a more generalized outrage at a universal inability to communicate or to find answers, not only because the right questions are not being asked, but also because right answers may not exist. Each of Bourgeois's sculptures is an expression of a vanquished fear and a declaration of her understanding and awareness of herself. In her work, identity is enunciated on her own terms, and ambiguity thus becomes a means of gaining control. While Bourgeois is decidedly ambivalent in her regard for Freudian thought, the concepts of disappearance and return and the mirror as the central metaphor for loss

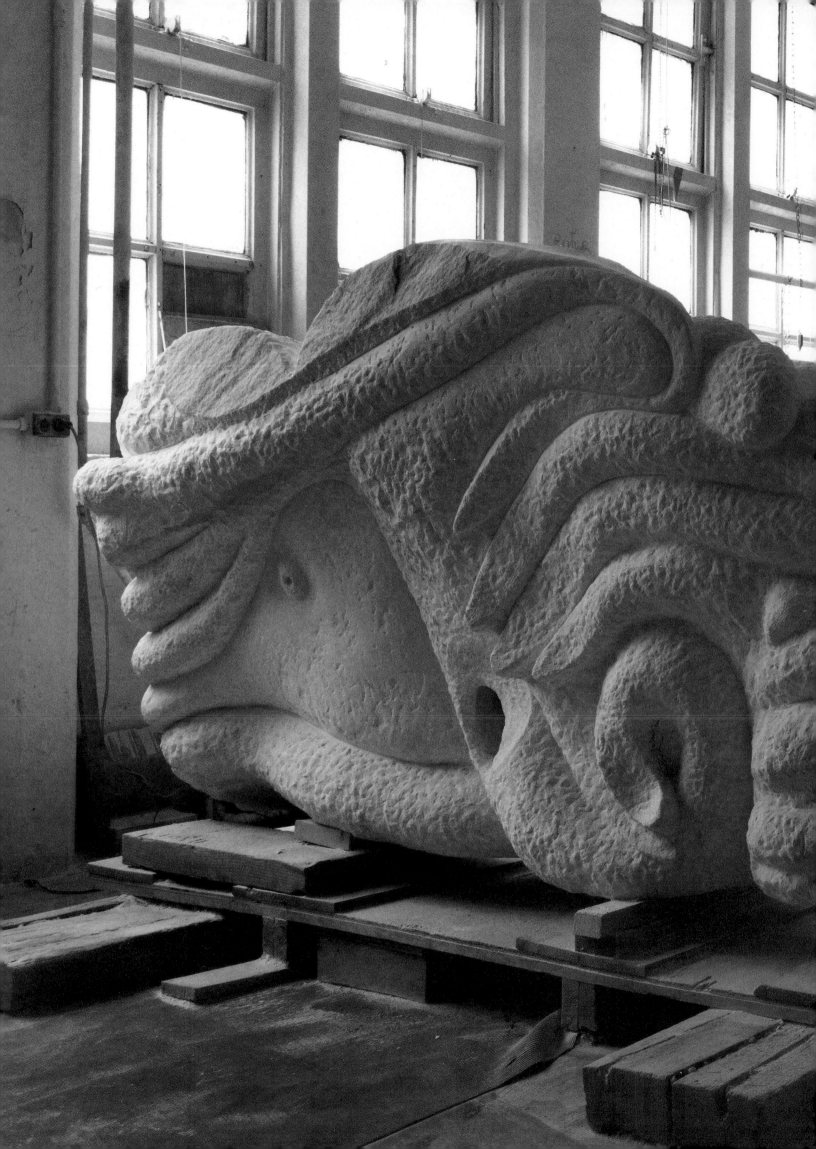

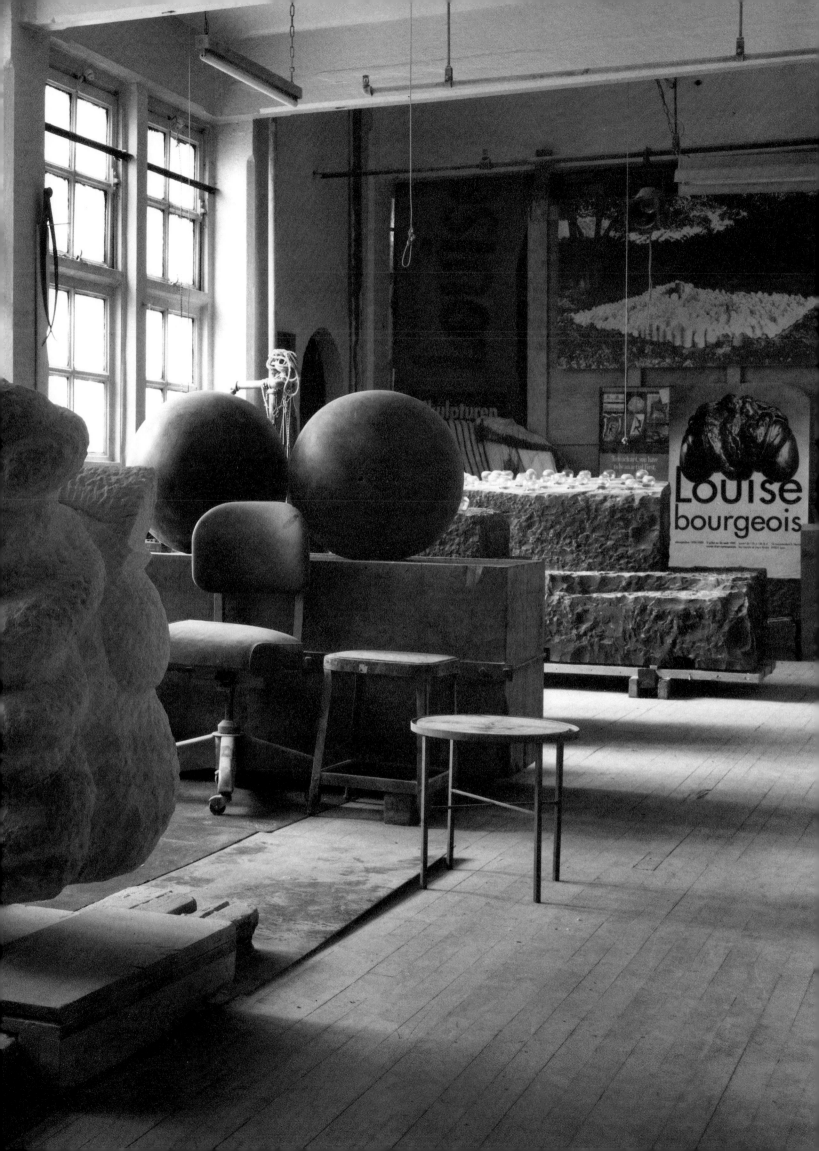

(signifying the finding of the self and the separation from the mother) are provocative in the context of her memories, which often center around impending or actual loss. Freud viewed the childhood peek-a-boo game of "here/gone" as an unconscious attempt to gain control of an uncontrollable situation, to recast "the experiences of life (which one endures passively)" into an active mastery.[18] Bourgeois vigorously denies that Freud's scientific analysis, especially his concepts regarding the role of the interpretation of repressed memory and dreams in psychosis, is of any use to the creative artist.[19] Perhaps this is because she feels that artists, through their work, already have access to their unconscious. Bourgeois has written, "The truth is that Freud did nothing for artists, for the artist's problem, the artist's torment—to be an artist involves some suffering. That's why artists repeat themselves—because they have no access to a cure."[20] Rather than work through a verbally based psychological investigation that requires a step-by-step formulation as the result of clinical observation, Bourgeois prefers acquisition of knowledge organically, through processes of repetition that center around the body. In the Cells, what she seems to be accomplishing is an appropriation of Freud's ideas for the purpose of their inversion; robbing Freud of his context, she feels free to exchange her own meaning for his.

In her work, then, a sensate dance of veils finally reveals a core meaning that emerges like a visual crystallization. In the earliest Cells, Bourgeois controlled the viewer's access by dictating narrow doorways or passages through which the viewer had to pass in order to gain physical or visual access to the contents of each Cell. More recently, she has begun to fashion metal and glass cages that restrict physical access while encouraging visual penetration from a wide variety of perspectives that are screened or otherwise partially obscured. Whether visual or physical, these openings and passageways operate similarly to the punctures and openings of her *Articulated Lair*. Emphasizing the singular perspective of the viewer, each Cell thus becomes an arena for intimate situations that alternate between impotence and omniscience. For example, to experience *Precious Liquids*, 1992 (fig. 21), the viewer must physically enter the space and traverse Bourgeois's world because there are no windows or other points of visual access. *Precious Liquids*, like many of the earliest Cells, is enclosed and therefore couched in a veil of secrecy that stresses the artist's ability to control outcomes while revealing her vulnerability. The more recent Cells, although structurally open and visually accessible, are no less mysterious in their allusions.

The found object provides another means of accomplishing Bourgeois's goal of complicity. This idea is one of the key distinctions between her work and that of the Surrealists, whom she views as pedants, part of an anti-humanist literary movement that was unable to distinguish between "book learning and real-world knowledge."[21] It is important to distinguish Bourgeois's use of *objets trouvés* from the Surrealist canon formulated in the nineteenth century by the comte de Lautréamont as the "chance meeting of an umbrella and a sewing machine on an operating table,"[22] especially as it was elaborated and refined in the twentieth century by Marcel Duchamp, André Breton, Max Ernst, Kurt Schwitters, later by Robert Rauschenberg, and most recently by artists such as Jeff Koons and Haim Steinbach. For Bourgeois, objects are not valuable as surrogates for the real world: just as there is no sense of chance in her arrangements, there is no intimation of the

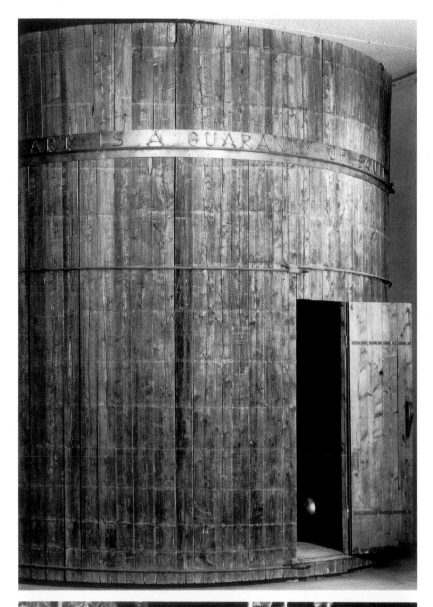

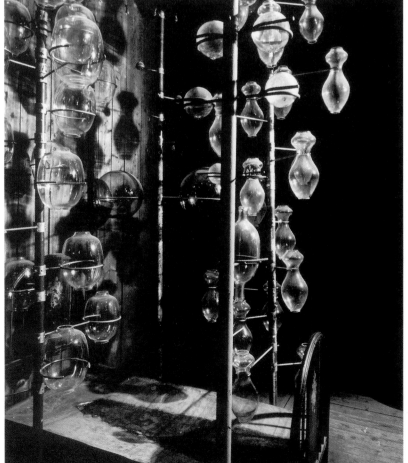

Fig. 21. *Precious Liquids*, two views. 1992. Wood, metal, glass, alabaster, cloth, and water, height 167¼ in. (425 cm), diameter 175¼ in. (145 cm). Musée National d'Art Moderne, Centre Georges Pompidou, Paris

simulacra in her aesthetic. Instead, the objects she uses are often actual documents from her life, and the value and dignity they have accrued through use is not separated from either their original function or their use within artistic tableaux. For Bourgeois, found objects serve as intermediaries between the artist's private memories and our similar but less distinct experiences. For example, the assortment of glass vessels ranging from wine carafes to bud vases in *Le Défi*, 1991 (pl. 31), codifies the artist's emotions, metaphorically arranging and categorizing personal memories as a glass menagerie that can be seen as similar to our own encyclopedic panorama of memories. Symbolically, transparent glass represents clarity, since it cannot hide secrets. But it is fragile: like truth or trust, once broken, it cannot be fully mended. So *Le Défi* is at once a confession and a challenge, a cabinet replete with fragile and precariously placed glass objects that dares us to approach delicately, without upsetting the equilibrium these objects require to survive.

In the Cells, Bourgeois's combinations of objects are "contextualized not through re-creating an appropriate historical setting but by means of fictive or imaginary environments and sites."[23] In this way, the Cells provide Bourgeois with avenues for addressing the violence of her own past, a past she constantly reframes to restate and vanquish what could not be successfully addressed within the immediate context of life. In *Cell (Choisy)*, 1990–93 (pl. 36), a flesh-colored marble architectural model of Bourgeois's early home in Choisy-le-Roi is imprisoned in a mesh cage; before the house stands a scale model of a guillotine. "People look at this house and say, 'You must have had a golden childhood,'" she says. "Well it was both a golden childhood and a dysfunctional childhood."[24] The resonance of the guillotine as an icon of the French Revolution is not lost on Bourgeois, and she enlarges its symbolism from the horribly misguided role it played in carrying out France's march toward *liberté, égalité,* and *fraternité* into a quotidian representation of all the cuts one must endure in life out of the need to break with present difficulties or the failures of the past. This sense of the cut is implicit in Bourgeois's rage—perhaps most vividly as a confrontation with the ultimate cut, death. *Cell (Choisy)* is replete with contradictions and conundrums: more subtle than the juxtaposition of the guillotine and the mansion, the accumulation of dirt and grime evident across the steel and glass exterior is an accretion from the past that gives the enclosure a world-weary, film-noir character that directly contrasts with the precious, pristine luminescence of the miniature stone residence. Overlapping accumulations of materials and images have become important to Bourgeois as a means of contrasting the nostalgia of her images and their carefully resolved imprisonment. Moreover, the contradiction between the coldly immaculate, oddly threatened marble house and these exterior patinas of ravagement belies the protective or imprisoning function of these edifices. The broken windows in the metal frames of the cell mockingly echo the dozens of open windows in the model house, underscoring Bourgeois's emphasis on the contrast between interior realities and exterior perspectives. Unlike the earlier, windowless *Curved House*, this beautiful model is abundant with openings, almost to the point of superfluity. However, it is dominated by the overbearing presence of the guillotine, which declares Bourgeois's independence, by way of separation, from the past she embodies in this multifaceted architectural ideal.

Cell III, 1991 (pl. 28), also alludes to the cut: a marble leg, severed just above the knee, emerges from a bed of marble; like a guilty party, a paper cutter sits with its arm raised, its weaponry menacing a small, arched marble female figure that rests on the cutter's platform. The narrow confines of the room also contain an oval mirror and a double-spigoted water faucet clearly labeled "hot" and "cold." If these objects were to be viewed as characters in search of a plot, the permutations of the scene would remain murky and equivocal; no clear activity is presented, but Bourgeois creates an overwhelming atmosphere of danger. The toes of the foot of the fragmented leg are curled under through the act of arching the foot; resting on the marble bed, this appendage provides definitive evidence of the tension of extreme emotion, but whether pleasure or pain is purposely left unclear. Further clouding the picture, the enigmatic perceptions evoked by water and mirror contrast sharply with the explicit emotionalism of the marble objects. Bourgeois has noted that the relationships of the many elements in her sculptures create "a system of dependency and fear." The objects "belong together but they do not communicate, because they have no power to choose."[25] And indeed, the elements of *Cell III* comprise an orchestration of specific meanings that congeal into a hermeticized, nonlinear narrative. Like all abstractions, what it symbolizes depends on the viewer's perspective and intimacy with the subject. But it is important to distinguish between interpretations that are open-ended and those that are dictatorially nihilistic, such as a reading of Bourgeois within the catalogue of sexual violence that defines the writing of the marquis de Sade.

The admixture of found and created objects in *Cell (Glass Spheres and Hands)*, 1990–93 (pl. 38), directly addresses group dynamics, whether involving the family or the hierarchies created by a classroom situation of teacher and students. Bourgeois selected an ensemble of five clear glass globes of various sizes to "represent the family—rigid, discrete, each self-contained individuals, proper in their little stools, but isolated; they cannot interact."[26] These spheres (fishing floats in their former existence) are arranged in a semicircle around a fabric-covered table, upon which rests a pair of clasped marble hands, gripped in pain and isolated from the larger dynamic.

Another cinematic rondo of associations is embodied by the mirror, perfume bottles, and delicately carved marble hands in *Cell II*, 1991 (pl. 27). Gripped together, the hands express a tense solitude that is directly contradicted by the delicately phrased *vanitas* of nine perfume bottles neatly arranged on a round mirrored tray. If clenched or clasped hands signify pain for Bourgeois, the traces of fragrance that remain in the empty perfume containers represent an "evanescence of pleasure" that is not completely graspable; sense of smell, in her words, possesses "the great power of evocation and healing."[27] The outer perimeter of *Cell II* is constructed of doors that leave only one point of entry to the interior narrative of the Cell. However, we are encouraged to penetrate the enclosure visually from various vantage points by peering through the cracks created by the hinged doors. Thus, we become participants in a heightened voyeurism that surrounds the elaborately formal display of the interior— almost as if we were observing another's dream, a detached yet mesmerizing state deliberately invoked by Bourgeois in her obsession with the shifting history of memory.

The people I like most are interested in portraiture, the symbolic and recognizable unique essence of a person. I, on the other hand, am interested in the portraiture of a relationship, how a relationship can be twisted, the effect people have on one another.
—LOUISE BOURGEOIS[28]

I f Louise Bourgeois's confrontational rubric of ambiguous engagement served merely as a meditation on her life, her sculpture would inevitably become extremely claustrophobic. To expand the realm of confession into a social dynamic, she always counterbalances ambiguity with structural precision. Bourgeois has described herself as "Descartes's daughter," saying that "I'm trying to be a Descartes . . . I think, therefore I am; I doubt, therefore I am; I am deceived, therefore I am."[29] Like the seventeenth-century French mathematician and philosopher, Bourgeois is attached to the objectivity of mathematical structure, which undergirds her emotions and ideas, and she uses the purity of geometry to expose with crystalline clarity the often painful mannerisms of varying psychological valences and the fleetingness of human relationships. In fact, she is a true descendant of the skeptical scientist-philosopher, epitomized by Descartes, who sought to understand the basic structure of the material universe as a way of coping with and bringing order to the inherent disorientation of the metaphysical landscape.

While firmly embracing the need for corporeal substantiality, her work insists that surfaces offer no more than a gateway to interior states, that objects fail unless the trap of materiality is somehow validated by human experience. Despite their physicality, her allusive object combinations sidestep the trap of the high regard for materialism, verging on preciousness, that has haunted aesthetics throughout this century. Instead she uses her materials to fashion concrete expressions of interior states that blur distinctions between body and mind. Bourgeois's dilemma is that any schism between body and mind is necessarily a false dichotomy; her purposeful ambiguity is a way of circumventing such distinctions by rephrasing the self in a tense that is constantly present. In her view, "fulfillment is not a durable thing, it is rather a reassurance that we can be fulfilled, even for a split second."[30] History, while an everpresent sourcebook for her work, exists only as it refines or confirms the realities of the present state.

The anthropomorphic or hermaphroditic nature of much of Bourgeois's imagery breaks down the barriers between materialism and spirituality, reason and emotion. By cross-referencing animal and human, feminine and masculine, Bourgeois rebuts the autonomous value of surface appearances, denying the dogma of materialism fundamental to twentieth-century thought and latent in any formalist reading of Modernism. Thus, her sculpture not only maintains a static physical presence, but also mandates a process of filtering and interpreting on the part of the viewer. For example, *Nature Study*, 1984, and *Femme Couteau*, 1982 (pl. 2), are simultaneously male and female, enforcing a physical and psychological transgression that becomes a seductive tango with Freud's psychoanalytical approach to hierarchies of identity. Freud's clinical observations described how the ego mediated between inside and outside worlds, and how the ego's "ability to distinguish between the inside and outside is assisted by reality-testing."[31]

For Bourgeois, however, borders between interior and exterior reality are always clouded; it is this recognition of the necessarily ambiguous state of being that provides the navigational tools necessary to comprehend the many facets of her work. Bourgeois always positions her work on the axis between emotional states and material perceptions. Like her insistent subversion of sexual differences, ambiguity becomes a powerful tool capable of mutating a recognizable image or figure fragment into an abstract icon or talisman with multiple associative overtones.

While there is no a priori acceptance of historical or mythological references in her work, mythology serves as a useful parallel construction for understanding Bourgeois's content. Mythologies play a significant though subliminal role in many of the artist's constructions, but Bourgeois is careful to point out that such references only operate as analogies and that they always follow rather than precede the creation of a work. Innately distrustful of language, and resolute in her belief that overinterpretation leads to misinterpretation, she does not want literary references to become the overriding perspective on her work. Thus the quite personal details of her life are always couched within structures whose lucid geometry creates a mathematical precision that heightens allusions to the broadening perspectives of classical myths. The symmetry of a work such as *No Exit* can be read in terms of the myth of Sisyphus, the classical hero condemned eternally to push a boulder up a mountain, only to have it roll down again.

The myth of Narcissus can be related in much the same way to *Cell (Eyes and Mirrors)*, 1989–93 (pl. 37). In this work, however, self-love is not the artist's primary concern. Undistinguishing, the outsized orbs in this Cell address the objectification of the gaze without the mitigating circumstances of human experience. Hanging mirrors interrupt the mesh walls of the Cell and freestanding mirrors surround the eyes, creating a cacophony of reflections, altered perspectives, and plausible alternatives that distract from the act of direct perception suggested by the marble sculpture. Through the profusion of mirrors, Bourgeois concretizes how "reality changes with each new angle. Mirrors can be seen as a vanity, but that is not at all their meaning. The act of looking into a mirror is really about having the courage it takes to look at yourself and really face yourself."[32]

Bourgeois's act of courage can perhaps be best seen in terms of her identification with Camus. Both artists have employed stairs as a metaphor for the essential nature of human existence: for each, action is always a necessary gesture, no matter how futile. This is the same dilemma Friedrich Nietzsche outlined more than a century ago in *Thus Spake Zarathustra*, his parable of overcoming the unconditional and infinitely repeated circular course of existence. Bourgeois's ambiguity, like Nietzsche's overcoming and Camus's absurdity, is her response to the recursive condition of mutual dependency between individuals and their environment, which she sees as forces of opposition or indifference that are united by the temporal demands of the moment. Despite the abundance of visual cues, mythological subtexts, and verbal clues in her work, Bourgeois is most interested in establishing a visceral rapprochement that takes advantage of the viewer's proximity to or perspective on her arrangements of objects. While her art is based almost exclusively on her experiences, it speaks not to the primacy of our intimacies, but to the ways we must engage in social interactions to give plausibility to our identities.

1 Albert Camus, "An Absurd Reasoning: Absurdity and Suicide," in *The Myth of Sisyphus and Other Essays*, Justin O'Brien, trans. (New York: Vintage International, 1955, 1991), 10.

2 Interview with the artist, March 2, 1993.

3 Louise Bourgeois, "In Conversation with Christiane Meyer-Thoss," in Christiane Meyer-Thoss, *Louise Bourgeois: Designing for Free Fall* (Zurich: Ammann Verlag, 1992), 128.

4 Ibid., 135.

5 Deborah Wye, "Louise Bourgeois: One and Others," in *Louise Bourgeois*, exh. cat. (New York: The Museum of Modern Art, 1982), 15.

6 Many of Bourgeois's works of this period were subsequently cast in bronze.

7 Meyer-Thoss, "Designing for Free Fall," in *Louise Bourgeois: Designing*, 69.

8 *Nature Study* is discussed in depth in Stuart Morgan, "Nature Study," in *Louise Bourgeois*, exh. cat. (Cincinnati: The Taft Museum, 1987), unpaginated.

9 Jerry Gorovoy, *Louise Bourgeois and the Nature of Abstraction*, exh. cat., Robert Miller Gallery (New York: Bellport Press, 1986), unpaginated.

10 Paul Gardner, "Louise Bourgeois Makes a Sculpture," *Art News* 87 (Summer 1988): 64.

11 Bourgeois, "In Conversation with Christiane Meyer-Thoss," 136.

12 Ibid.

13 Camus, "An Absurd Reasoning," 12.

14 Ibid.

15 Interview with the artist.

16 Louise Bourgeois, artist's statement in *The Carnegie International*, Lynne Cooke and Mark Francis, eds., exh. cat. (Pittsburgh: The Carnegie Museum of Art, 1991), 60.

17 Bourgeois has said many times that the events of her early childhood form the core of her artistic impetus. Bourgeois's family history is discussed in detail in "An Interview with Louise Bourgeois by Donald Kuspit," in *Louise Bourgeois* (New York: Vintage Books, 1988).

18 Geoffrey Green, *Freud and Nabokov* (Lincoln: University of Nebraska Press, 1988), 48. Freud codified his theories on disappearance and return in *Beyond the Pleasure Principle* (1920).

19 Bourgeois's mistrust of psychological overinterpretation is similar to Vladimir Nabokov's well-documented and intense rejection of Freud's ideas; in his autobiography, Nabokov wrote, "I do not believe in any kind of 'interpretation' so that his [Freud's] or my 'interpretation' can be neither a failure nor a success" (Nabokov, *Strong Opinions*, quoted in Green, *Freud and Nabokov*, 19).

20 Louise Bourgeois, "Freud's Toys," *Artforum* 28 (January 1990): 111–13. Commenting on the 1990 exhibition *The Sigmund Freud Antiquities: Fragments from a Buried Past* (University Art Museum of the State University of New York, Binghamton), Bourgeois wrote that Freud's collection reminded her of Madame Tussaud's Wax Museum because it was merely a historical document and perhaps provided Freud with a distraction from his primary work. She took exception to the focus and intent of Freud's collection and his possible motives, remarking: "Art is a reality. The artifact is a manufactured object; a work of art is a language. The artifact has only an educational or sentimental value. The work of art has an *absolute* value. How could Freud have had an eye for esthetic quality when the esthetic of some of these objects is so low?"

21 Interview with the artist.

22 Comte de Lautréamont, *Les Chants de Maldoror* (1868–70; reprint Paris: J. Corti, 1969).

23 Cooke and Francis, eds., *The Carnegie International*, 17.

24 Interview with the artist.

25 Meyer-Thoss, "Designing for Free Fall," 60.

26 Interview with the artist.

27 Bourgeois, artist's statement in Cooke and Francis, eds., *The Carnegie International*, 60.

28 Bourgeois, "In Conversation with Christiane Meyer-Thoss," 140.

29 Meyer-Thoss, "Designing for Free Fall," 71.

30 Bourgeois, "In Conversation with Christiane Meyer-Thoss," 127.

31 Green, *Freud and Nabokov*, 65.

32 Interview with the artist.

CHRISTIAN LEIGH

THE EARRINGS OF MADAME B . . . : LOUISE BOURGEOIS AND THE RECIPROCAL TERRAIN OF THE UNCANNY

In the forties and fifties in Europe and America, artists and writers were still interested in the notion of the uncanny—the extraordinary, unearthly world in its cerebral and psychological sense—if only as a pervasive aftertaste. The words Surrealism and Symbolism and the names William Carlos Williams and Odilon Redon, among others, had not yet been banished by the thought police. Only recently, after the fall of orthodox Marxism, have they been returned, somewhat enervated, to the specious mother tongue of Postmodern discourse. After decade upon decade of catastrophic realism, social and otherwise, in our art and culture, the uncanny world can once again be opened and mined. I am thinking of the Wim Wenders film *Wings of Desire*, in which modern-day weather-beaten angels hover above broken Berlin, feeling the angst of their pathos-filled mortal charges, all the while anxiously awaiting their own human fall from grace. I am thinking of the sharp-edged fish-lamp sculptures of Frank Gehry, emanating light from their whimsical insides, half cartoon, half apparition. I am thinking of the brave poststructural theorist Slavoj Zizek, whose brilliantly deranged insistence that William Shakespeare must have read Jacques Lacan suggests that the supernatural has a bearing even within the usually rigid terrain of cultural criticism.

But most of all, I am thinking of the deserved, though somewhat belated preeminence of Louise Bourgeois in the contemporary art scene of the last eight or nine years. Rising like a proud, pristine phoenix in a Pasolini opera from the ashes of the past, overcoming obstacles as mighty as deconstruction and as petty as simulation, Bourgeois reigns supreme, and her subjects do not (and cannot) hide their worship, for her stamp is all over their works as brazenly as so often their politics are written on their black crepe Comme des Garçons sleeves. In the past two Whitney Biennials, it was not hard to find traces of Bourgeois everywhere—in sculpture, in painting, in photography, and especially in the works of the many artists who have taken a stick to beat the dead horse of installation art—even if, and possibly because, they tend to be bested by Bourgeois every step of the way.

The universal interest in and concentration on Bourgeois and her work in the early nineties is as truly uncanny as the work itself can be. For it comes without the benefit of a movement driven over the finish line by either a

professor or a dictator. Rather, Bourgeois is a movement unto herself. What her followers do tends to be a footnote, an aside, an afterthought lost in her wake. As she moves ahead, they come up on her last move. Bourgeois's direct influence can be seen in the works of many contemporary artists, including Katharina Fritsch, Kiki Smith, Janine Antoni, Rachel Lachowicz, Tishan Hsu, Rona Pondick, Annette Lemieux, Annette Messager, Cindy Sherman, Laurie Simmons, Sherrie Levine, Saint Clair Cemin, David Hammons, Sophie Calle, Rosemarie Trockel, and Robert Gober (all among the most important artists of the younger generation), and none of them can escape the shadow cast by her extraordinary career. As one artist said to me when she was forced to abandon a new work in progress upon discovering that Bourgeois had already done it, "You just can't deal with the human body from a psychological point of view without repeating what Louise Bourgeois has done."

What is crucial to understand here is that it is Bourgeois who is responsible for making this terrain possible for investigation within contemporary art once again, because before her recently waged and won battles, it was simply not allowed to touch on this subject matter if one expected to be taken seriously. If philosophy, literary criticism, and contemporary theoretical practice abandoned the strains of disfigurement that we associate with the uncanny of some forty or fifty years ago, so too did art and fiction.[1] In search of areas deconstructed and destroyed, *nouveaux romans* eked out existentially and otherwise, and geometric and abstracted canvases drawn and dripped, intellectuals and others would have run the rafters and left the ship to sink—with melting clocks, sliced eyes, and purloined letters set adrift in a sea change.[2]

For Louise Bourgeois, whose art of the forties in New York grabbed hard at matter and clung tight, Surrealism and its retrograde progeny must have seemed like a curse, a plague. On the other hand, the sensual seedlings of Symbolism, left unharmed by the destruction of Surrealism, would be incorporated and mutated whole. It is impossible to know what Rainer Maria Rilke's words "I am as one who would remind you of your childhood" may have meant to Bourgeois back then or if she had even read them, but I assume that they would have had a deeper effect than the work of such cornerstones of Modernism as Martha Graham or Samuel Beckett.

In *The Anxiety of Influence*, Harold Bloom notes that "the uncanny is perceived wherever we are reminded of our inner tendency to yield to obsessive patterns of action. . . . A man and a woman meet, scarcely talk, enter into a covenant of mutual readings; rehearse again what they find they have known together before, and yet there was no before."[3] Bloom's "before" refers to past experiences—replete with all of the emotional baggage of obsessive behavior—that each one in the couple has undergone individually. They become merged, activating the illusion of a shared experience. It is precisely from the center of Bloom's uncanny "before" that Bourgeois's work emanates and gains its pervasive strengths.

Bourgeois has said, "Every day you have to abandon your past or accept it and then, if you cannot accept it, you become a sculptor."[4] Though endless memories of childhood are summoned up when we are in the presence of an object by Bourgeois, it is never *her* childhood we encounter directly. In other words, though Bourgeois's work deals directly with obsession, it does not do so obsessively. We do not experience souvenirs of the artist's past or

depravity (as we do in the work of, say, Jonathan Borofsky and Bruce Nauman) or those of the culture's (as in the art of Chris Burden and Lemieux). Rather, we are moved to experience our own memories by means of a psychological construct in which active empathy is summoned on an internally subtle scale.

Born in Paris in 1911, Bourgeois would begin early to subversively transgress and dismantle the legacy of the uncanny in her work, even if doing so meant at once destroying and resurrecting, internalizing and rebuilding, satirizing and parodying. She would go to great lengths to resuscitate the uncanny on her own terms, while in fact returning it to its truest essences and origins, never falling victim to generalities or caricature. Realism would not be welcome in Bourgeois's garden. Nor would dogmatic metaphor, which had come to be the modus operandi of the Surrealists and their offspring, just as browbeaten realism would later become the calling card of the eighties players she would teach a thing or two to some four or five decades later.

While Bourgeois's early sculpture (from the mid- to late forties and early fifties) would tend toward the totemic, as if reaching toward the heavens, using blocks, straight lines, and ladders, drawings and engravings from the same period would use thin black lines as if strands of hair, woven together and kept apart, in their totality conjuring utopian images of architecture and women, or the two combined. The cruel, unpredictable cosmos and the lonely, sympathetic heroine are conjoined physically and psychologically, held in a tender balance between reality and fantasy. What is exceptional about Bourgeois and her complex appropriation of the uncanny is that she brings off resonant effects not by subject matter, imagery, or configuration, but by suggestion. The space around a Bourgeois is corrosively charged, redolent of the uncanny like the steamy breath exhaled in the narrative cold air of a story by Brontë, Shelley, or du Maurier.

We feel the innards of a Bourgeois sculpture, drawing, or installation under our skin, just as the truth or life source in a Bourgeois is located under its skin. To quote Freud in his seminal essay "The 'Uncanny'":

The souls in Dante's Inferno, *or the ghostly apparitions in* Hamlet, Macbeth, *or* King Lear *may be gloomy and terrible enough, but they are no more really uncanny than is Homer and his jovial world of gods. We order our judgment to the imaginary reality imposed on us by the writer, and regard souls, spirits, and specters as though their existence had the same validity in their world as our own has in the external world. . . . The situation is altered as soon as the writer pretends to move in the world of common reality. In this case he accepts all the conditions operating to produce uncanny feelings in real life; and everything that has an uncanny effect in real life has it in his story.*[5]

Never simply a formalist, and never susceptible to purely formalist readings (those who have played it that way seem foolish), Bourgeois creates an art of the psyche in the best possible application of the term. Beyond the merely literal, sentimental, or narrative in the specific sense, the claim that she lays to memory is subjective, refined, and ultimately contextless.

What is important in her work is the sense it conveys that something is in motion and actually occurring, even though that something tends to remain unstated and amorphous. These oracles do not tell us stories that move us.

Rather, they push us to remember or invent stories of our own that move us; we move ourselves. As the psychoanalyst Jentsch has so rightly noted, the obstacle presented by the challenge of so moving us is that each person is moved by uniquely different things, based entirely on experience.[6] Bourgeois intuitively understands this concept and extends it to us as a goal. These works engage us to converse with ourselves in ways that can often be difficult or painful. Like those strange moments when a flash of light, a color, a voice, or a smell tips off the unconscious, the Bourgeois object calls up a bizarre uninvited memory that has the power to bring on sadness, regret, mourning.

This moment, though grounded in sadness and memory, is a newborn one. What is definitively new is the physical and emotional impact of the confrontation with memory, as well as the uneasiness that accompanies this sudden encounter. I know at times I have hoped that I would never have that kind of memory ever again. The tangible feeling called up is equally rooted in body and mind; hence its impact is startlingly uncanny, dangerously dear, singularly painful. Herein lies the strength of Bourgeois's work. Above all, she never privileges body over mind or mind over body. Instead, she commingles the two and conjoins them, clarifying that to be truly moved, one must utilize both faculties simultaneously.[7]

In the eighties, Bourgeois, for her part, touched on and implied uncanny areas such as love, anger, tenderness, and cruelty, and she played with the forbidden, doing things with art that we have been told art cannot and should not do, and eliciting responses much in the same way. She did so while Pop Art still reigned in America, and her work fought against its ice-cold, often brutal cynicism. If Warhol made it fashionable to be a sadist, Bourgeois made it permissible not to be. Her empathy would turn out to be pioneering and brave in the extreme. Her fearlessness would come to be her triumph, as she took on and conquered some of the most difficult projects of her time.

When Neo-Expressionism reared its ugly, splattered head in the early eighties, Bourgeois countered with sleek, pristine, sensual sculptures made from marble, rubber, wood, and bronze. *Nature Study*, 1984 (pl. 6), a highly polished bronze object, looks like a brash golden bust, suggesting a perverse hybridized cross between a decapitated, crouching woman with multiple breasts and a trepidacious if headless gargoyle, similar to the ones that hang growling over Paris on Notre Dame. The work is at once mother and monster, and its ability to conjure visual and cerebral images of birth, death, and, at worst, matricide and infanticide is nothing short of intense. I think of *Nature Study* as Bourgeois's abstracted retelling (or untelling) of Euripides' *Medea*, a metarepresentation of the objectification of woman as creator and destroyer, and as possibly destroyed. And then again, the work can be seen as a golden calf as well, served as if for sacrifice: a woman offering herself up as an idol to be dutifully served and then relieved of that position, discovered as mere mortal and slaughtered as such. Once again, the Bourgeois object is neither self-contained nor dependent on overbearing context, as in the Postmodern game, but creates its own world culminating in the viewer's participatory response. Uncanniness is called up in the manner of Bloom's "counter sublime," which embraces subjective notions of beauty rather than formal ones. In its ugliness, Bourgeois's object becomes more than "beautiful."[8]

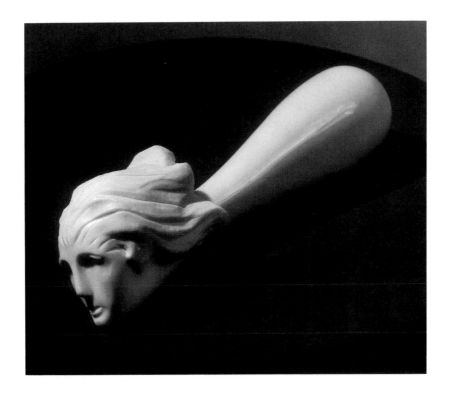

Like *Nature Study, Femme Maison*, 1983 (pl. 3), a work from the same period, is a hybrid on the order of fable. Sitting atop what appears to be a female body heaped over as if in spasm, wearing a flowing dress or shroud draped and twisted around in knots, is a lovely, architecturally pure and sound house akin to something Louis Kahn might have built. It is a house of levels, perhaps even a temple, and it occupies the place where the head should be, if slightly miniaturized. There is a strong, stubborn subtlety to this work. If the architectural form suggests Modernism, then the slumped, flaccid body implies classicism. And yet the combination is much more than a joke or a play on art history.

It is not an overstatement to say that the power of Bourgeois's work made it acceptable again, in the eighties, to make art that is not about art, and *Femme Maison* shows that. In the hands of another, lesser artist, the building on top of *Femme Maison* might have been huge, crushing the figure beneath it, like a piano dropped from the tenth floor of an office building in a Mabel Normand routine. Such a simplistic approach would forfeit Bourgeois's difficult merging of body and mind. In *Femme Maison* the structure is small and perfect, not harsh and monstrous, and it is to Bourgeois's credit that the work evokes feelings of fear and peril rather than guffaws and sermons. By not belaboring the specific or the particular, Bourgeois leaves the meaning of her objects open-ended, allowing any number of readings, from the ridiculous to the sublime. The woman depicted in *Femme Maison*, with her body of weight and her head of weightlessness, could be Bloom's heroine, who is "go[ing] beyond discontinuity, on the airy journey up into a fearful freedom of weightlessness."9 And then again, she could be the Wicked Witch of the East, killed by the unsuspecting Dorothy riding the tailwind of a psychological tornado of the unconscious.

Other important works of the early eighties include the daringly beautiful *Fallen Woman*, 1981 (fig. 22), a small white marble object that is a cross between a judge's gavel and a door knocker, with a curved phallic handle and the lovely head of a waiflike woman, chin to the ground. Though suggestions of the "phallic woman" abound, the object's tender and intimate

Fig. 22. *Fallen Woman.* 1981. Marble, 3¾ × 4 × 13½ in. (9.5 × 10.2 × 34.3 cm). Private collection

beauty subverts the notion. Similarly, *Blind Man's Buff*, 1984 (pl. 5), confuses and confounds. A white marble totemic shape juts out of the square base on which it sits, suggestive of a large, fat phallus. It is, three quarters of the way up, made of a collection of rounded breasts. Its top is more savage, with the stone cut sharp and malicious. The male phallus is ultimately tamed by the female breasts, or is it the other way around? Is the female conquered by the male? Their conjunction is frightening, like a hybridized pair of parents, mother and father, fighting for control over the kingdom. The amorphous nature of the work contributes to its strength. Nothing is wholly definable or categorizable, and each viewer must experience the work personally.

What is most radical about Bourgeois's work of the eighties is the equally matched cerebral and physical strength and dexterity she summoned to conjure touching, passionate, enveloping, and often frightening images of women and their bodies, even if at times those bodies took a strange turn toward the male or hermaphroditic. In this way, Bourgeois would subversively counter the image of the woman artist as a melancholy maker of forlorn if beautiful objects to be smiled at and written off, much in the way that critics tend to write off melodramas centered on female characters as sentimental fluff while extolling the "brave" virtues of shallow male buddy films. While her work tends toward the subjectively female, Bourgeois's approach appropriates what has long been considered male, as if to take down the notions of femininity and masculinity one peg at a time. If standardized and clichéd images and expectations of works by women artists were transformed in the decade, Bourgeois stands at the pinnacle of that change.

As the eighties proceeded and a kind of supposedly radical poststructuralist mafia of thought quickly became dominant, Bourgeois—as if to deny its overbearing presence—pressed forward with an aggression and force that went unmatched. (Even Robert Ryman, who experienced an impressive decade simultaneously with Bourgeois, did not exhibit works of such profound consequence and forward movement.) She would come to be a feminist artist who refused to make pedantic art about abject feminism. Instead, Bourgeois created objects that are feminist in their direct and across-the-board refusal to be categorized as either female or male, all the while summoning the strength of femininity by mastering a lucidly laid terrain of subjectivity in which masculinity and its qualities are laid on the line. Her stance may be best summarized by the Robert Mapplethorpe portrait of Bourgeois executed in 1982 (fig. 23) in which she stands smiling slyly and holding her work *Fillette*, 1968—a sculpture that looks more than anything else like a giant erect penis and testicles (or dildo)—under her arm as if she were showing off the captured keys to the kingdom and laughing off their value. "I've got them, and you want them, but I'll never give them back. They're mine, all mine," is what she seems to be saying, and the effect is redolent of self-invented and owned power.

Rosalind Krauss has written, "The appeal of Louise Bourgeois's work for feminism is obvious and sure." And yet in the same compelling essay (in which she wisely invokes Marcel Duchamp's *The Bride Stripped Bare by Her Bachelors, Even* and Gilles Deleuze and Felix Guattari's "desiring machines"), Krauss seems to lament that "writers about Louise Bourgeois's sculpture have fallen into the habit of calling it abstract. . . . [T]his

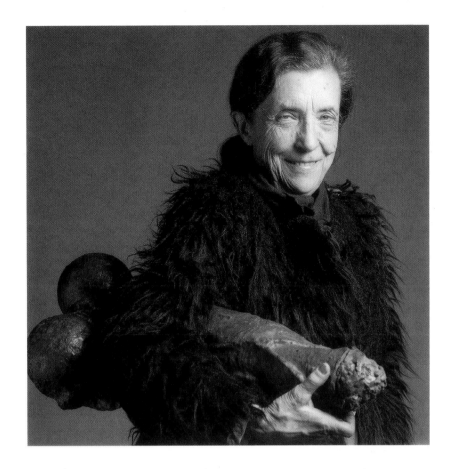

tendency is the function of . . . the unanalyzed acknowledgment of the morphological ambivalence that grips the objects." She seems somewhat disappointed with Bourgeois's own statement that "I am not particularly aware of, or interested in, the erotic in my work . . . I am exclusively concerned, at least consciously, with formal perfection" and would appear to be up in arms that Bourgeois's work has not generally been discussed in the realist terms that would ground it within the political mainstream of criticism and finally domesticate it and remove it from the realm of the uncanny.[10] Yet to categorize Bourgeois's works in relation to the body parts that are invoked or called up — breasts, vaginas, penises — is the best way to rob them of their power and effect. Surely, I prefer Bourgeois's own admitted (or should I say flaunted) quest for formal perfection over the realist readings of the eighties, for if Bourgeois did not attain formal perfection, her works would be as facile as are those of many of her imitators.

Perhaps the most psychologically compelling of the works of this critical period is *Nature Study (Velvet Eyes)*, 1984 (pl. 7), with its cold, cruel, sinister stare, an object made of marble and steel. Set inside a slab of silver-blue marble, which in its slanted shape brings to mind the stands built for the reading of the holy books lost from the tabernacle, is a pair of large, almost cartoonish, somewhat crossed eyes, black pupils on white ground. The eyes are like something out of the corner of a late Philip Guston painting, macabre and amusing. Chillingly, the references the work calls up (not only Guston's painting, but Oedipus, the Dali-designed dream sequence in the Alfred Hitchcock film *Spellbound*, and Snow White's innocent stare) are somehow less evocative than the personal conversation each viewer has with the work. In Bourgeois's art, references are used not to show how smart the artist is or to test the viewer's Postmodern agility, but to

Fig. 23. *Louise Bourgeois, 1982.* Copyright © 1982 The Estate of Robert Mapplethorpe

transport the viewer from a rational mindset to a state of empathetic mind- or soul-searching, to a place where experience supersedes memory.

The blunt, staring eyes of *Nature Study* remind me of an anecdote in Freud's "The 'Uncanny'" that illustrates precisely how and why Bourgeois's objects are so convincingly unnerving. It concerns the story "The Sand-Man" from E.T.A. Hoffmann's *Nachtstücke*:

This fantastic tale begins with the childhood recollections of Nathaniel: in spite of his present happiness, he cannot banish the memories associated with the mysterious and terrifying death of the father he loved. On certain evenings his mother used to send the children to bed early, warning them that "the Sand-Man was coming"; and sure enough Nathaniel would not fail to hear the heavy tread of a visitor with whom his father would then be occupied that evening. When questioned about the Sand-Man, his mother denied that such a person really existed, but his nurse could give him more definite information: "He is a wicked man who comes when children won't go to bed, and throws handfuls of sand in their eyes so that they jump out of their heads all bleeding. Then he puts the eyes in a sack and carries them off to the moon to feed his children. They sit up there in their nest, and their beaks are hooked like owls' beaks, and they use them to peck up naughty boys' and naughty girls' eyes with."

Freud continues:

Although little Nathaniel was sensible and old enough not to believe in such gruesome attributes to the figure of the Sand-Man, yet the dread of him became fixated in his breast. He determined to find out what the Sand-Man looked like; and one evening, when the Sand-Man was again expected, he hid himself in his father's study. He recognized the visitor as the lawyer Coppelius, a repulsive person of whom the children were frightened when he occasionally came to a meal; and he now identified Coppelius with the dreaded Sand-Man.[11]

So is rational thought swept aside in Bourgeois's work. What is most unnerving about her art is a sense that the things we know to be true are so easy to discard in favor of the sensuous and exotic attractions of neuroses. (Bloom offers examples of such neuroses "as a variety of the uncanny": "A man's unconscious fear of castration manifests itself as an apparently physical trouble in his eyes; a poet's fear of ceasing to be a poet frequently manifests itself as a trouble of his vision."[12]) What we fear, as Freud has said, is what we often secretly wish for most of all, if only in the subconscious, because if we were to experience our worst fears, we would be liberated from them. In Bourgeois's objects, we feel the positive inclinations of the soul—the very best things we are capable of—as heavily as we do the negative—the very worst things. They are literalizations of dreams and nightmares, the beautiful and erotic and the horrendous and neurotic.

Bourgeois's objects of the later eighties and early nineties would reach a level of elegance and formal perfection that even Brancusi would have envied. Hard materials are melted into sinuous shapes that are never short of miraculous in attaining their desired formal and psychological effect. *Mamelles*, 1991 (pl. 32), a cast-rubber wall relief that looks like a landscape painting made up predominantly of candy-colored pink breasts, is such a triumph. What comes to mind is a Fortunato Depero Futurist field painting rendered in skin. The breasts jut out and hang this way and that

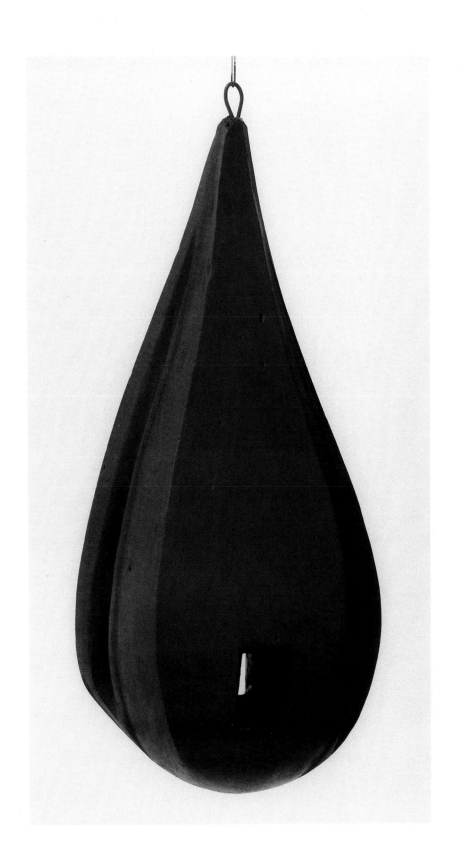

Fig. 24. *Lair*. 1986. Rubber, 43 × 21 × 21 in. (109 × 53.4 × 53.4 cm). Courtesy Robert Miller Gallery, New York

from the dimensional field, sitting atop a number of tunnels. Sculptures hang from the ceiling as if appropriated from a vision: *Legs*, 1986 (pl. 11), with its two long, skinny, uneven dangling limbs; *Lair*, 1986 (fig. 24), a tear-shaped sculpture with a square opening cut into it like a window or duct that recalls an emotionally laden ellipse from a Modigliani at the Philadelphia Museum of Art; and *Henriette*, 1985, a kind of half-stumpy and half-skinny deformed leg. The hybrid in this work is always half rational and half of the nether depths, though these effects are never reached cheaply or facilely.

Particularly impressive works of the time are a group of pink marble sculptures that use square, rugged slabs as self-contained bases for small and irregular realist forms, limbs, and anthropomorphs. *Nature Study*, 1986 (pl. 12), is the roughest of the group. Its beautifully shaped and glistening base serves as a kind of metaphoric pillow for a rolled and knotted length of string that reminds me of intestines or an evil cartoon rope. *Untitled (with Hand)*, 1989 (pl. 20), is the home for a ball with one crooked arm that looks as if it belongs to either a large baby or a tiny adult coming out of its side. *Décontractée*, 1990 (pl. 21), has a pair of hands atop its foundation, palms up, cut off sharply and cleanly above the wrist. In *Untitled (with Growth)*, 1989 (pl. 19), the slab seems to have living, tallish, round-edged cultures growing out of its surface. This work's brilliance lies in its tender ability to attribute life to an inanimate object, as well as in its direct reference to art as growth and motion. The pro forma of contemporary theoretical practice is taken on head-first in that the object makes its motives known almost subliminally, and its motives concern neither Modernism's slouching toward tomorrow nor Postmodernism's slouching toward yesterday, but rather an experientially defined, materially bound exploration of motion that is grounded in the here and now. Even if memory is utilized, it is utilized in the present tense, actively experienced.

For all their brilliance, not even these works in their combative and poignant resolve and intelligence nor the entire refined oeuvre of Bourgeois's extraordinary more-than-fifty-year career could prepare one for the work that she would produce and exhibit between 1991 and 1993. A series of stellar installations, these creations would sum up and crown the trend toward installation art, even if Bourgeois seemed to be intending nothing of the kind. She was able, in these works, to summarize the impetus for the creation of installation art (to deepen the level of engagement), all the while subverting the notion by removing the objects directly from the theatricality of the seminal installations of El Lissitzky and the Russian avant-garde. Bourgeois's installations are psychological constructs, with entrances and exits suggested and implied, rather than theatrical spaces with stage lefts and stage rights marked with press-type lettering. Even though Bourgeois would utilize theatrical effects to achieve her ambitious goals, she would do so only formally. The content, in its generative totality, would wipe away any and all impressions of manipulation and stagecraft.

As if firing an automatic rifle of transcendent brilliance, Bourgeois over the period of a few years would strike like Patton on D-Day, each and every time hitting the bull's eye. The first of these battles would be won at the 1991–92 Carnegie International in Pittsburgh. As featured in this impressive exhibition that included important installations and works by many international artists, her six-part installation of Cells is a watershed work, not only in Bourgeois's career, but in art history. Like Joseph Beuys's *I Like America and America Likes Me*, Vito Acconci's *Seed Bed*, and the Bruce Nauman video installation *Clown Torture*, the Cells change the way we think about art and, more important, change how we experience it by making the viewer's presence essential to the work's completion.

Setting out to reinvent the wheel every time, Bourgeois would go further still. She would reinvent the wood that the wheel would eventually be built from, as her statement about the Cells makes clear:

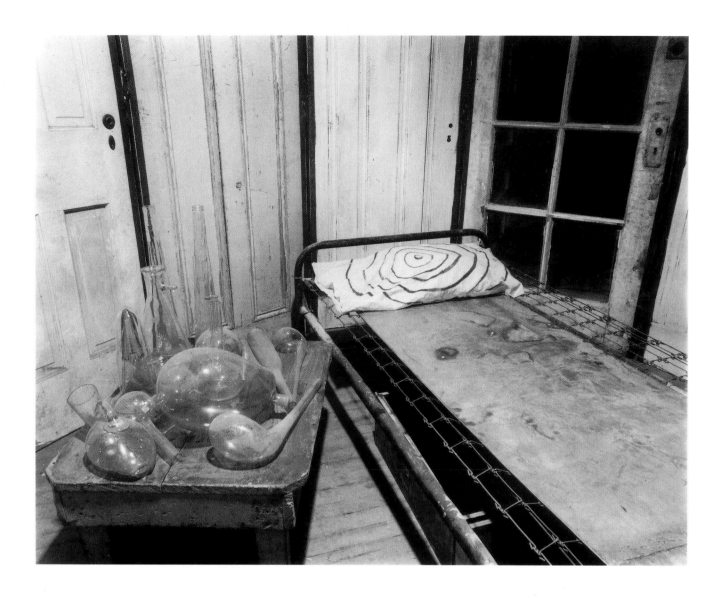

The subject of pain is the business I am in. To give meaning and shape to frustration and suffering. What happens to my body has to be given a formal abstract shape. So, you might say, pain is the ransom of formalism. The existence of pains cannot be denied. I propose no remedies or excuses. . . . I know I can't do anything to eliminate or suppress them. I can't make them disappear; they're here to stay. The Cells represent different types of pain: the physical, the emotional and psychological, and the mental and intellectual. Each Cell deals with fear. Fear is pain. Often it is not perceived as pain, because it is always disguising itself.[13]

The Cells at the Carnegie International were installed as a series of six spaces separated and held together by groupings of wooden doors, some with windows. The doors and windows abut each other snugly or sit closely by each other, suggesting layers of skin or a protective dam. One cannot enter into the vital center of any of the Cells, as they are created in such a way as to keep the viewer on the outside looking in, yet their cumulative effect is never wholly objective. The voyeuristic distance we must keep from each Cell only adds to the pervasive power of the work. "Each cell deals with the pleasure of the voyeur, the thrill of looking and being looked at."[14] The operative word here is *thrill*. The uncanny is called up in these works because they always keep us outside their realm. The magic of the work resides in its ability to keep us out while drawing us in. It is much like the frightening thrill of being in a relationship: the quest for total security and intimacy is always countered and subverted by the impossibility of entering

Fig. 25. *Cell I.* 1991 (work in progress). Mixed media, 83 × 96 × 108 in. (210.8 × 243.8 × 274.3 cm). Courtesy Robert Miller Gallery, New York

a stranger totally. The mystery is what attracts, yet it is clearly what repels and keeps us fearful but wanting more. "The Cells either attract or repulse each other," writes Bourgeois. "There is the urge to integrate, merge, or disintegrate."[15]

In *Cell I* (fig. 25) a dilapidated box spring that could provide refuge for one and only one is covered over partially by a flat, dirty mattress, draped with a cloth embroidered with quotations by Bourgeois, and a pillow, on whose beige surface the artist has drawn a target. Next to the bed is a wooden table, on top of which is a selection of clear blown glass shapes that recall pipes, snifters, bottles, and jars, all of them empty. What is most hauntingly suggested is what is missing: the bed's invisible occupant, the contents of the bottles, the reason this Cell was occupied, the reason it now is not. *Cell II* (pl. 27) has in it a mirrored tray with nine empty perfume bottles and a pair of clasped marble hands lying on it. What is most interesting is the missing perfume—the condensation of beauty, pleasure, and rapture—evaporated, as if Bourgeois were qualitatively bemoaning the temporary and fleeting nature of satisfaction and pleasure.

Cell III (pl. 28) is harsher, bolder, rougher; it suggests at once pleasure and pain, and where the two converge. A bubble window in one of the doors provides the screen for examination of the scene, which includes a pink marble sculpture with a leg sticking up and out, a two-headed faucet marked "hot" and "cold" attached to one of the doors, and a wooden pedestal with a paper cutter whose large blade hovers threateningly over a marble female figure in the *Arch of Hysteria* pose (see pl. 35). This Cell suggests our complicity with terror—we are part of a scenario of our own making in which we are both victim and victimizer. *Cell IV* (pl. 29) has a large, flat disc leaning against one of the planks with a wooden spatula-like utensil held steady by a visible string hanging from its top center; a pink marble bust with a large ear attached to the neck; and a small wooden kneeling plank. If the disc implies a drum and the spatula the instrument to make it sound, then the ear attached to the neck of the bust would appear to be an evocation of empathy (communicating and acting through feeling), while the kneeling plank provides a neutral place to ponder.

Cell V (fig. 26) is closed off entirely. Whereas the other Cells in the installation permit partial entry, this one denies us even this mercy. The most abstract of the six Cells, it contains no pure figurative imagery as the others do. Sitting in its off-limits center are two large balls made of painted wood. The message is loud if not totally clear—"Keep out"—almost as if the words were coming from the two objects themselves. It is the fragile nature of relationships and pairings that is being marked here, and what brings it off most of all is the work's relationship to the other Cells in the installation. As a single work, *Cell V* might not deliver its message as clearly, but in all of Bourgeois's work, there is no such thing as autonomy; all works exist at their best in relation to either other objects or other motifs, whether visualized or invisible (left unstated and only implied). This is why when we see a Bourgeois in the world, it still retains its power, which is never reliant upon the white-box mentality of elegant exhibition installation.

Cell VI (fig. 27) is, in its cyclical resolution, by turns touching, defiant, pained, and hostile. It continues to grow when considered in direct relation to *Cell V*. A small, tarnished metal stool sits in the center of four painted

Fig. 26. *Cell V*. 1991. Painted wood and metal, 92 × 72 × 72 in. (233.6 × 182.8 × 182.8 cm). Solomon R. Guggenheim Museum, New York 92.4006

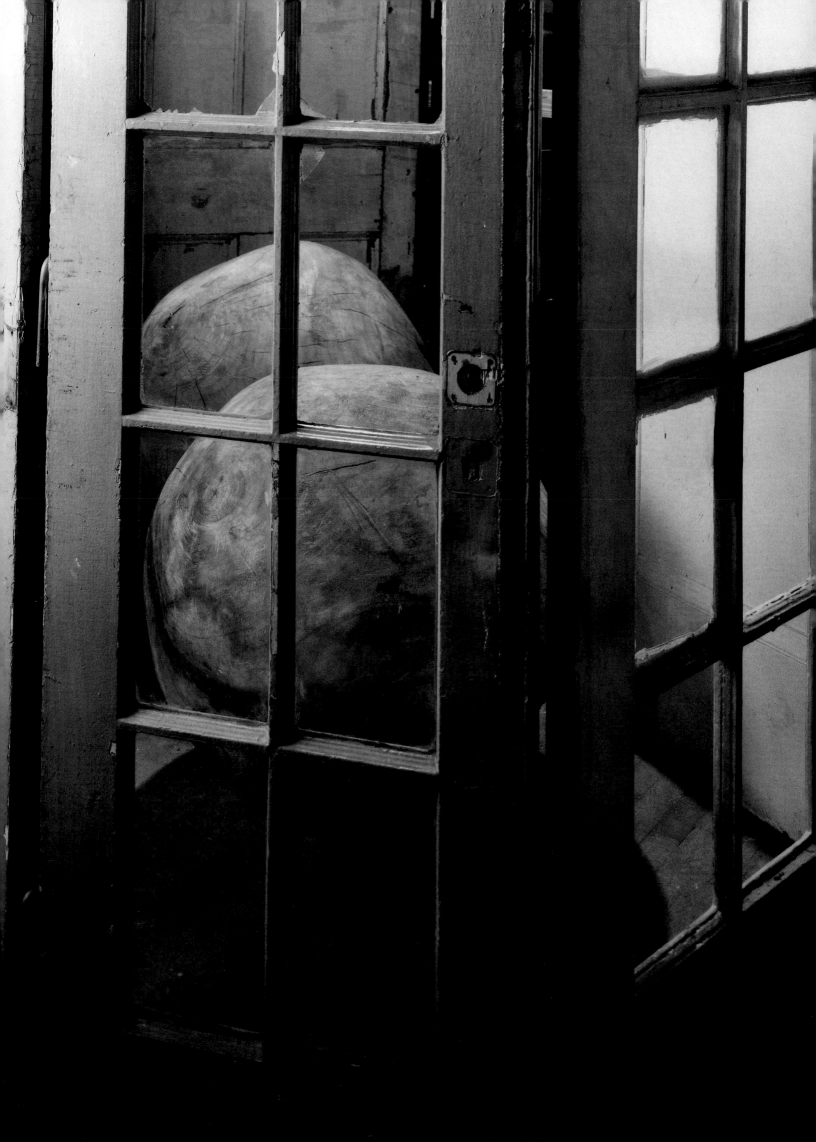

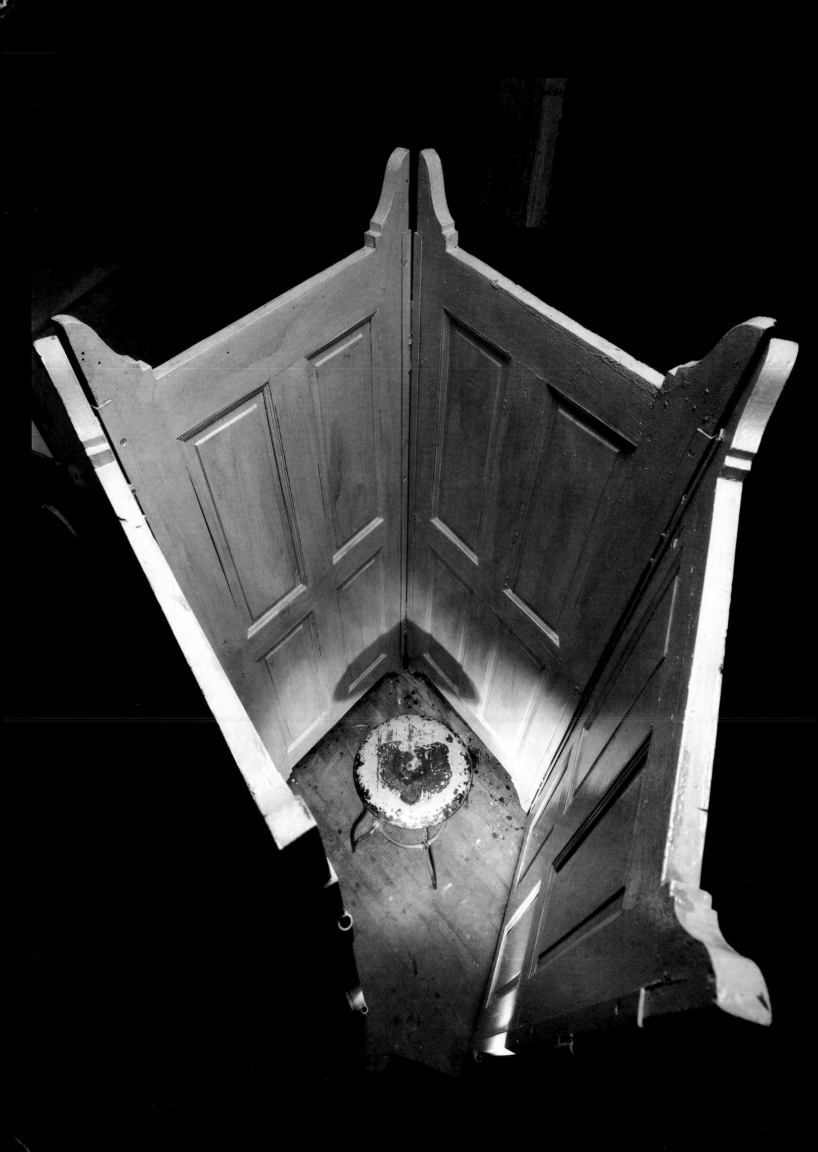

blue doors, with a small space left for entry (and exit). Everything Bourgeois and her work bravely argue for is contained in this Cell. While basking in solitude, it aggressively refuses to concede the pleasures and freedoms offered by this state. As if making a case for the artist, or human being, as solitary inventor of his or her own universe, the Cell specifically reveals itself to be all-powerful and of great consequence. Subjectivity in solitude is privileged above all else, not only as a creative ritual or right, but as a necessary Nietzschean "will to power." Bourgeois's *Cell VI* insists that seizing subjectivity is to demand responsibility for one's every thought, decision, action, emotion—all essential raw material for sculpting.

If, as Bourgeois has said, she is in the business of pain, then we can see that this business is a crucial one. Pain is not always experienced in negative regions or negatively; the decisions we make to relieve pain can be harrowingly consequential. For some they revolve around living and dying, killing or being killed, loving or turning away, being pained or inflicting pain. In rendering and implicating the uncanny in terms not of the simplistic effects of the fantastic, but of the commonplace—body, pain, emotions, fears, memory, thought—Bourgeois dares to empower not only herself, but her viewer as well. In subjectivity, she suggests, we can change the world. She suggests, again radically, that we must begin by changing ourselves, however slowly, one "cell" at a time.

Bourgeois followed the Cells at the Carnegie International with a number of important works realized in site-specific situations. In *Dislocations*, an exhibition made up entirely of installations at The Museum of Modern Art in 1991, Bourgeois presented the surprisingly fresh *Twosome*, 1991 (fig. 28), more tongue-in-cheek and less complex than other recent works. A pair of moving black, wheeled cylinders (two abandoned gasoline tanks) set upon a stretch of locomotive track and lit from inside by a revolving red light, *Twosome* would take on the notion of large-scale kinetic sculpture with a vengeance, first and foremost by humanizing the endeavor. In this work motion is literalized: the smaller cylinder moves slowly back and forth into the larger one. At once reminiscent of automatic sex and the American oil rigs of Douglas Sirk's *Written on the Wind*, where industry is just another excuse for men to participate in ridiculous contests of virility and machismo, the sculpture looks like a "fucking machine."

Other uncanny adventures would follow for Bourgeois, most notably *Precious Liquids*, an installation at *documenta 9* in Kassel, Germany, in the summer of 1992, and an exhibition of works utilizing the recurring motif of the needle as associated with women and "women's work" at Galerie Karsten Greve in Paris. In *Precious Liquids* (fig. 21), which deals with the various ways that the body reacts to states of pressure by producing liquids, Bourgeois returns to an area she had explored brilliantly and resonantly in the Cells. Sweat, blood, vomit, semen, urine, tears, milk, are all conjured. What is offered in *Precious Liquids* is a theoretical deconstruction of the uncontrollable states of the body and its inevitable consequences. Inside a round room, Bourgeois offers miscellaneous glass objects hung from steel poles positioned over a bed with a puddle of water, an alabaster breast lit from within, an oversized man's trench coat, inside of which a tiny white dress is suspended, two large wooden balls, and two rubber balls—all organized and arranged in a manner that is as culminative as it is retrospective in tone, while being generative and speculative in nature. Works from

Fig. 27. *Cell VI*. 1991. Painted wood and metal, 63 × 45 × 45 in. (160 × 114.3 × 114.3 cm). Courtesy Robert Miller Gallery, New York

OVERLEAF:
Fig. 28. *Twosome*. 1991. Steel, paint, and electric light, length (variable) 38 ft. (11.5 m), diameter 80 in. (203.2 cm). Courtesy Robert Miller Gallery, New York

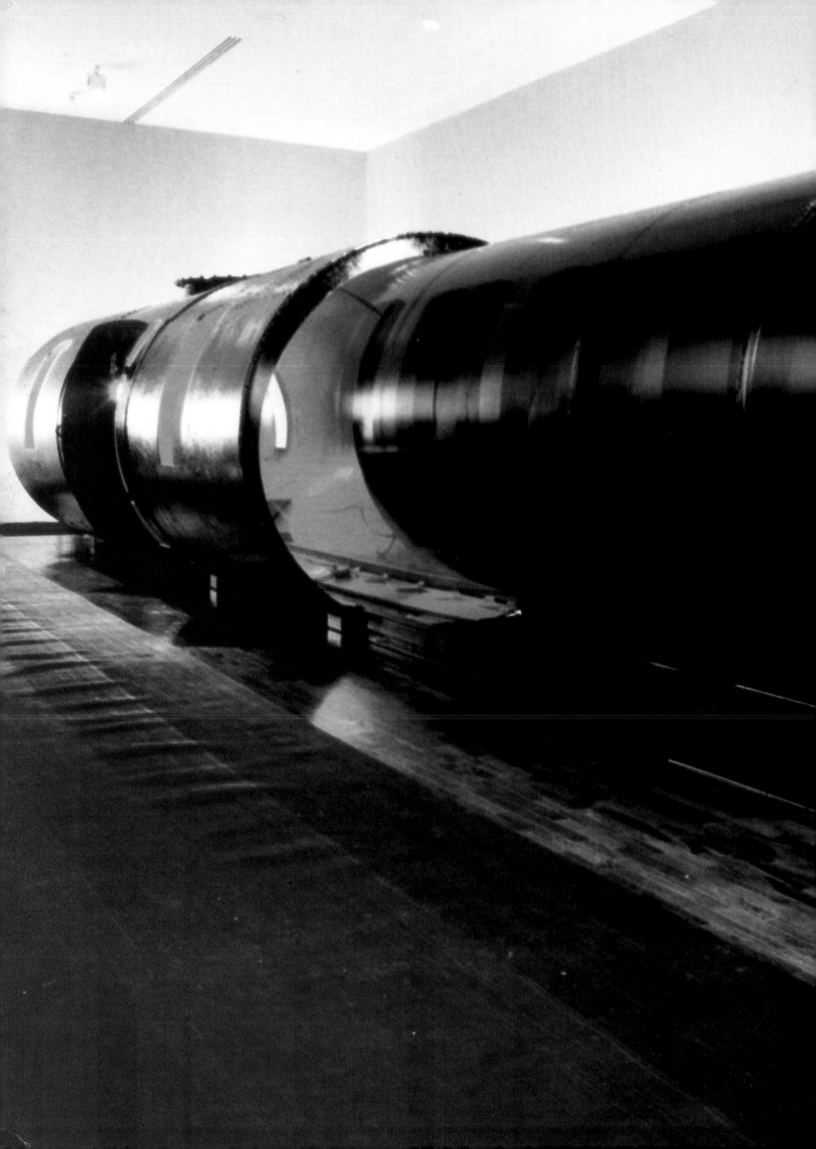

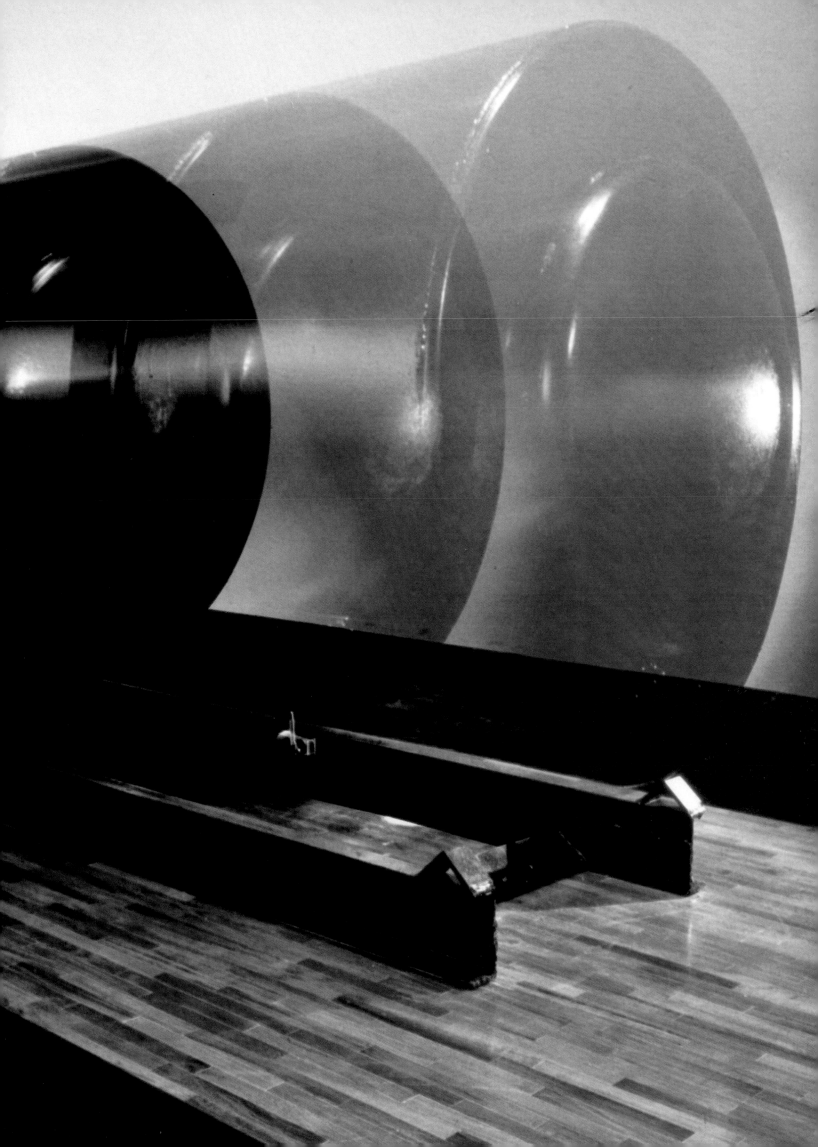

various periods in Bourgeois's production are either reused or recalled in quotation, and yet the reflexivity is jarringly unprecious. This is not Bourgeois offering us Bourgeois's Greatest Hits. Rather, as an artist at the height of her creativity and craft, Bourgeois is the proud owner of a rich and resonant language that she rightfully claims as wholly her own, self-invented and self-contained. *Precious Liquids* thinks back while looking ahead; it never looks back.

I would like to conclude this essay with a personal reflection. When I think of Louise Bourgeois's career and work, I think of the great French auteur Max Ophüls (another artist whose late masterpieces transcend and almost eclipse his earlier ones), specifically his second-to-last film, *The Earrings of Madame de . . .* (1953), made at a time when, as I have argued, an interest in the uncanny had to be expressed in a subversive, roundabout way. Ophüls, who had never truly abandoned the uncanny (in fact he worked more and more toward it), made a film based on the romantic novel by Louise de Vilmorin, in which a pair of precious earrings is moved around in a tragic circle that is "a progression from frivolity to destruction, chronicled through a supple flow of glittering images."[16]

The Earrings of Madame de . . . tells the story of the frivolous, elegant, and selfish Madame de, who sells a pair of beautiful diamond earrings she loves in order to pay a debt. She lies to her husband, General de, telling him that she has lost them. When a newspaper article mistakenly reports that the earrings have been stolen, the anxious jeweler who bought them from Madame de informs the general. He in turn buys the earrings and gives them to his mistress as a kind of payoff. The mistress travels to Constantinople, where she has a bad night at the roulette wheel and sells the earrings to a baron who is an Italian diplomat. Posted to Paris, the diplomat falls in love with Madame de. Their affair is sealed by his gift of the earrings to her, which leads to a duel between the general and the baron, the shock of which kills Madame de, who has a heart attack.

In Ophüls's film, it is a pair of earrings, inanimate objects, that carry messages of love as well as eventual fates of death. At the beginning of the film, the earrings represent only the money they can bring to settle a silly debt. In the hands of the general, they are a pretty bribe to buy off the possible problems stemming from an extramarital affair. From there they come to symbolize true love, deception, pathos, and, eventually, death.

Like Ophüls, Bourgeois affirms that everything, no matter how inconsequential on the surface, carries with it the possibility for destruction or transfiguration. Within her reciprocal terrain of the uncanny, Bourgeois conjures from her past images and scenarios of great power that force us to reckon with our own subjectivity and responsibility. Bourgeois tells us that what we do matters: everything comes back at us like a boomerang, and we control the course with our actions. Simple objects—and that is really what art amounts to, in comparison with disease, war, love, and death—can carry the world within them.

Jean-Luc Godard has posed the uncanny question, "What if looking at a simple traffic jam on the streets of Paris, if looked at in the right way, at the

right time, can lead to the cure for AIDS?"[17] Bourgeois, in her extraordinary reach with objects, appears to be walking on the same street as Godard, looking for meaning and salvation in simple scenes and scenarios. Where Godard gives us his camera panning repetitively back and forth, Bourgeois has fixed her gaze on herself for more than half a century. Bourgeois's art renders the self as the bearer of all things, great and small, good and evil. Subjecting herself to the grisliest of dissections, she insists that we the viewers look as intently as she does, not only at her, but at ourselves as well. Here is where her radicality lies. She illuminates the responsibilities we must insist on and the choices we must make by personalizing them first and only thereafter universalizing them. In so doing, Bourgeois gives license to an uncanny utopia whose foundation is laid within the self and whose force pours continually out.

[1] The philosopher Richard Rorty would insist that the uncanny has been abandoned in favor of pragmatism.

[2] Consider as an example Guy Davenport's reading of the 1942 painting *Hide-and-Seek* by Pavel Tchelitchew in an essay from the publication accompanying the 1991 exhibition *Art of the Forties* at The Museum of Modern Art. He begins: "[*Hide-and-Seek*] is a system of visual puns. . . . Children playing hide-and-seek are deployed in the branches on an ancient tree, which is a hand and a foot. In a cyclical progression of the seasons that alludes to Arcimboldo (in principle but not in technique) Tchelitchew has constructed a poetic statement that is at once beguilingly magical, Proustian, Rilkean, and boldly biological." Davenport counters his initial dive into the arena of the uncanny, however, with a predictable argument about how works of art reflect the news events that surround them: "Once they are in the world, paintings have their destinies. We can say that Max Ernst's *Europe after the Rain*, of 1940–42, is exact in its foresight, and that Pablo Picasso's *Guernica* was not so much a response to a tragic event in 1937 as a preparation of our eyes for violence that is still raging. . . . Within two weeks of Tchelitchew finishing *Hide-and-Seek*, this happened: the murder of 192 children at Treblinka, on August 6, 1942." What follows is a newsreel-style telling of the events of that fateful day, ending with philosophizing about Tchelitchew's ability to "[speak] for the Holocaust." Davenport, in *Art of the Forties*, Reva Castelman, ed., exh. cat. (New York: The Museum of Modern Art and Harry N. Abrams, 1991), 15–16.

[3] Harold Bloom, *The Anxiety of Influence* (London, Oxford, and New York: Oxford University Press, 1973), 77.

[4] Louise Bourgeois, "Self-Expression Is Sacred and Fatal: Statements," in Christiane Meyer-Thoss, *Louise Bourgeois: Designing for Free Fall* (Zurich: Ammann Verlag, 1992), 184.

[5] Sigmund Freud, "The 'Uncanny,'" in *On Creativity and the Unconscious*, Benjamin Nelson, ed. (New York: Harper & Row, 1958), 131.

[6] "In his study of the 'uncanny,' Jentsch quite rightly lays stress on the obstacle presented by the fact that people vary so greatly in their sensitivity to this quality of feeling." In ibid., 134.

[7] This stance, when abstracted, is reminiscent of Richard Rorty's call for active empathy: "In my utopia, human solidarity would be seen not as a fact to be recognized by clearing away 'prejudice' or burrowing down to previously hidden depths but rather, as a goal to be achieved. It is to be achieved not by inquiry, but by imagination. . . . Solidarity is not discovered by reflection but created. . . . A historicist and nominalist culture [on the other hand] would settle . . . for narratives which connect the present with the past, on the one hand, and with utopian futures, on the other." Richard Rorty, *Contingency, Irony, and Solidarity* (Cambridge and New York: Cambridge University Press, 1989), xvi.

[8] Bloom, *The Anxiety of Influence*, 79.

[9] Ibid.

[10] Rosalind Krauss, "Portrait of the Artist with *Fillette*," in Peter Weiermair, Lucy Lippard, Rosalind Krauss, et al., *Louise Bourgeois*, exh. cat. (Barcelona: Tàpies Foundation, 1990), 234–40. (Original German edition Frankfurt: Frankfurter Kunstverein, 1989.)

[11] Freud, "The 'Uncanny,'" 152–53.

[12] Bloom, *The Anxiety of Influence*, 77–78.

[13] Louise Bourgeois, "Louise Bourgeois," *Balcon* (Madrid), issue 8–9 (1992): 44.

[14] Ibid.

[15] Ibid.

[16] Stephen L. Hanson, "The Earrings of Madame de. . . ," in *Magill's Survey of Cinema*, Foreign Language Films, vol. 2 (Englewood Cliffs, New Jersey: Salem Press, 1985), 903–6.

[17] Jean-Luc Godard, quoted in Raymond Bellour, "(Not) Just Another Filmmaker," in *Jean-Luc Godard: Son + Image*, Raymond Bellour and Mary Lea Bandy, eds., exh. cat. (New York: The Museum of Modern Art and Harry N. Abrams, 1992), 215–31.

STATEMENTS

LOUISE BOURGEOIS

Cell (You Better Grow Up)

The piece is a cell, a seven-by-seven-by-seven-foot cube (pl. 39). It has
overtones of a jail and its occupant, of the inescapable; it also has overtones
of the biological cell. Its sides are made of woven iron bars and glass.
Mirrors, which pivot vertically or horizontally, have been inserted in the
ceiling and on two sides. Inside is a block of pink marble. Three hands are
carved in the stone. Sitting on three pieces of wooden furniture are objects:
a glass tower and three perfume bottles, a ceramic container with three
openings, and a stack of glass shapes.

The three hands are a metaphor for psychological dependency. The one
large hand is holding the two small childlike hands as if to protect them. It is
the hand of a mentor or guide, of an active, compassionate, reasonable
adult. The little hands are helpless and dependent. They are in a state of
fear and anxiety, which makes them passive. They long for inner peace: for
the guarantee of acceptance and love, for instant reassurance, for the
absence of fear. Eternally acting out their terror, they have no control, no
understanding of what the fear consists of.

First there is fear, the fear of existence. Then comes a stiffening up, a
refusal to confront the fear. Then comes the denial. The terror of facing
ourselves keeps us from understanding and subjects us to the repetition of
acting out. It is a tragic fate.

The mirrors superimpose on one another. They interact, giving a multi-
ple view of the world. The mirrors reflect the many difficult realities, one
worse than the next. To the child, the world they show seems distorted and
disordered. To the reasonable adult, the view they give is not a frightening
one, because the mechanism of the hinge is obvious.

Through self-knowledge we recognize and understand the mechanisms
of our fears. We cease being dependent on the unknown and the acting out
stops. The goal is to become active, and to take control. Until the past is
negated by the present, we do not live.

The perfume bottles put us in a nostalgic mood with the powerful recall
of smell. In our refusal to confront our fear, we retreat into nostalgia. Fear
condemns us to a rejection of the present. The present is kept intolerable.
We must call for help from the past to solve the problems of today.

The self-indulgent shapes in glass and in ceramic are a form of romanti-
cism, a state of abandon, a laissez-faire attitude, a childlike dream. They
are the things we do without having to face the consequences.

The artist, like the child, is passive. The artist remains a child who is no
longer innocent yet cannot liberate himself from the unconscious. The

acting out of his terror is self-involved and pleasurable. Some artists act all their lives instead of thinking. Self-expression excludes learning. Sublimation is a fantastic pleasure but also a fantastic privilege. Sublimation is living in heaven with the permission of your conscience. But the price of this sublimation, this acting out, is the absence of self-understanding or even of the desire for it. It is humiliating to be a toy in the hands of a fear that grips you so tightly.

Some people have declared that if artists were analyzed they would stop being artists. I disagree. Self-knowledge makes artists better artists. The process does not destroy the ability or the wish or the need to self-express. Ignorance is bliss, but its ransom is to keep you a prisoner of your own fears.

The tiny figure inside the stacked glass shapes is cut off from the world. That's me. The little hands are mine. They are self-portraits. I identify with the dependent one. The world that is described and realized is the frightening world of a child who doesn't like being dependent and who suffers from it. So the moral of this Cell is, you better grow up.

Reprinted from Marc Dachy, ed., *Et tous ils changent le monde*, exh. cat., Biennale d'art contemporain de Lyon (Lyon: Réunion des Musées Nationaux, 1993), 236–37.

LYNNE COOKE

My subject is the rawness of the emotions, the devastating effect of the emotions you go through. The materials are my means. They are there to serve me, I'm not there to serve them.
—LOUISE BOURGEOIS[1]

Cell II: an altarlike tableau is enclosed by a screen made of six blue doors hinged together (pl. 27). The barred threshold means that the viewer has to look through the windows in order to survey the inner sanctum, in which a group of empty perfume bottles stands on the mirrored surface of a pedestal, like an offering. All once contained Shalimar, but no trace of the scent now lingers. Adjacent to these delicate flasks is a pair of carved hands whose rosy marble fingers are knotted as if under the strain of intense emotion—pain, suffering, or a related kind of distress. Unusually, Bourgeois's symbolic language here pertains to the senses rather than being derived from bodily organs. Sight, smell, touch—the pleasures offered by each are evoked and then heightened subtly—by repetition, refraction, and reflection—only to be frustrated.

That pain may be pleasure is intimated not only in the way that sensory denial is enacted in this Cell, but in the way that erotic memory is engaged; for these details and fragments suggest metonymically what can only be indicated to the conscious mind by means of displacement and repression. Freud linked the atrophy of humankind's sense of smell to the advance of civilization and the consequent repression of sexual life. In teasing the voyeur with allusions to the *renifleur, Cell II* presents with singular if oblique eloquence an image of yearning for untrammeled sexuality.

Lair and Cell—these are the two terms Louise Bourgeois employs for the environments she has constructed over the past thirty years. Most contain neutral spaces, that is, spaces with no immediate gender identity or identification, unlike the Femmes Maisons, first realized as drawings and paintings during the 1940s and subsequently occasionally reprised as sculpture (figs. 6, 7, 19; pl. 3). Appearing initially in her oeuvre in the early sixties, the Lairs were organic forms with dark, mysterious interiors (figs. 17, 24). Given their amorphous exteriors and labyrinthine interiors, they resisted easy identification and so were at best apprehended experientially—albeit via an imagined inhabitation. *Articulated Lair*, 1986 (pl. 9), the most recent and largest to date, is, exceptionally, scaled to human dimensions and can be entered. Although it is a sanctuary—rest is vouchsafed by the provision of a small stool—escape is always possible: there are two doors, one at either end. The sole embellishment, a cascade of organic black forms, provides an overlay of symbolic meaning whose allusions are, if not precise, nonetheless readily intuited. That intimacy is here inextricably linked to loneliness should not surprise anyone familiar with Bourgeois's oeuvre; for her whole enterprise might be characterized as an attempt to populate, even fill, spaces with solid forms, and hence to counter loss and absence. Her signature vocabulary of mutating bulbous, phallic, or breast-like protuberances alludes to mouths, penises, anuses, breasts, and other organs through which desire and need are manifest.

Produced during the early 1990s, the Cells are altogether different in that they become playgrounds of fetishism and of libidinal energy displaced from the significant to the substitute (figs. 25–27; pls. 27–29, 35–40). For the first time in Bourgeois's oeuvre, found objects are incorporated in ways that draw tellingly on their past identities; and assemblage, a technique that can readily be viewed, as Bourgeois herself treats it, as a restorative, restitutive activity, has become the principal means of construction. Ironically, the recuperative gestures manifest here serve not to assuage but, as before, to "give meaning and shape to frustration and suffering."[2]

[1] Louise Bourgeois, "In Conversation with Christiane Meyer-Thoss," in Christiane Meyer-Thoss, *Louise Bourgeois: Designing for Free Fall* (Zurich: Ammann Verlag, 1992), 123.

[2] Louise Bourgeois, "Self-Expression Is Sacred and Fatal: Statements," in ibid., 189.

CHRISTOPHER FRENCH

One of the things that makes the work of Louise Bourgeois so appealing is its ability to create situations of taut, geometric purity and then defile them, and by doing so, create convincing alternative realities that contradict the impoverishment of our daily imaginations. I don't mean to suggest that Bourgeois is an inventive fabulist, so much as a rigorously moral realist. She makes her sculpture not to explore formal territories, but to illustrate object lessons from her own life, expanding them to the level of societal observations, as if to say: "This is the way life is. It is neither good nor bad, but it is our destiny." In *Untitled (with Hand)*, 1989 (pl. 20), for example, Bourgeois has created a metamorphic image of isolated humanness that, like a votary at an atheist's convention, is as disturbingly familiar as it is utterly foreign. (Strikingly, this form did not follow but preceded the natural concordance of mushroom and wooden sphere that occurs in *Gathering Wool*, 1990 [pl. 23].) This disquieting combination of pure and human form is, of course, an elegantly stated contradiction in terms. But beneath the obvious incongruities of humanity and inhumanity in Bourgeois's forms there resides a subtler conundrum. For despite its vivid allusion to the imagined security of childhood innocence, the miniature arm remains the intruding stranger; in this sculpture it is not its patently human attributes but the artificial construct of geometry that sustains the completeness of identity. To this conjunction of opposites, the artist has added a permanent inscription etched into the roughness of her stone pedestal: "I love you, I love you, I love you." This confident declaration is as unsettling as the artist's oddly endearing sculptural formulation. Compare this assertion with the questioning inscription that encircles the base of the companion piece *Untitled (with Foot)*, 1989 (pl. 18): "Do you love me? Do you love me? Do you love me?" Finally, a third version states: "We love you. We love you. We love you." The linkage between these inscriptions, like the linkage between object and statement in each of these works, gets to the heart of what Bourgeois's art is about. Her direct language ably articulates the relationship between the artist and the objects she creates, while the human relationships undergirding these expressions in stone establish the uneasy reciprocity between artist and viewer that is in fact the artist's great accomplishment. Not that Bourgeois's art is ever warm and cuddly. There's an alien howl in her work that can disturb and shock. In *Nature Study*, 1984 (pl. 6), or *Mamelles*, 1991 (pl. 32), for example, it threatens to devour rationality like a locust. This is irritating work; it gets under the skin and gnaws, making me feel my own latent inhumanity. But in sharp contrast to the prevailing tendency toward polarized approaches to art that alternate between emotional confession or polemical muteness, Bourgeois's art provides vivid examples of the communicative power that art affords when it establishes the discipline of complicity.

JOSEF HELFENSTEIN

Inspiration and Obsession

In general, drawing is regarded as a medium of artistic spontaneity and directness. It is the art form that most clearly reflects the immediacy of psychic expression. The drawings of Louise Bourgeois possess these qualities to an unusual extent, but there is far more to them than that. It seems to me that her drawings are marked by an intense interaction—or symbolic agreement—between form and content: the roughness of their execution, their quality of primariness, combines with an extraordinary power of emotional expression. At times, the line and some of the forms evoke the crudity of children's drawings. And yet the starkness of the drawing and the often sculptural clarity of the forms reveal the hand of a sculptor: they find a linguistic equivalent in the affecting clarity of Louise Bourgeois's short stories.

The drawing *Hours of the Day—Creative Energie* (fig. 29) was done in 1990, on the back of a used envelope. It shows an array of circles, spreading out from the bottom to the top and overlapping each other in different ways. Above right, and interlocking with the circles, are the only rectangular forms, one small and one large. The areas of overlap between the circles are colored variously in pencil hatching, red ballpoint, and blue crayon. The small, red, nearly circular form in the center of the lower edge looks like a starting point, a moment of fertilization, for the upward movement of the circles. It seems natural to see this form as the germ of the creative process, the source of the inspiration.

The notes at bottom left and the string of numbers that run up the left-hand side make it clear that the drawing is a representation, however rough

Fig. 29. *Hours of the Day—Creative Energie*. 1990. Ink, crayon, and graphite on paper, 12½ × 9½ in. (31.7 × 24.1 cm). Private collection, Bern

and schematic, of the process of creative development as applied to the course of one day. It is an attempt to represent that inner process to which Louise Bourgeois as an artist is subject, or which she can voluntarily set in motion: the mechanism of inspiration. The idea of a "mechanism of inspiration," which goes back to the Surrealists, seems entirely appropriate to this drawing, which represents the process with the cool objectivity of a diagram.

Artistic inspiration is well known to be one of the most powerful myths in the history—or, to be more precise, the historiography—of Western art. Within art it has mostly been presented in an idealized form ("Artist and Muse"). In modified forms, this tradition has been maintained in the twentieth century: Giorgio de Chirico and Max Ernst, but also James Joyce, Louis Aragon, and André Breton more or less concur in describing artistic inspiration as an instant of revelation, a sudden epiphany. Not without a touch of deliberate mystification, Paul Klee depicted himself in 1919 in a pose of otherworldly contemplation, with eyes closed (fig. 30). Louise

Bourgeois, by contrast, does not show the artist: she shows creative energy in the form of an abstract, stereotyped, even everyday process. It is here, for all her stark objectivity, that she betrays a touch of self-dramatization: the hourly timetable on the left stresses the stubborn regularity, even the obsessiveness, of her manner of working—a well-known characteristic of this particular artist.

The artist's work is presented in terms of a recurrent, Sisyphean rhythm; inspiration is rooted in compulsive obsession. This impression of compulsive rhythm is reinforced, in a way, by the two eyes at top right, which do not seem to belong to a face. The circles themselves can be interpreted as a symbol of seeing. At least in formal terms, *Hours of the Day—Creative Energie* reveals an affinity with such other recent works as the installation *Precious Liquids*, 1992 (fig. 21). These connections illustrate the many-layered and simultaneously precise nature of this unassertive drawing. Its precision declares itself not least in the degree of reflection that it contains: reflection on the conditions that govern art itself.

———

Translated from the German by David Britt

Fig. 30. Paul Klee. *Lost in Thought (Versunkenheit)*. 1919. Pencil on notepaper mounted on board, 10⅝ × 7¾ in. (27 × 19.7 cm). Norton Simon Museum, Pasadena, California; The Blue Four-Galka Scheyer Collection P.1953.22

JENNY HOLZER

Years ago, I followed Louise Bourgeois around the Whitney because I was curious about her, but too timid to approach. I was impressed that everyone else seemed afraid of her.

When I review the testimony about what is wrong with women, her work is the perfect rebuttal.

I enjoy her skinning, cutting, and jamming body parts.

Her work seems neither male nor female, but both with a vengeance; the meat breeds itself.

In addition to her human pieces, she seems to grow individuals or colonies from space spores.

I like that Bourgeois spends a long time studying and producing her art. Her subjects are ancient, and she has worried them for decades.

I have the fantasy that she has fun from time to time, and doesn't do anything she doesn't want to do.

I imagine Bourgeois knows that everything is possible between people, and that the unthinkable occurs routinely.

ARTHUR MILLER

Louise Bourgeois's art is directly linked to memory as well as her subconscious life. She has managed to find an aesthetic of the mind's deep layers and—so it appears to me—insists on not distorting or even jostling those layers any more than artistic form requires. But somehow there is nothing hermetic or cut off in her work; given a minimum of patience, it begins to speak to the viewer with a humanistic tenderness. Of course it is finally the form she creates that counts, and I am sure there are some who reject her work for not being beautiful. In a sense, she is constantly reproducing her inner self with the intention, I suppose, of making a tactile contact with the soul of her audience rather than an intellectual one. It is an art, first of the eye of course, but finally of the interior life into which vision leads. In effect, she is as though talking profoundly to herself, just loudly enough to be overheard. Whatever else her work may be, it seems full of an implacable truthfulness to her recall, her dreams, her most private vision, and in that there is a beauty of integrity, which informs her art.

LOIS NESBITT

My early work is the fear of falling.
—LOUISE BOURGEOIS[1]

Stone-cold eyes crouch, watching. Squat cylinders, their heads lopped off, huddle close, breaking each other's falls. Breasts and phalli spawn in hordes. No one wants to be alone. I try to dismiss Bourgeois's work — I'm too afraid to look.

Later on it became the art of falling. How to fall without hurting yourself.

The humor shines through. In one performance, Bourgeois induces respected art historians to parade in bulbous, breastlike costumes. In the sculptures, mismatched body parts and funky scale shifts mock "masculine" and "feminine," and any ideals of physical beauty we still have fall without grace. I take a few falls myself and begin to look at last at Bourgeois's work, warily, out of the corner of my eye.

Later on it is the art of hanging in there.

Swollen, pendulous masses dangle from the ceiling, airborne but not in flight. Too heavy for their cords, they stay up there anyway, bound for earth but resisting free fall. I'm back on my feet, for the moment. Hanging in there—the art of living, the art of a lifetime. I can't imagine a better teacher.

[1] All quotations are from Louise Bourgeois, "Self-Expression Is Sacred and Fatal: Statements," in Christiane Meyer-Thoss, *Louise Bourgeois: Designing for Free Fall* (Zurich: Ammann Verlag, 1992), 177.

MIGNON NIXON

Disappearances

What if you folded your body into a certain house, gave up the separation between them? This would not be like imagining your body as a house, or figuring a house as your body. So if not, then, a matter of constructing a metaphor—body as house, house as body—what would it mean to collapse your body into a certain house?

Distinctions like this one—the differences between body and environment, inside and outside, subject and object, male and female, to name a few—have been disappearing within the work of Louise Bourgeois since the late 1940s when she produced a little book of stories coupled with

engravings entitled *He Disappeared into Complete Silence* (fig. 8). These stories turn on losses, disappointments, and cruelties—a woman is abandoned by her son, a man murders his wife and cooks her for dinner, a man loses his hearing and with it his connection to the world—that are told flatly, with few words, in taciturn refusal of the prerogatives of language. The engravings that accompany the stories are unpeopled, instead depicting an architecture of objects—ladders, elevator shafts, windowless buildings—that are similarly affectless and resistant to narrative. Figure, or character, hardens into a condition of objectness as the distinction between internal and external—a difference both opened up and covered over by language—breaks down.

Forty years later, in 1989, Bourgeois materialized the condition of an inside and outside folded together in two large-scale works, *No Escape* and *No Exit* (pls. 16, 17), that seem to reenact the mute scenarios of those early stories, this time with real objects. *No Exit* is composed of a weathered wooden staircase, partially enclosed from behind by a pentagonal folding screen of wide panels and flanked in front by two tremendous, smooth spheres of well-worn wood. In *No Escape*, a rough white staircase is set within a niche formed by a folding metal screen in front of which two stout, square timbers are stationed. Both works refuse the narrative, programmatic implications of architecture by constructing a mise-en-scène of repetition—a staircase that leads nowhere, failing to connect a downstairs to an upstairs, instead enacting the back-and-forth, the up-and-down, the over-and-over of obsession.

Read against each other, these two works that appear so similar, like doubles, immediately produce a series of reversals and substitutions—whitewashed for weathered, and square pillars for spheres, for example. The chain of substitutions extends the repeated action inscribed in the staircase to an implied series, not unlike the suite of etchings with their similar architectural set-ups. These substitutions suggest a sort of semiotics of desire, an inescapable logic of substitution and repetition.

There is, however, a further doubling enfolded here, but withheld from view, one that takes the form of a second disappearance. We recognize the first disappearance as a withdrawal into silence, or aporia, restated here in a refusal of the distinction between interior and exterior, between a body and a certain house. The second disappearance is, we could say, into doubleness itself.

Behind each staircase is a little door hung at about eye level, opening into a dark closetlike space. A beam of light pointed at the door confirms the presence of something to see. Inside *No Exit*, twin hearts of pale blue rubber are suspended side by side. The interior of *No Escape*, meanwhile, harbors two giant spheres, identical to the ones posted outside *No Exit*, but here nestled together in darkness, and in complete silence.

ADRIAN PIPER

When I first saw a sculpture by Louise Bourgeois I felt myself to be in the presence of something alive, organic, and erotic that would continue to transmute into yet further forms and essences as I looked at it; something that bespoke an intimacy so deep it made me physically and psychologically uncomfortable, as though my mother's breast and belly were beckoning me back to infancy. I have always found Bourgeois's work intensely disturbing for this reason. I see it and I become immediately aware of throwing up resistance to seeing it too clearly, to allowing its full impact to bring home to me my own regressive desires to go home—to enveloping flesh, suckling breast, immediate gratification. This is without question the most physically sensuous work I have ever seen, and the work that most fully embodies the notion of the activity of sculpture as a sublimation of the painful and fulfilling acts of lovemaking and giving birth.

Bourgeois's importance for contemporary artists is indisputable and invaluable. She has disavowed interest in the political dimensions of art, yet her own work is profoundly political in the best sense: it draws us into a space in which the dynamics of power and surrender, of gender identity, the circumscription of the body, and relation to the mother are unavoidable. It forces us to become aware of our own status as incomplete adults who aspire to maturity through repressive acts of de-eroticization, acts that Bourgeois's work ridicules and scrutinizes at the same time. It reminds us of the chasm that separates the corporeal and infantile beings we are from the cerebral and self-governing agents we tell ourselves we are. Allowing oneself to feel the full force of the insistently sensuous forms she creates can be an intensely embarrassing, illuminating, and transformative experience.

In 1988 I had not yet met Bourgeois personally. That year I published in *Real Life* a rebuttal to a scathing attack on me by a prominent white male critic who had argued, at a length of nine pages in his own vanity publication, that my writing was a sign of mental illness and my work was not worth discussing. I felt that I was fighting, not only for my professional life as an artist, but for the right to be treated with dignity and respect even by those who disliked my work. I also felt that this critic had put me in a no-win situation, since I knew that by fighting back I would be labeled "difficult" and shunned by many in the art world. I was very depressed about the whole matter. Then I received a phone call from Arlene Raven: Louise Bourgeois was having a cocktail party in my honor and wished to invite me to her home to partake of the festivities! My feelings upon hearing this were indescribable; suffice it to say that I was very honored and very moved by her kindness and generosity of spirit. It was a wonderful, supportive, entertaining evening that I will never forget, and I felt deeply privileged to meet one of my all-time artistic heroines personally under these circumstances. At one point she called for a toast, saying to me, "I'm sure you don't want to talk at length about the reason why we're toasting you, but we're going to toast you anyway." What a perfect, subtle hostess. I could've hugged her; but wanting to be the perfect guest of honor, I refrained.

RICHARD SERRA

Rage

But for me as a child everything you called out at me was positively a heavenly commandment, I never forgot it, it remained for me the most important means of forming a judgment of the world, above all of forming a judgment of you yourself, and there you failed entirely. Since as a child I was with you chiefly during meals, your teaching was to a large extent the teaching of proper behavior at table. What was brought to the table had to be eaten, the quality of the food was not to be discussed—but you yourself often found the food inedible, called it "this swill," said "that beast" (the cook) had ruined it. Because in accordance with your strong appetite and your particular predilection you ate everything fast, hot, and in big mouthfuls, the child had to hurry; there was a somber silence at table, interrupted by admonitions: "Eat first, talk afterwards," or "faster, faster, faster," or "there you are, you see, I finished ages ago." Bones mustn't be cracked with the teeth, but you could. Vinegar must not be sipped noisily, but you could. The main thing was that the bread should be cut straight. But it didn't matter that you did it with a knife dripping with gravy. Care had to be taken that no scraps fell on the floor. In the end it was under your chair that there were most scraps. At table one wasn't allowed to do anything but eat, but you cleaned and cut your fingernails, sharpened pencils, cleaned your ears with a toothpick.
—FRANZ KAFKA, from "Letter to His Father"

This piece is basically a table, the awful, terrifying family dinner table headed by the father who sits and gloats. And the others, the wife, the children, what can they do? They sit there, in silence. The mother, of course, tries to satisfy the tyrant, her husband. The children are full of exasperation. We were three children: my brother, my sister, and myself. There were also two extra children my parents adopted because their own father had been killed in the war (the First World War). So there were five of us. My father would get nervous looking at us, and he would explain to all of us what a great man he was. So, in exasperation, we grabbed the man, threw him on the table, dismembered him, and proceeded to devour him.
—LOUISE BOURGEOIS[1]

I am told of childhood traumas, but that seems to be only part of the story. I am not sure wherefrom or how these obvious, direct, concentrated, and dense forms come into being. The source of pain, the core of the anxiety remains indecipherable, and yet these sculptures trigger in me the memory of personal experiences I'd rather forget. Her subjectivity forces me to deal with my own. The work causes states of fear so brief that speech always comes too late. The meaning evades me: discursive analysis, conceptual terms fail. All tracking leads to dead ends. Imposition of formal logic and conjectures of academic language do not resolve the content. The works leave me stuck with my vulnerable self.

[1] Statement by Louise Bourgeois (on *The Destruction of the Father* [fig. 9]) in Jean Frémon, *Louise Bourgeois: Rétrospective 1947–1984*, exh. cat., Repères, Cahier d'Art Contemporain no. 19 (Paris: Galerie Maeght Lelong, 1985), 6.

NANCY SPECTOR

Behind rusted industrial fencing sits a miniature house carved from translucent marble (pl. 36). In the muted light seeping through the soot-laden windows of Louise Bourgeois's studio, its pink surface appears as permeable as skin, its hollow windows stare like so many vacant eyes. An exact replica of the artist's childhood home in Choisy, this house makes the private dimensions of Bourgeois's work explicit; it seduces the viewer with promises of autobiographical disclosures, intimate confessions, recovered memories. Affixed to the side of this cagelike enclosure, a faded shop sign salvaged from the Bourgeois family's tapestry business reading "Aux Vieilles Tapisseries" furthers the narrative reference. Anyone familiar with the artist's long career and expansive, interrelated oeuvre already knows of her early emotional trauma with familial betrayal and how she has manifested this experience in numerous drawings, sculptures, and installations. But this marble cell of a house, trapped within its own prison cell, seems to offer new testimony. You are enticed into entering the metal structure—the interior space of the artist's life—by a narrow fence door hanging slightly ajar. However, the razor-edge of the guillotine suspended above the entrance stops you in your tracks.

The psychosexual drama of the home has pervaded Bourgeois's art from its very inception. Femme Maison drawings from the 1940s represent woman and the house as inextricable entities; the female body—its uterine cavities, its nurturing embrace—is depicted, in the most Freudian of terms, as the physical extension of domestic architecture (figs. 6, 7, 19).[1] Reiterated over and over again in Bourgeois's sculptural nests, lairs, and labyrinths, the home is portrayed as a female site, the interstices of which encompass the pleasures and pains of woman's experience. So homebound, so bound to the home, women's narratives are spatially determined. According to psychoanalyst Jessica Benjamin, "what is experientially female is the association of desire with a space."[2] In the past few years, Bourgeois has increasingly mapped such narratives, her own narratives, in overtly spatial, even architectural terms. The recent Cell structures—haunting mise-en-scènes that alternately attract and repel their visitor-viewers—are compact theaters of emotional intensity.

As a territory, the cell bespeaks confinement, a claustrophobic site of submission and solitude. However, in biological terms, the cell is also a living organism, the smallest structural unit capable of sustaining independent functions. When Bourgeois demarcates space, both readings are inscribed within its boundaries. As feminized sites, the Cells enact the social isolation that has been woman's experience; but they also reveal woman's interior life, the inner place that can be understood in Benjamin's words as "part of a continuum that includes the space between the I and the you."[3] Bourgeois's architecture rehearses this state of female "intersubjectivity" in which the borders between the inner psychic and the outer empirical realms collapse. Her art has always exercised this fluidity; her narratives forever embrace the bonds between self and others. The early wooden totemlike "presences," for instance, were conceived and exhibited in clusters as surrogates for lost friends and relatives. "I summon all of the people I miss,"[4] claims Bourgeois. The relationship informing Cell (Choisy) is one of painful and perilous triangulation: the bond described

here is between father, mistress, and daughter. But throughout the oeuvre, other more tender, emotional geometries are rendered: daughter and mother; mother and three sons. Common to all of the work, however, is the connection between artist and audience, an intimate relationship to which Bourgeois brings, in spatial terms, the beauty and the danger, the joys and the wounds, of woman's desire.

[1] In 1919 Freud wrote, "There is a joke saying that 'Love is homesickness,' and whenever a man dreams of a place . . . and says to himself while he is still dreaming: 'this place is familiar to me, I've been there before,' we may interpret the place as being his mother's genitals or her body." Quoted in Anthony Vidler, *The Architectural Uncanny: Essays in the Modern Unhomely* (London and Cambridge, Mass.: The MIT Press, 1992), 152.

[2] Jessica Benjamin, "A Desire of One's Own: Psychoanalytic Feminism and Intersubjective Space," in *Feminist Studies/Critical Studies*, ed. Teresa de Lauretis (Bloomington: Indiana University Press, 1986), 97. These ideas were suggested to me through a reading of Giuliana Bruno's essay on Rebecca Horn's films, "Interiors: Anatomies of the Bride Machine," in *Rebecca Horn*, exh. cat. (New York: Solomon R. Guggenheim Museum, 1993).

[3] Benjamin, "A Desire of One's Own," 95.

[4] Interview with the artist, April 1992.

GINNY WILLIAMS

The first time I saw Louise Bourgeois's work, I knew that I'd own it. I was in the Robert Miller Gallery to look at a body of Mapplethorpe photographs when I saw her Museum of Modern Art catalogue. I snitched it; and there began a love affair that has endured through each new piece she makes.

The first major piece I acquired was the early *Observer*. I remember Louise's story about how she grew up with a piece of art "observing" them as children. She was referring to the two cast stone sculptures of Pomona and Vertumnus that stood in the garden at Choisy, where she lived as a child. My *Observer* went into the hallway at my home and observed my teenage children. It sits today in the same spot it found when it arrived.

Several pieces later, my daughter Payne and I flew to London to see Louise's show at Riverside Studios and in particular her marble sculpture *The Sail*, 1988 (pl. 15). We checked into the hotel and immediately headed for Hammersmith, only to find the exhibition had just closed. *The Sail*, wrapped in blankets, sat on top of a flatbed truck in front of the building. We climbed up onto the back of the truck to take a peek—the first time either of us had seen the sculpture. We were very excited by the adventure and the sculpture and bit by bit had the workmen uncover the entire piece. It was extraordinarily beautiful sitting up on the truck in the early morning English mist, and within the hour *The Sail* became Payne's and started its journey back across the waters to Denver.

The Sail is related to Louise's Femme Maison theme of the 1940s in its fusion of the woman's body and architecture. The projection of the body onto the world and the introjection of the world into the body are expressed in the pure forms of *The Sail*. Its openings are windows or eyes or orifices that gather rain and snow and shed tears as water seeps through them. *The Sail* sits on the lawn in back of my home in Denver, and during the winds that followed the volcanic eruption of Mount St. Helens, red earth from Utah was blown across Colorado, turning the rain and snow pink and coloring the fluids that seeped through the orifices. Like the sculpture's one highly polished plane, which resembles the sail of a boat billowing in the wind, Bourgeois's sculpture commands the space around it, as *The Sail* commanded the space in front of the U.S. Pavilion at the Venice Biennale after it sailed once more across the ocean.

I love Louise's work for many reasons, but most of all for its variety and its intelligence. And I love Louise as much as I do her work; her freshness, originality, and intelligence are among the best gifts of the twentieth century.

To spend an hour with Louise is high adventure, filled with wit, love, and unexpected tidbits of wisdom. These encounters with Louise and her art are some of the most rewarding in my life.

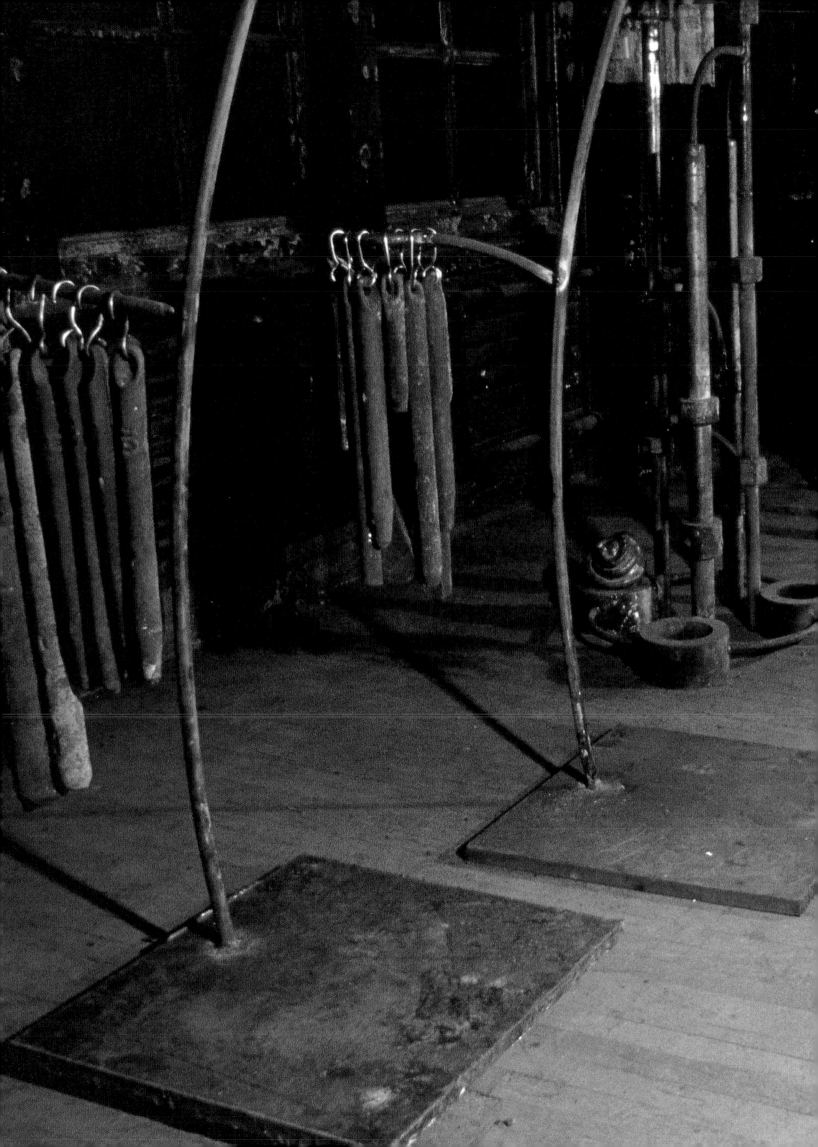

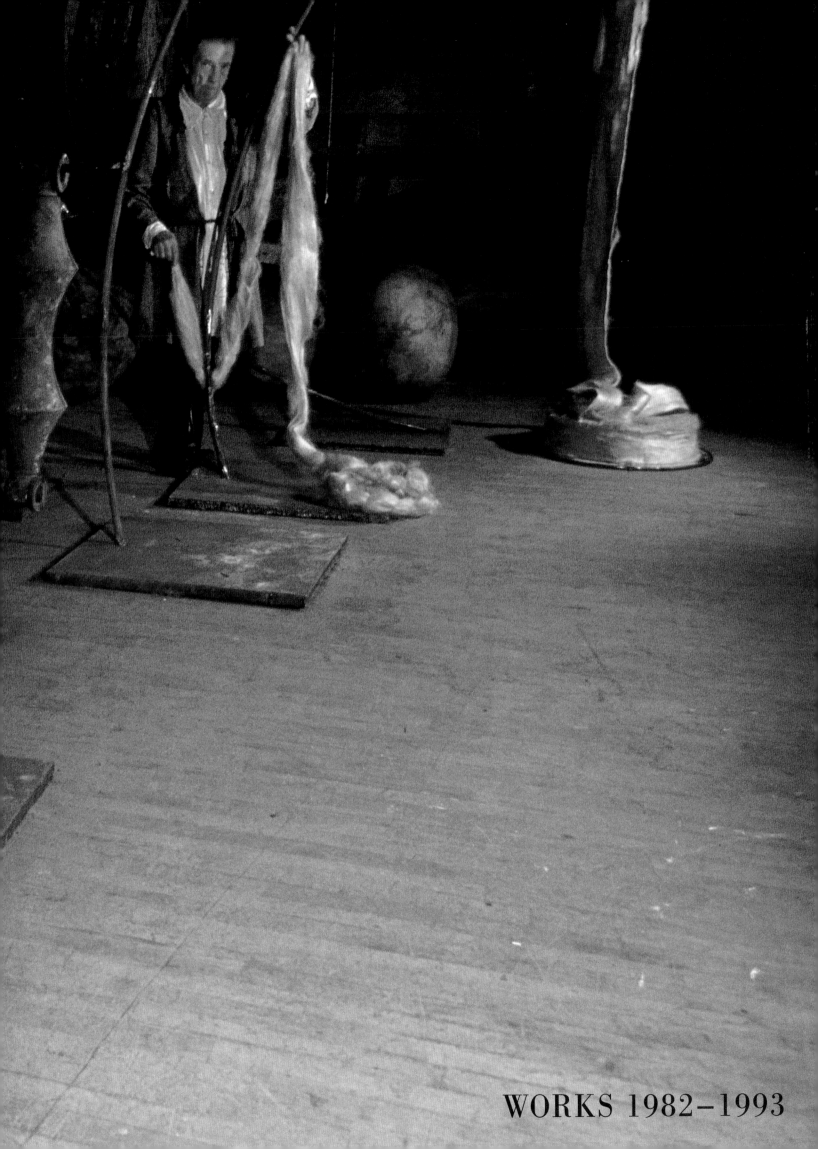

WORKS 1982–1993

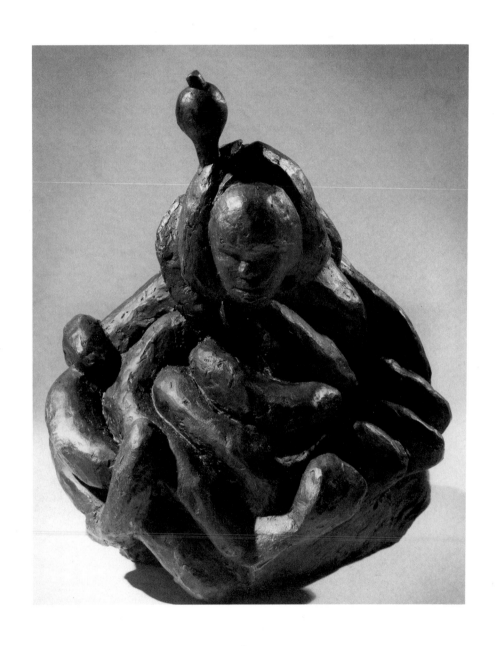

PRECEDING PAGES:
Louise Bourgeois in her studio,
1992. Photograph by Peter
Bellamy

Plate 1. *Female Portrait*. 1962–
82. Bronze, 13 × 13 × 11½ in.
(33 × 33 × 29.2 cm). Collection
of the artist; courtesy Robert
Miller Gallery, New York

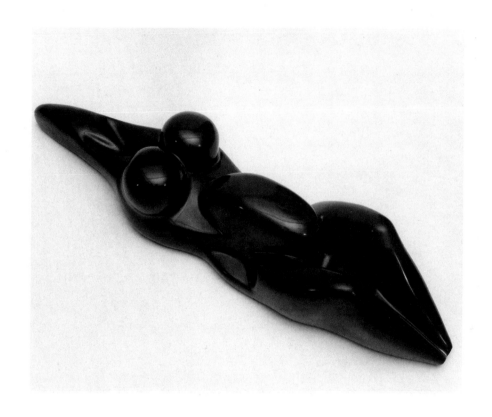

Plate 2. *Femme Couteau.* 1982.
Black marble, 5½ × 30½ × 8
in. (13.9 × 77.4 × 20.3 cm).
Collection of Jerry Gorovoy,
New York

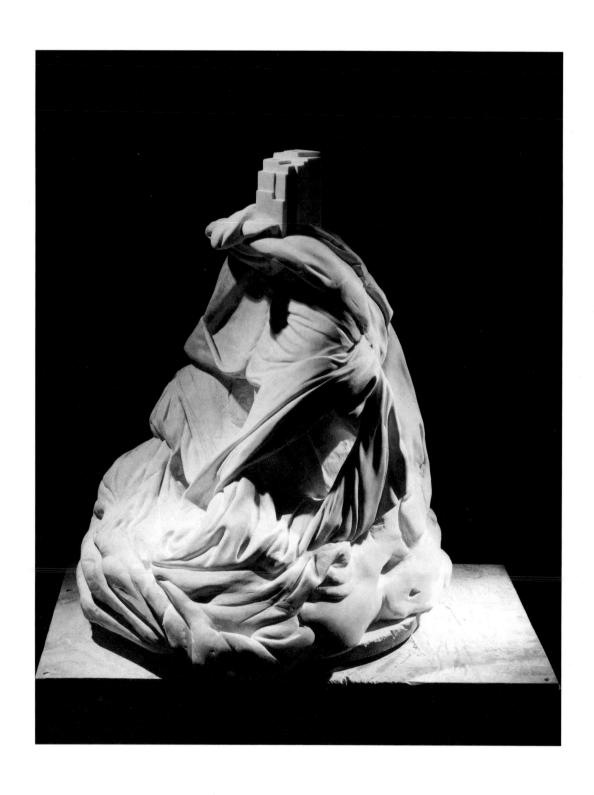

Plate 3. *Femme Maison*. 1983.
Marble, 25 × 19½ × 23 in.
(63.5 × 49.5 × 58.5 cm).
Collection of Jean-Louis
Bourgeois, New York

Plate 4. *The Curved House.*
1983. Marble,
11½ × 3½ × 23⅝ in.
(29 × 8.5 × 60 cm).
Kunstmuseum Bern

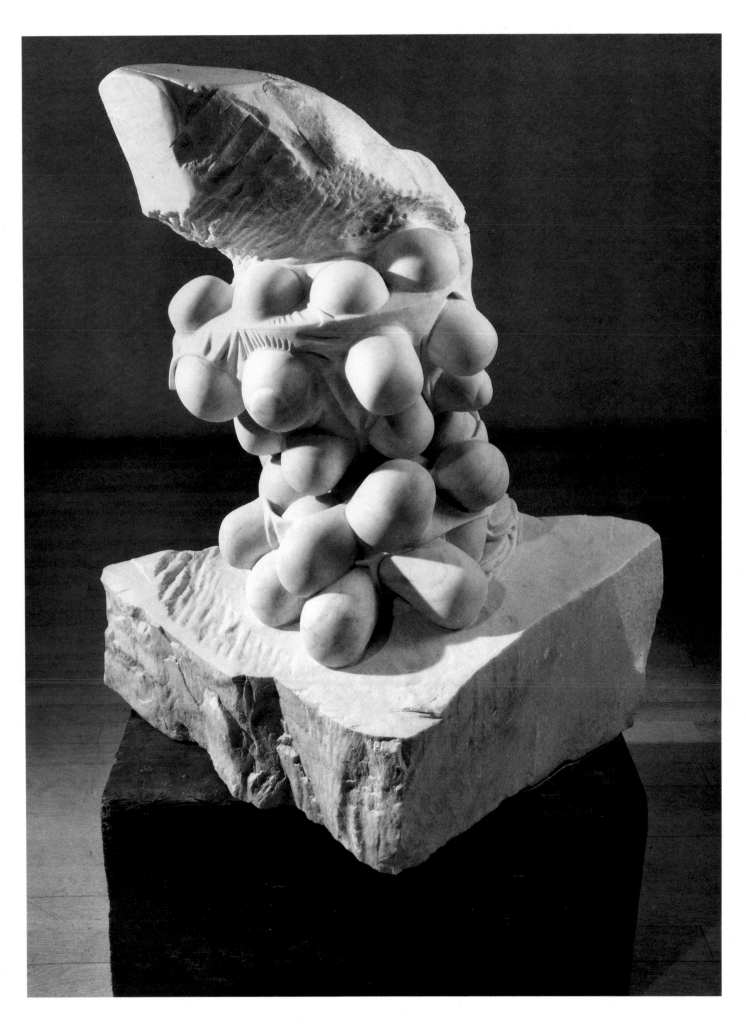

Plate 5. *Blind Man's Buff*. 1984.
Marble, 36½ × 35 × 25 in. (92.7 × 88.9 × 63.5 cm).
Collection of the artist,
courtesy Robert Miller Gallery, New York

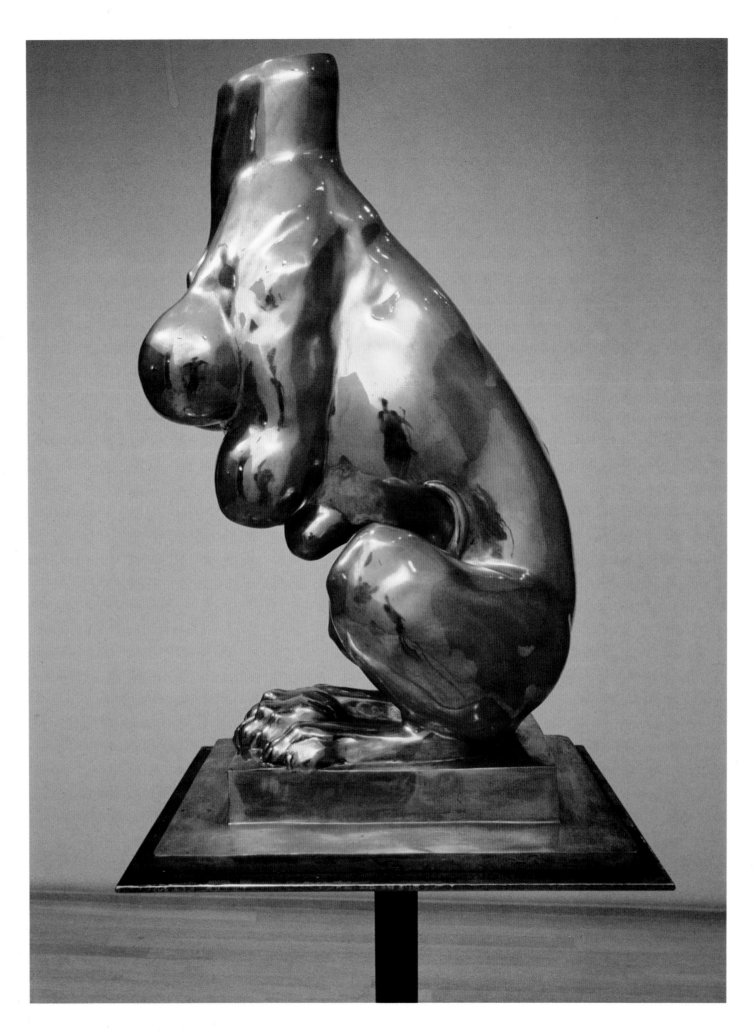

Plate 6. *Nature Study.* 1984. Bronze, polished patina, 30 × 19 × 15 in.
(76.2 × 48.2 × 38.1 cm); steel base 41 × 15 × 20 in. (104.1 × 38.1 × 59.8 cm).
Whitney Museum of American Art, New York; Purchase with funds from
the Painting and Sculpture Committee 84.42

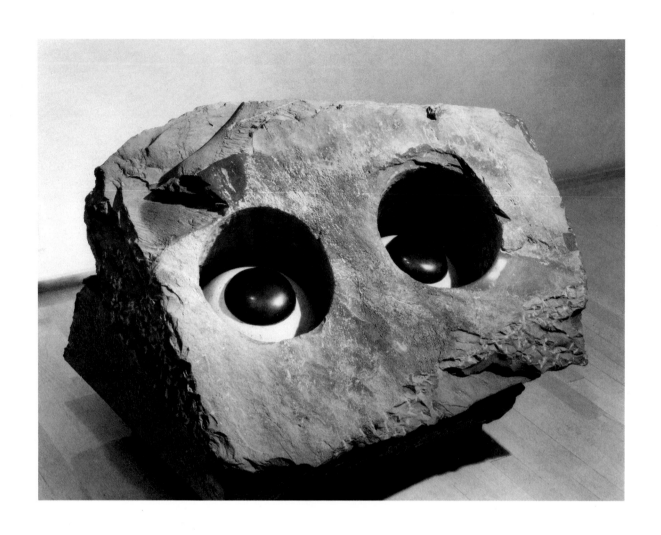

Plate 7. *Nature Study (Velvet
Eyes)*. 1984. Gray marble
and steel, 26 × 33 × 27 in.
(66 × 84 × 68.5 cm); steel
base, height 4½ in. (11.4 cm).
Collection of Michael
and Joan Salke, Boston,
Massachusetts

OPPOSITE:

Plate 8. *Spiral Woman*. 1984.
Bronze and slate disc; bronze
11½ × 3½ × 4½ in.
(29.2 × 8.9 × 11.4 cm); disc,
diameter 1 × 34¾ in.
(2.5 × 88.3 cm). Collection of
Elaine Dannheisser, New York

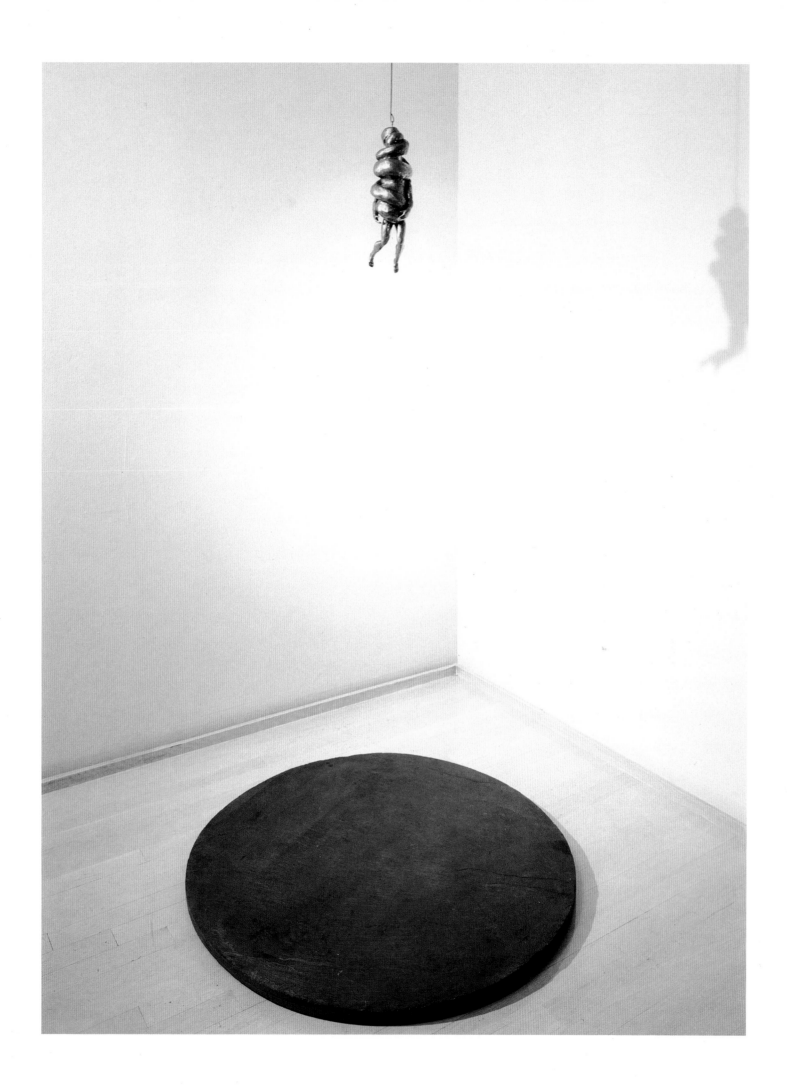

Plate 9. *Articulated Lair*.
1986. Painted steel and rubber,
height 132 in. (335 cm), width
and depth variable. The
Museum of Modern Art,
New York; Gift of Lily
Auchincloss and of the artist
in honor of Deborah Wye (by
exchange)

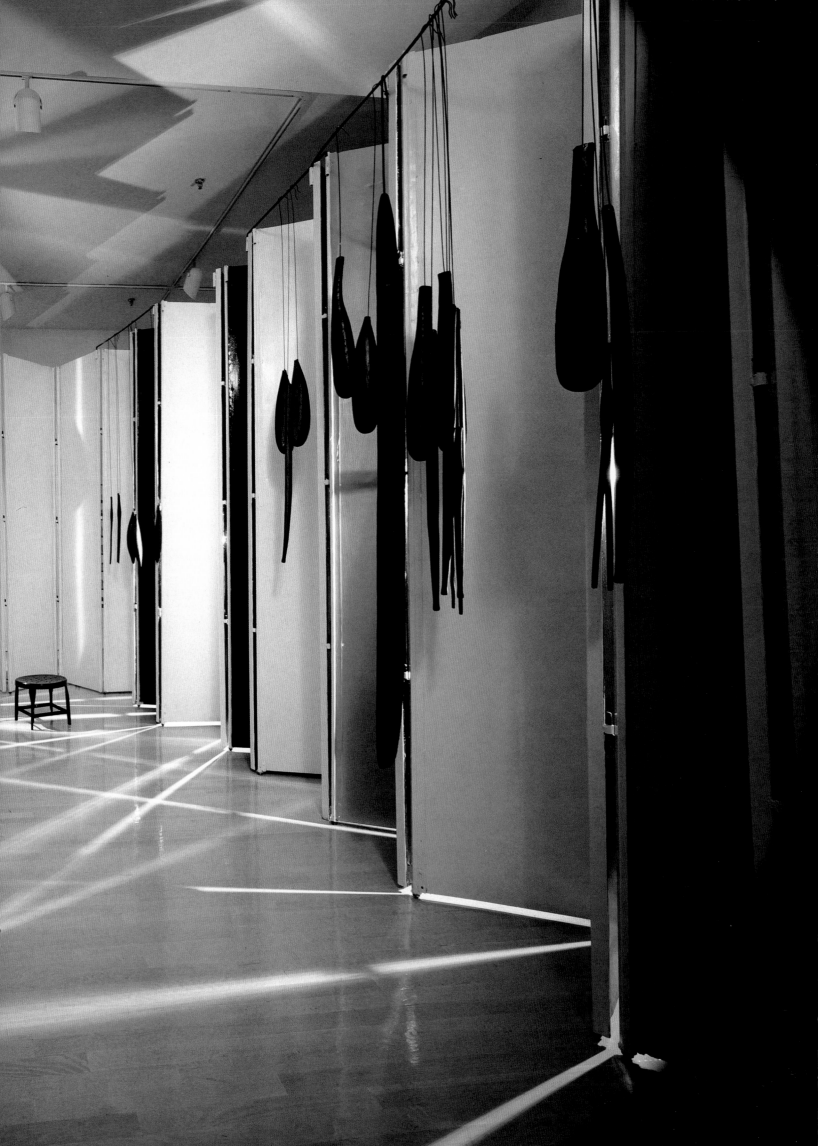

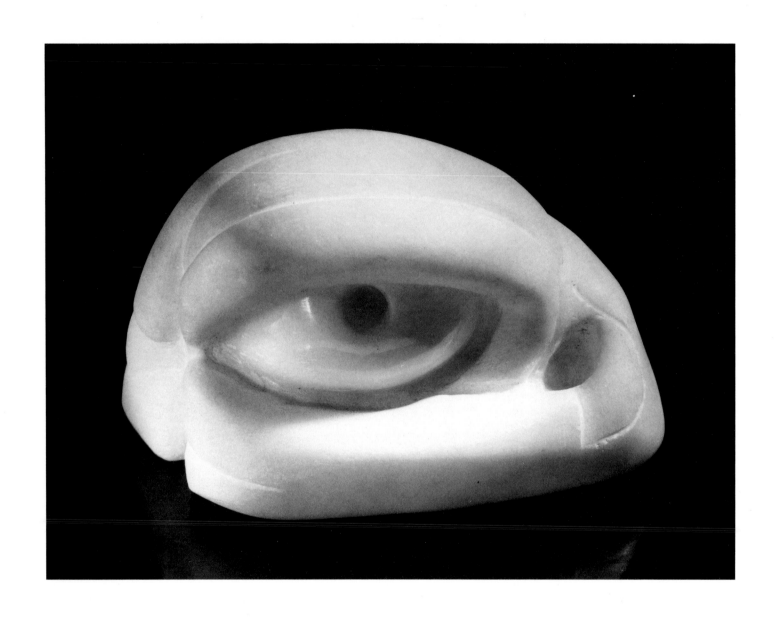

Plate 10. *Bald Eagle*. 1986.
Marble, 4⅛ × 7 × 5½ in.
(10.4 × 17.7 × 13.9 cm).
Collection of John Eric Cheim,
New York

OPPOSITE:
Plate 11. *Legs*. 1986. Rubber,
each leg 123 × 2 × 2 in.
(314 × 5 × 5 cm). Collection
of the artist; courtesy Robert
Miller Gallery, New York

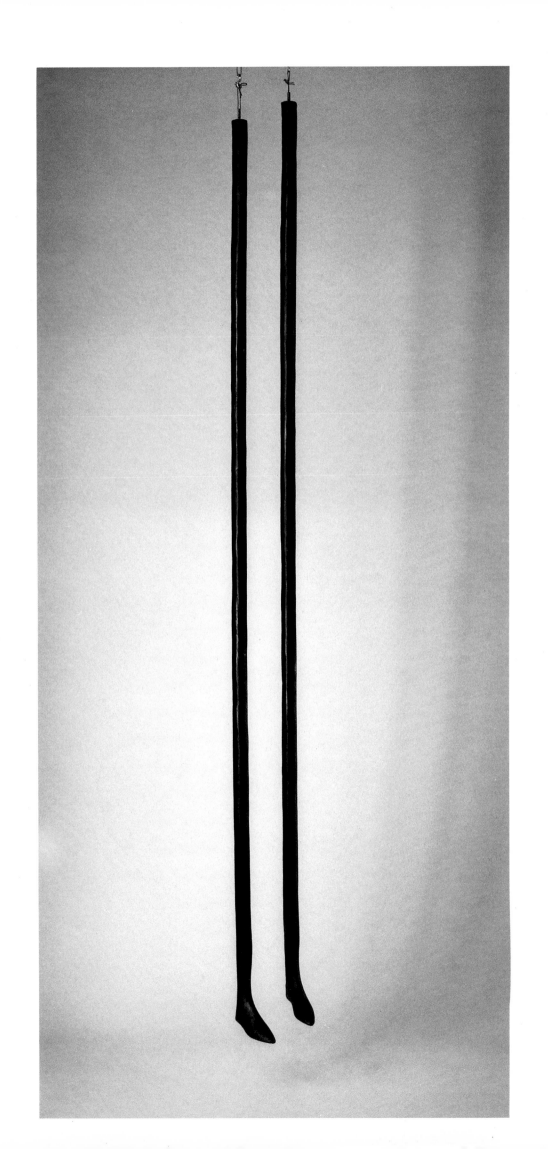

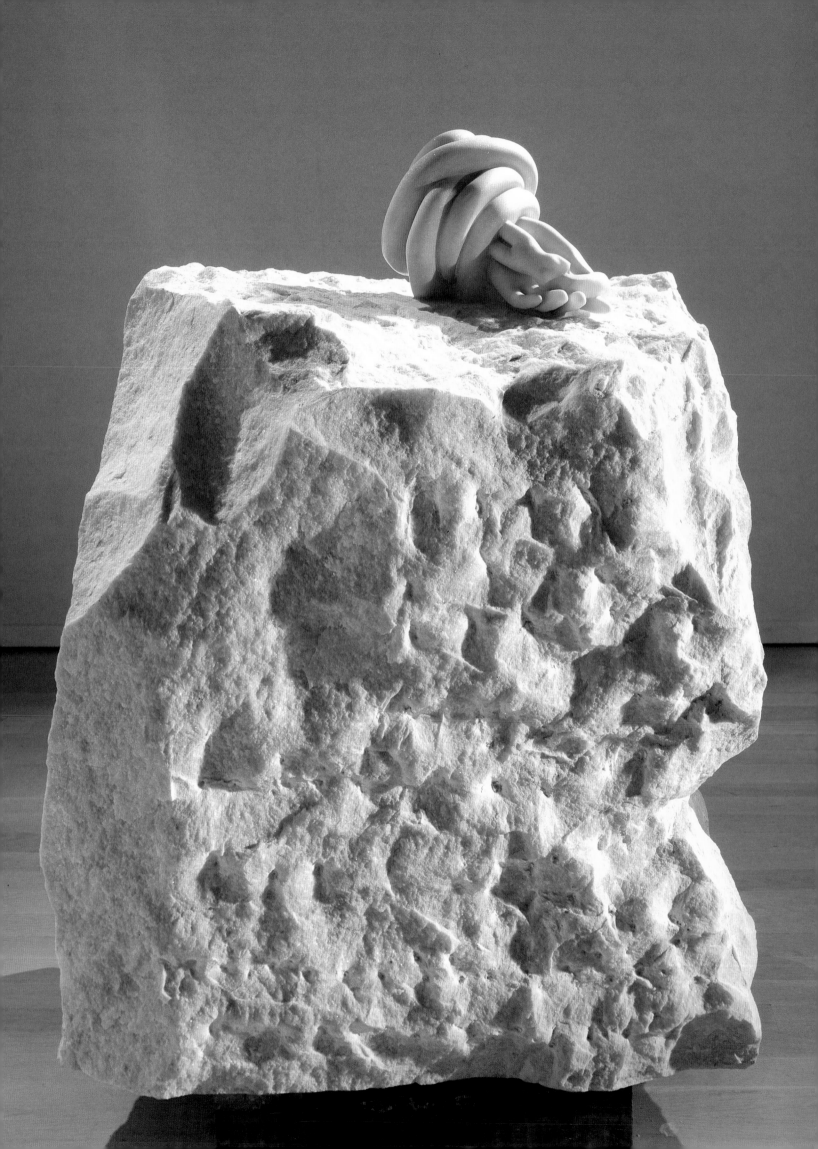

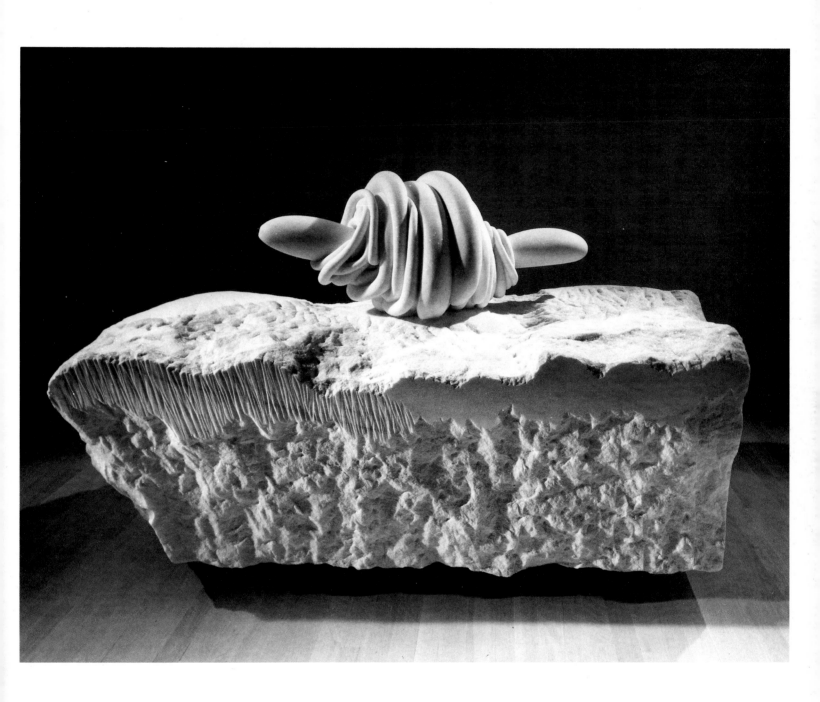

OPPOSITE:
Plate 12. *Nature Study*. 1986.
Pink marble, 33 × 28 × 21½
in. (83.8 × 71.1 × 54.6 cm).
Private collection

Plate 13. *Nature Study*. 1986.
Marble, 35 × 61 × 29 in.
(88.9 × 155 × 74 cm).
Collection of the artist;
courtesy Robert Miller Gallery,
New York

99

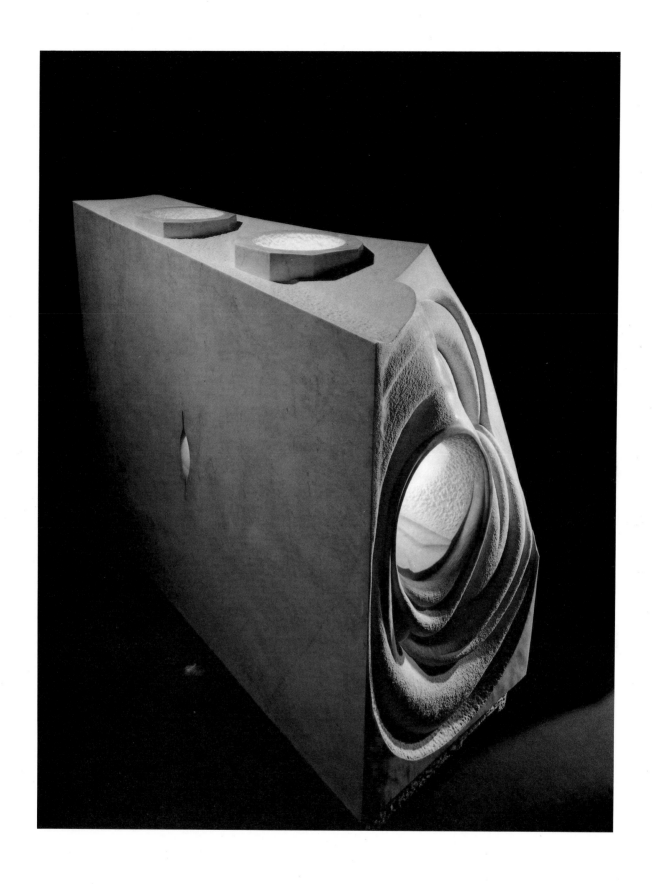

OPPOSITE:

Plate 14. *Maison*. 1986. Steel
and plaster, 75 × 20½ × 9½ in.
(190.5 × 52.1 × 24.1 cm).
Collection of Fundación
Cultural Televisa, Mexico City

Plate 15. *The Sail*. 1988.
Marble, 60 × 30 × 70 in.
(152.4 × 76.2 × 177.8 cm).
Ginny Williams Family
Foundation, Denver

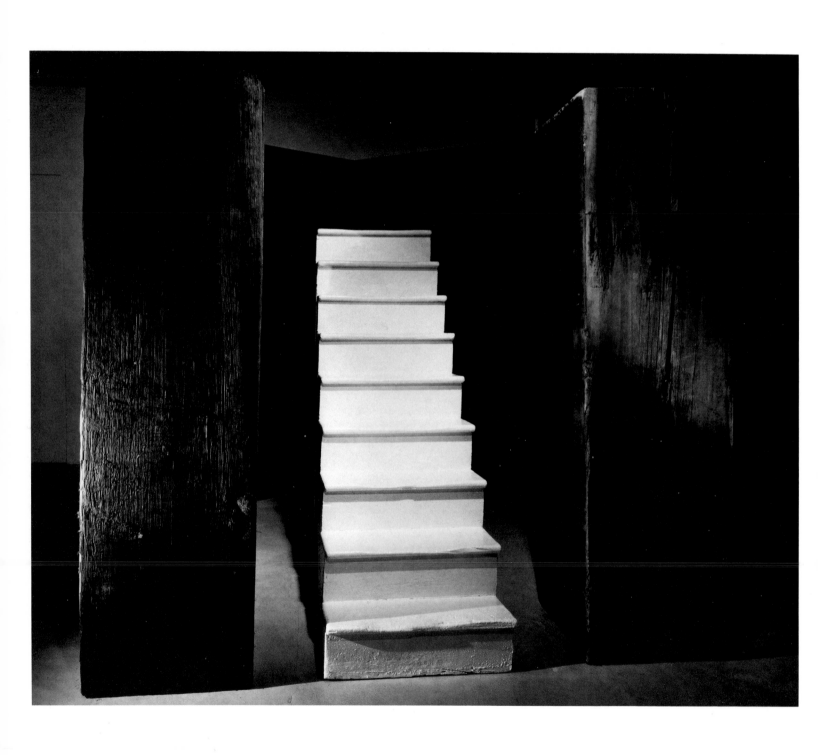

Plate 16. *No Escape*. 1989.
Wood and metal, 96 × 99 × 120
in. (243.8 × 251.4 × 304.8
cm). Collection of Pentti Kouri,
Greenwich

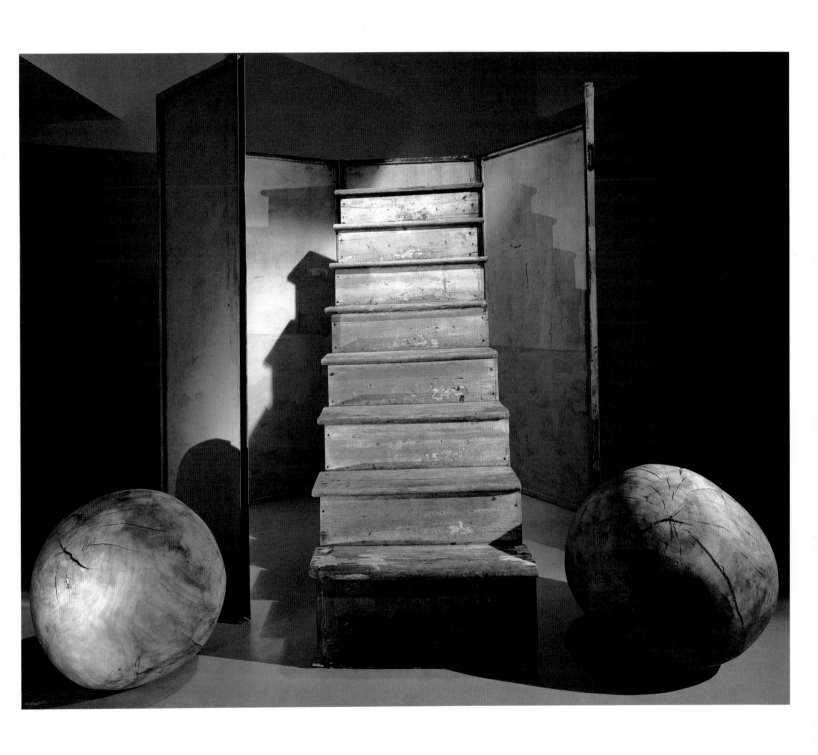

Plate 17. *No Exit*. 1989.
Wood, painted metal, and
rubber, 82½ × 84 × 96 in.
(209.5 × 213.3 × 243.8 cm).
Ginny Williams Family
Foundation, Denver

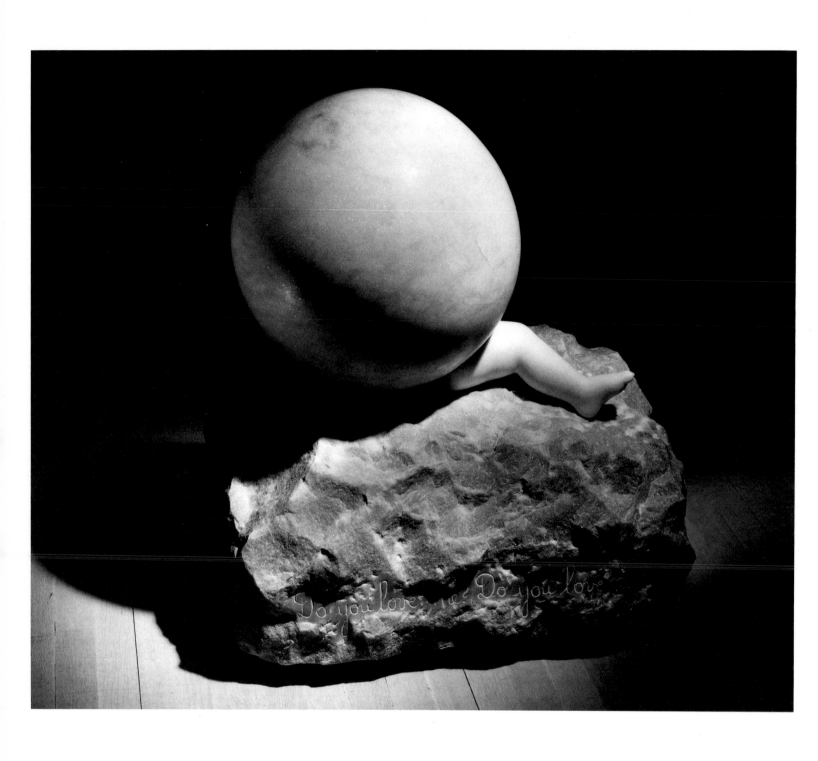

Plate 18. *Untitled (with Foot)*.
1989. Pink marble,
30×26×21 in.
(76.2×66×53.3 cm).
Collection of the artist;
courtesy Robert Miller Gallery,
New York

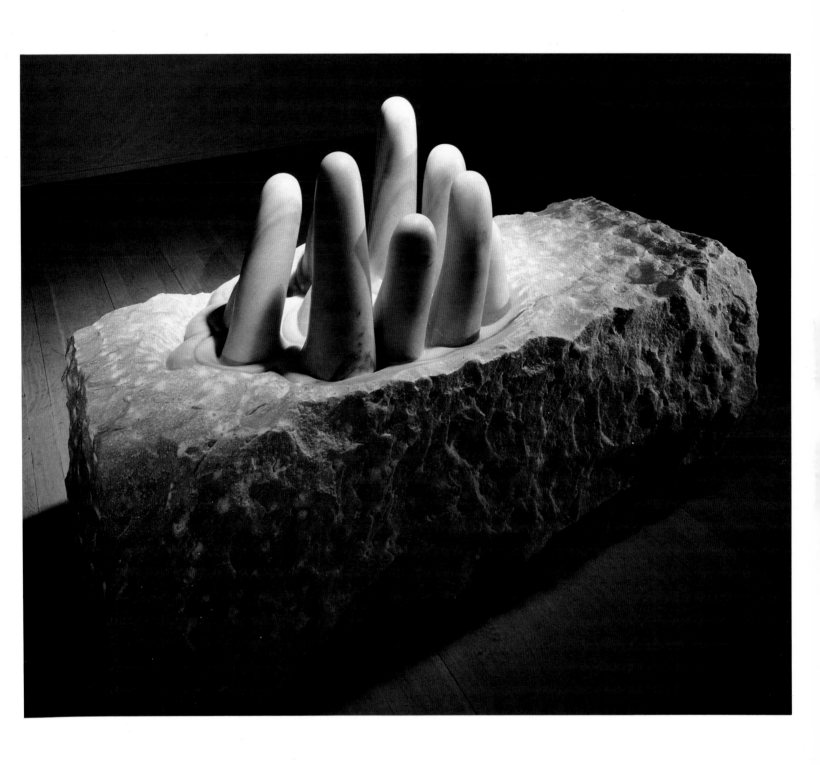

Plate 19. *Untitled (with Growth)*. 1989. Pink marble, 31½ × 21 × 57 in. (80 × 53.3 × 144.7 cm). Ginny Williams Family Foundation, Denver

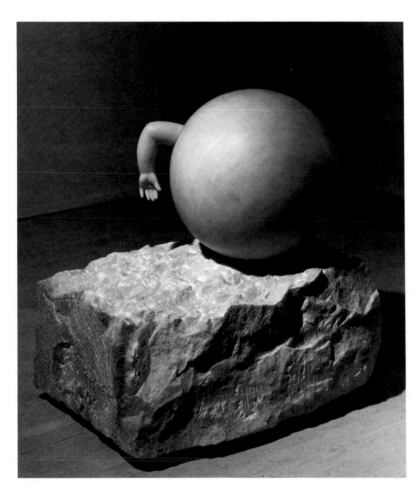

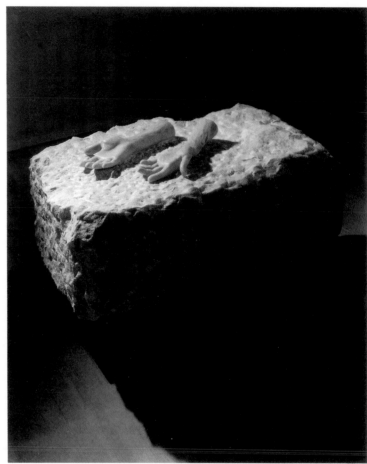

Plate 20. *Untitled (with Hand)*.
1989. Pink marble,
31 × 30½ × 21 in.
(78.7 × 77.4 × 53.3 cm).
Collection of Jerry Gorovoy,
New York

Plate 21. *Décontractée*. 1990.
Pink marble and steel base,
28½ × 36 × 23 in.
(72.3 × 91.4 × 58.4 cm).
Collection of the artist;
courtesy Robert Miller Gallery,
New York

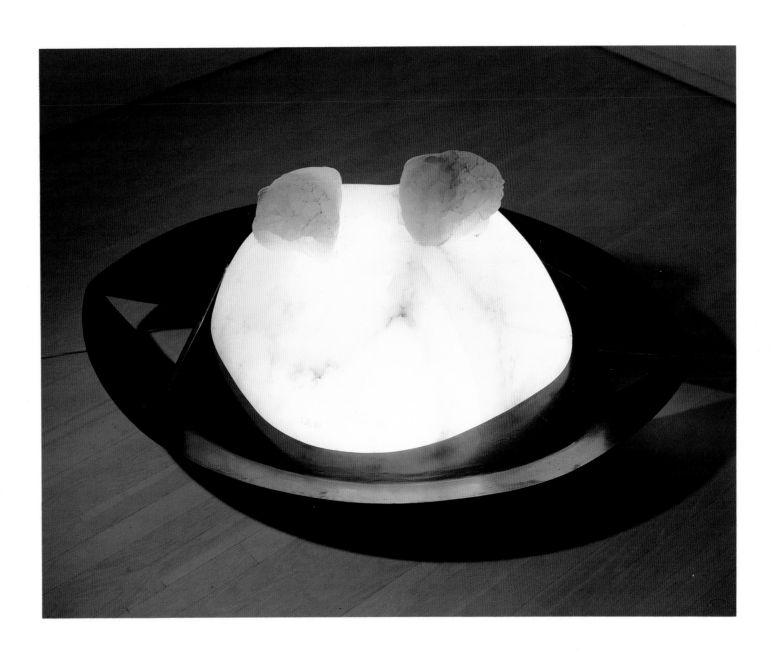

Plate 22. *Coeurs*. 1990.
Alabaster, steel, and
fluorescent lights, $20 \times 44 \times 35$
in. ($50.8 \times 111.7 \times 88.9$ cm).
Collection of the artist;
courtesy Robert Miller Gallery,
New York

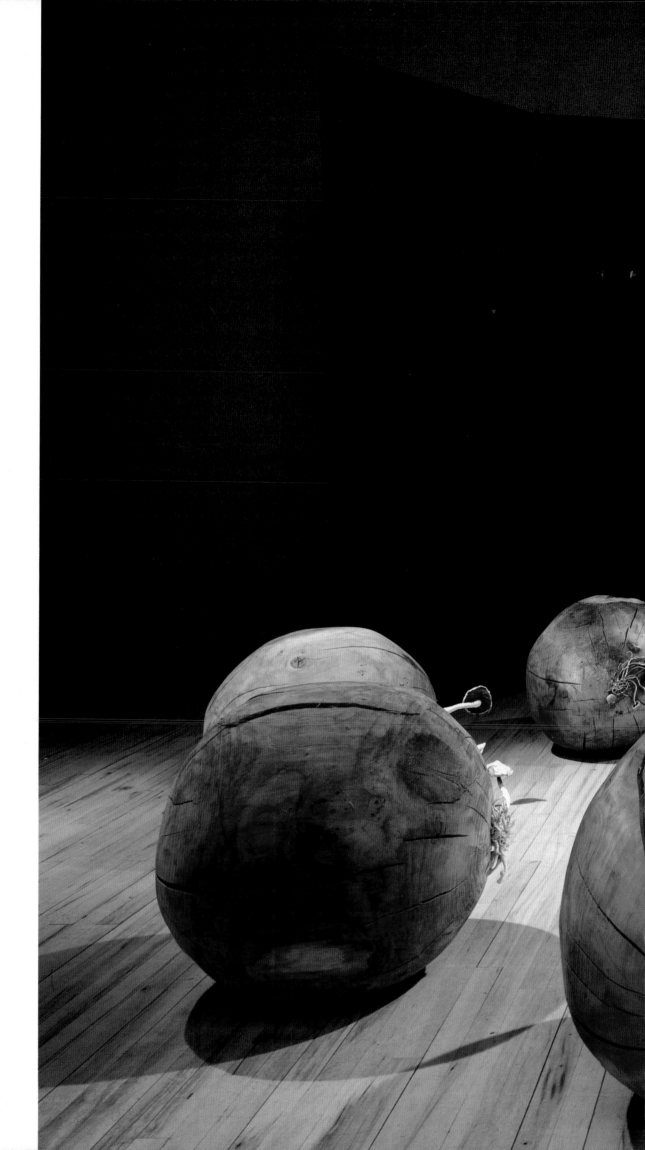

Plate 23. *Gathering Wool.*
1990. Metal and wood,
96 × 156 × 180 in.
(243.8 × 396.2 × 457.2 cm).
Collection of the artist;
courtesy Robert Miller Gallery,
New York

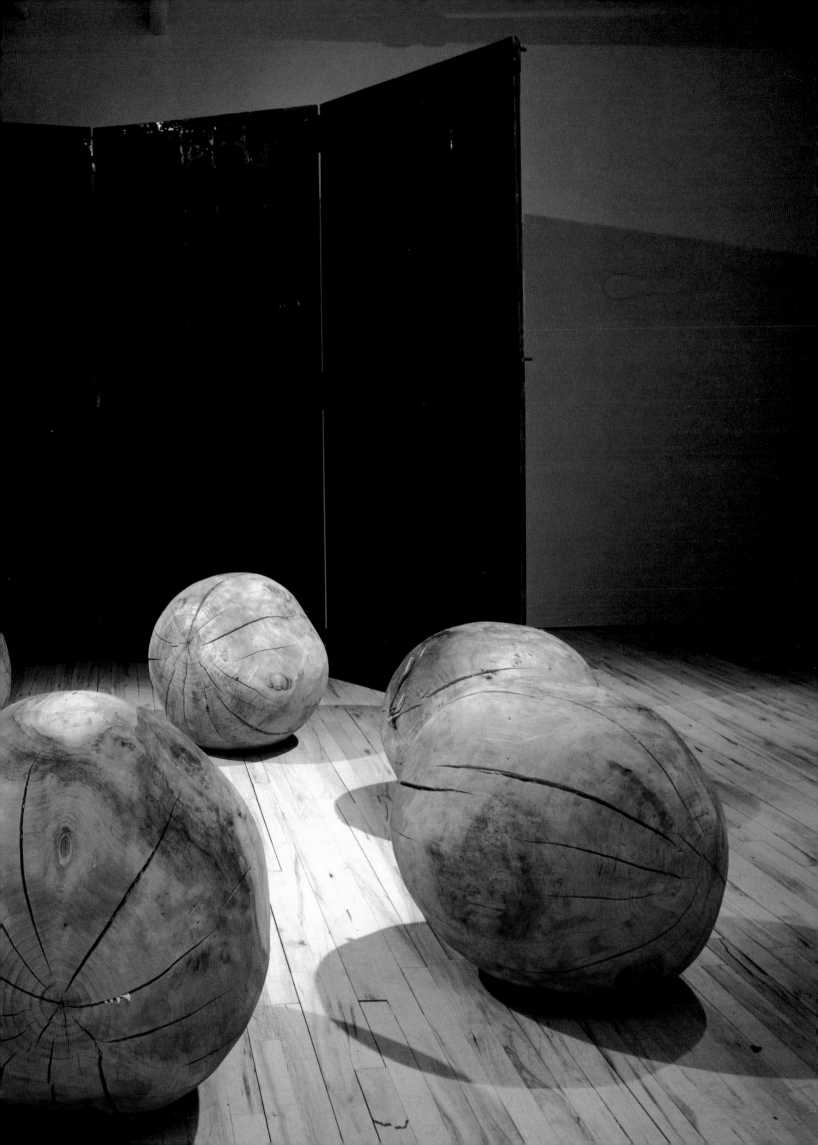

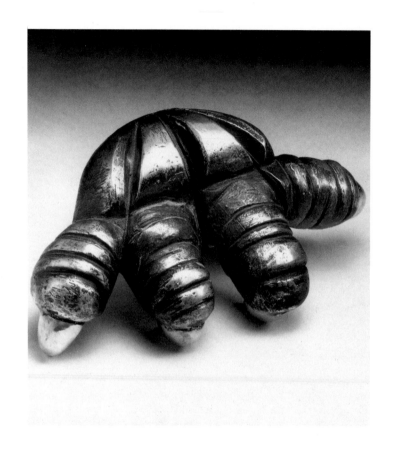

Plate 24. *Give or Take (How
Do You Feel This Morning?).*
1990. Bronze, 4½×9×6 in.
(11.4×22.8×15.2 cm).
Collection of the artist;
courtesy Robert Miller Gallery,
New York

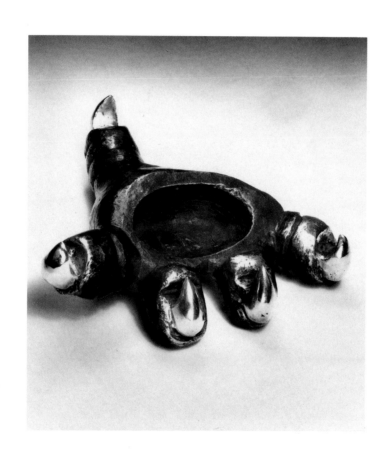

Plate 25. *Give or Take II.*
1991. Bronze, 3¼ × 9 × 9½ in.
(8.2 × 22.8 × 24.1 cm).
Collection of the artist;
courtesy Robert Miller Gallery,
New York

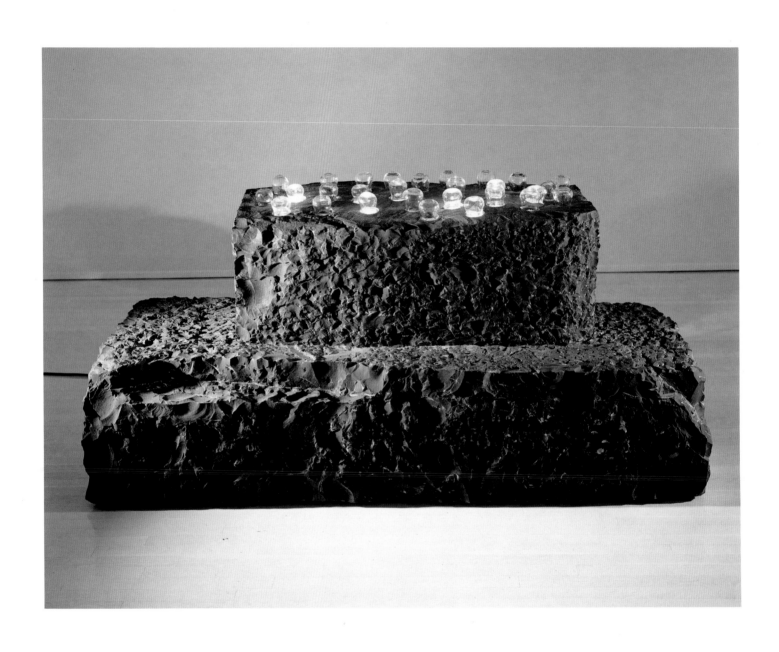

Plate 26. *Ventouse*. 1990.
Black marble, glass, and
electric light, 34 × 78 × 32 in.
(86.3 × 198.1 × 81.2 cm).
Collection of the artist;
courtesy Robert Miller Gallery,
New York

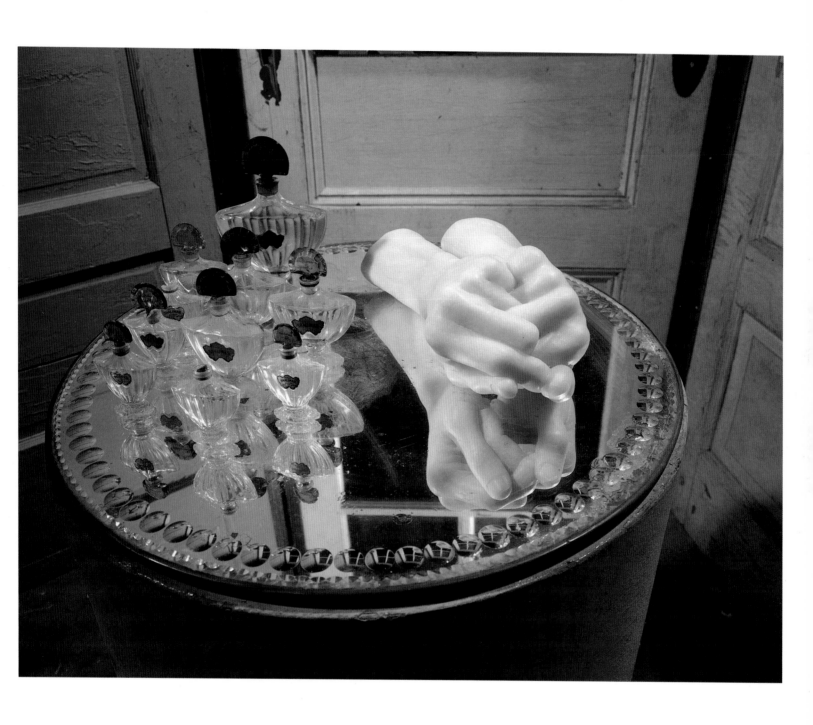

Plate 27. *Cell II*. 1991. Mixed
media, 83 × 60 × 60 in.
(210.8 × 152.4 × 152.4 cm).
The Carnegie Museum of Art,
Pittsburgh; The Heinz Family
Acquisition Fund of The
Carnegie Museum of Art, 1991

113

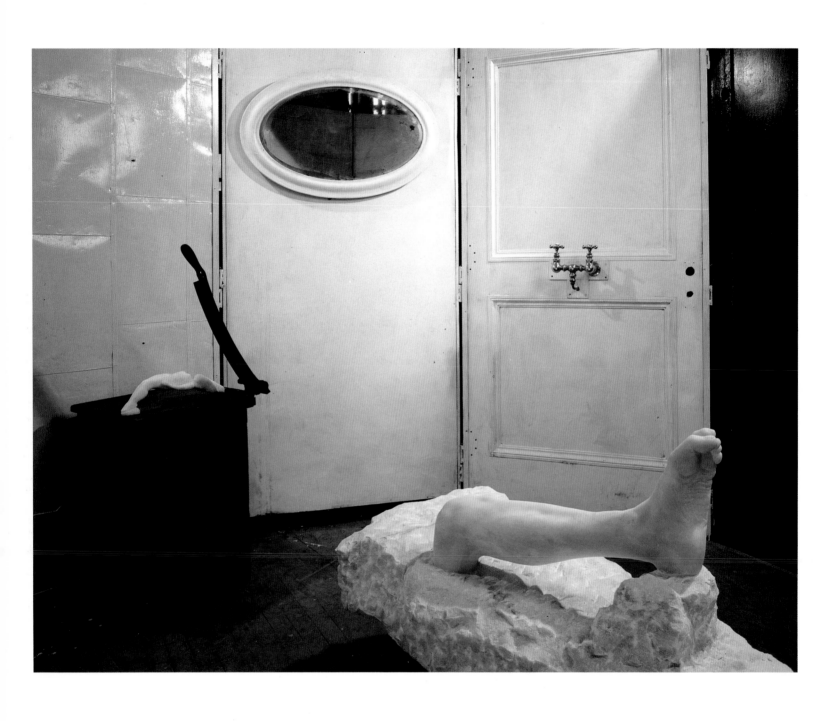

Plate 28. *Cell III*. 1991. Mixed
media, 111 × 130½ × 165⅛ in.
(281.9 × 331.4 × 419.4 cm).
Ydessa Hendeles Art
Foundation, Toronto

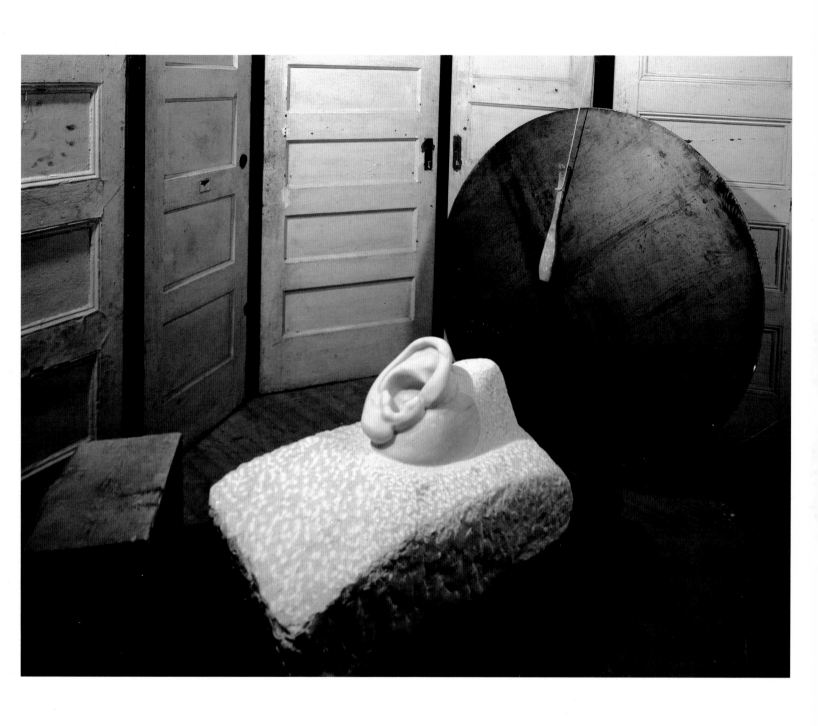

Plate 29. *Cell IV*. 1991. Mixed
media, 82 × 84 × 84 in.
(208.2 × 213.3 × 213.3 cm).
Collection of Ginny Williams,
Denver

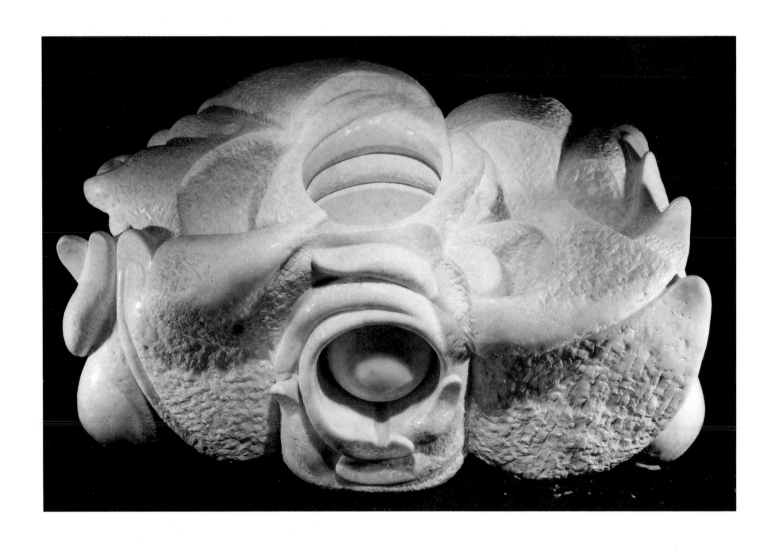

Plate 30. *Cleavage*. 1991.
Marble, 45 × 77½ × 30 in.
(114.3 × 196.8 × 76.2 cm).
Collection of the artist;
courtesy Robert Miller Gallery,
New York

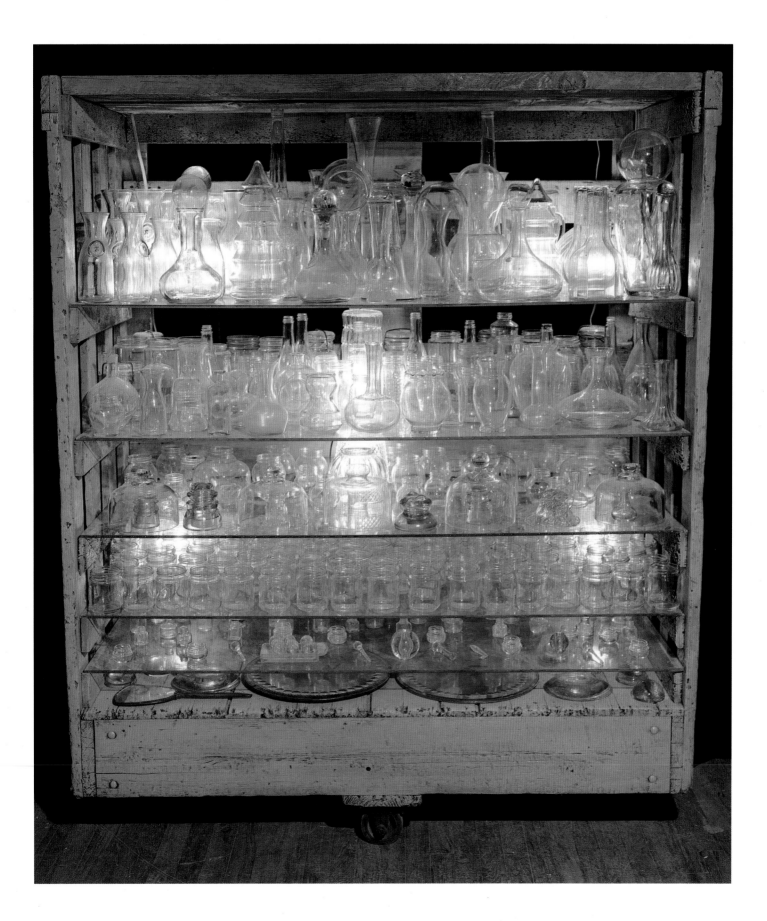

Plate 31. *Le Défi.* 1991.
Painted wood, glass, and
electric light, 67½ × 58 × 26
in. (171.4 × 147.3 × 66 cm).
Solomon R. Guggenheim
Museum, New York 91.3903

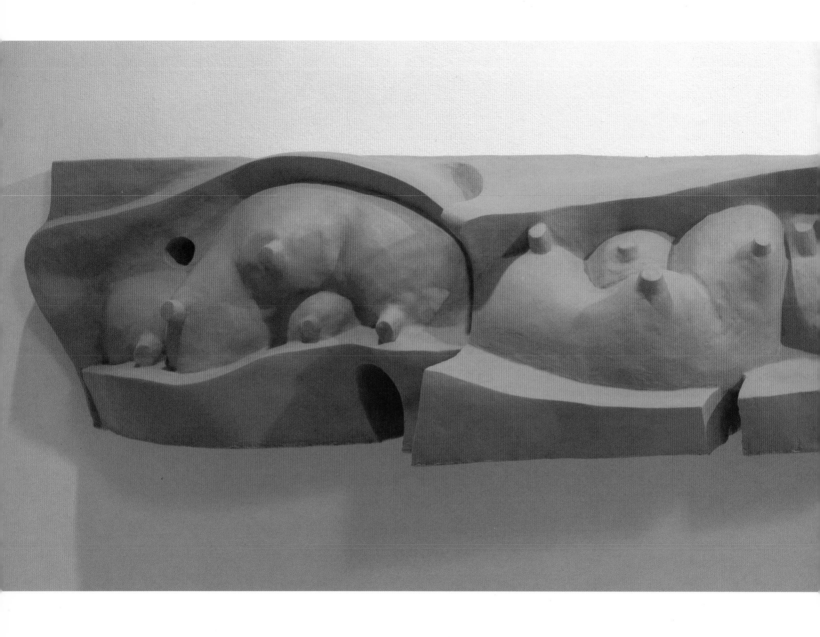

Plate 32. *Mamelles*. 1991.
Rubber, 19 × 120 × 19 in.
(48.2 × 304.8 × 48.2 cm).
Collection of the artist;
courtesy Robert Miller Gallery,
New York

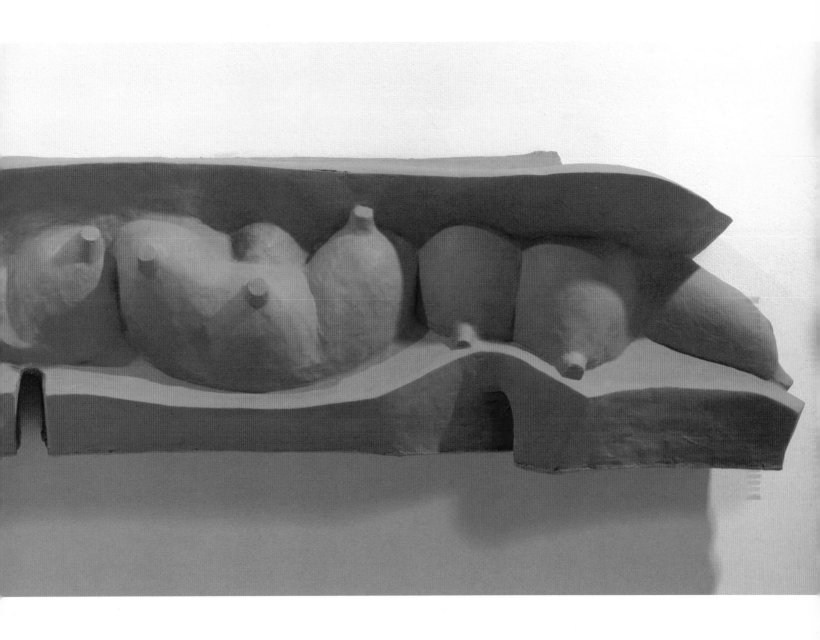

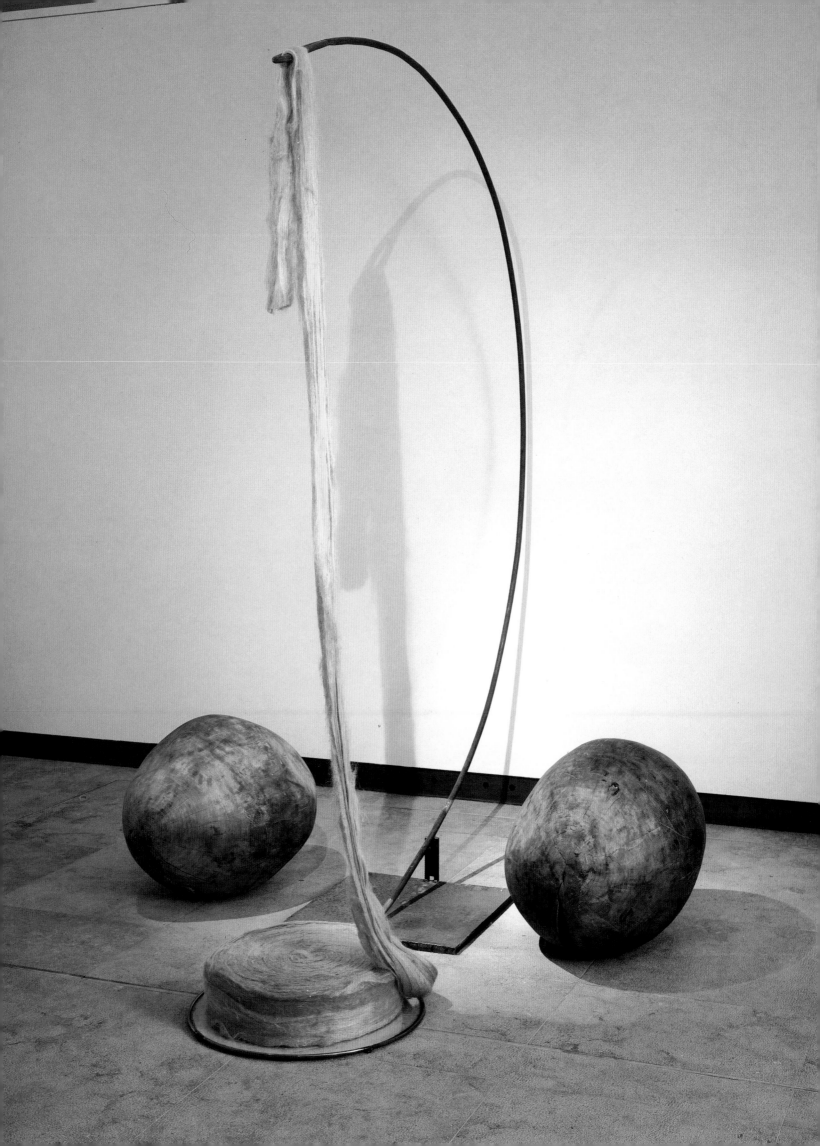

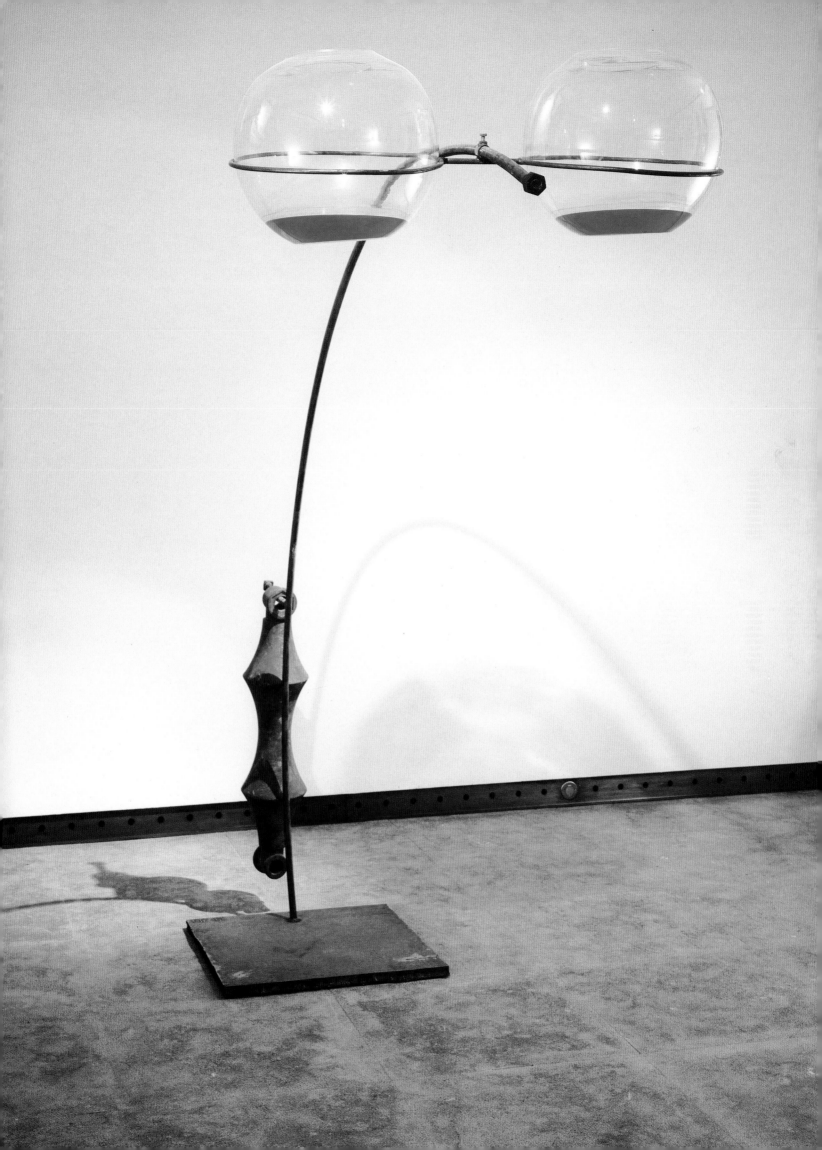

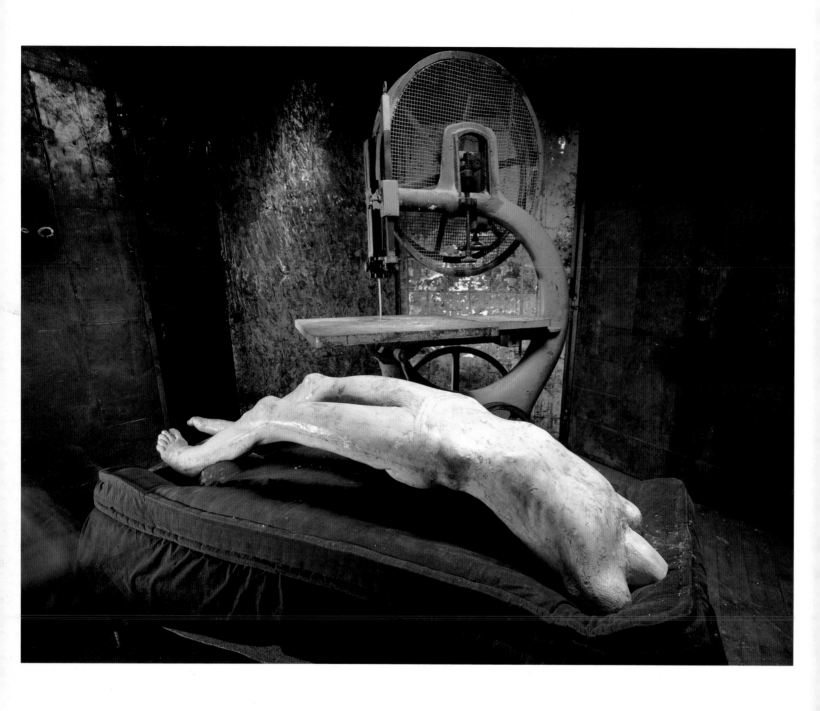

Plate 35. *Cell (Arch of
Hysteria)*. 1992–93 (work in
progress). Plaster, steel,
cast iron, and fabric,
119 × 145 × 120 in.
(302.3 × 368.3 × 304.8 cm).
Collection of the artist;
courtesy Robert Miller Gallery,
New York

OPPOSITE:
Plate 36. *Cell (Choisy)*. 1990–
93. Marble, metal, and glass,
120½ × 67 × 95 in.
(306 × 167.5 × 241.3 cm).
Ydessa Hendeles Art
Foundation, Toronto

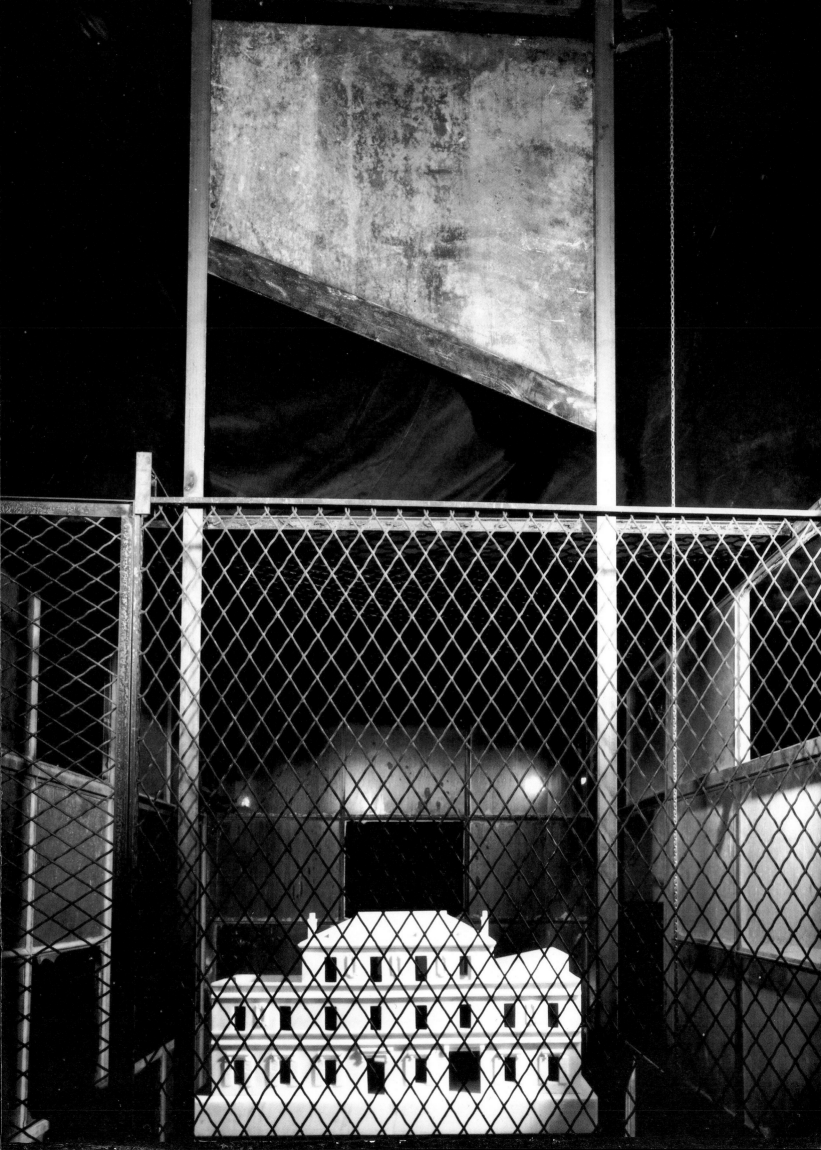

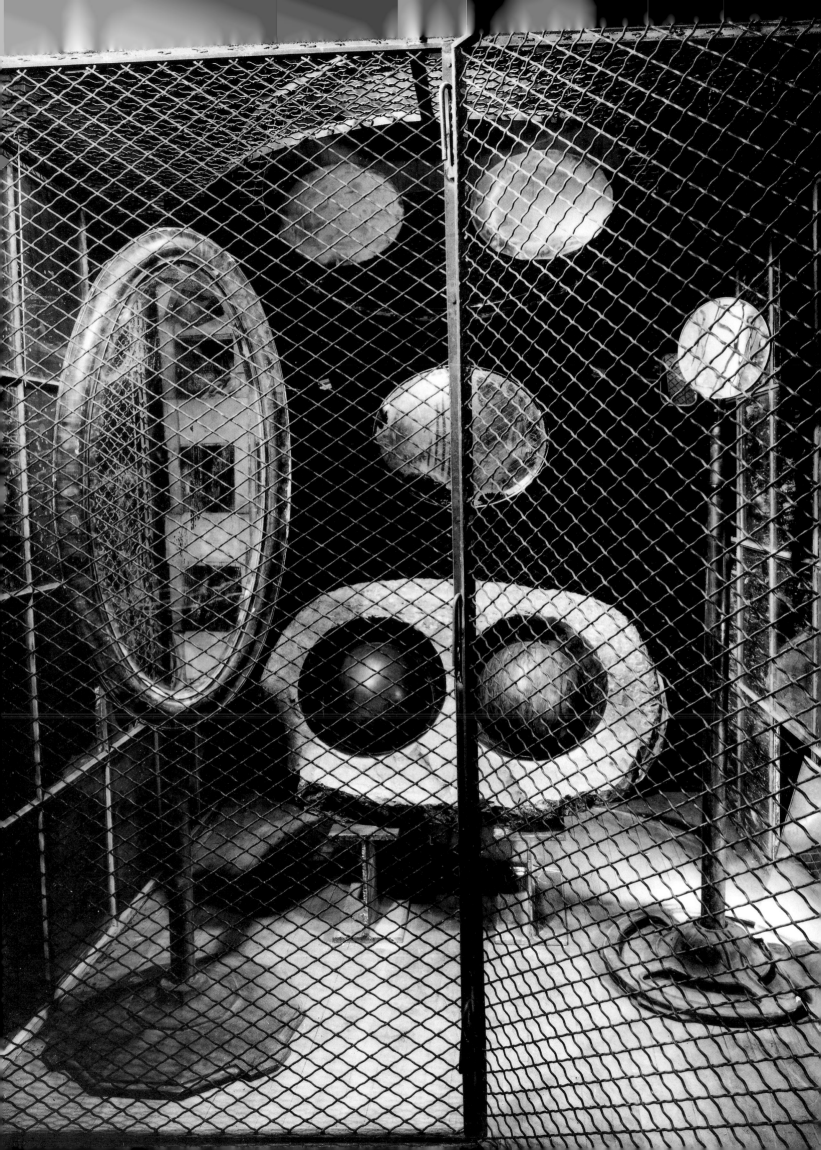

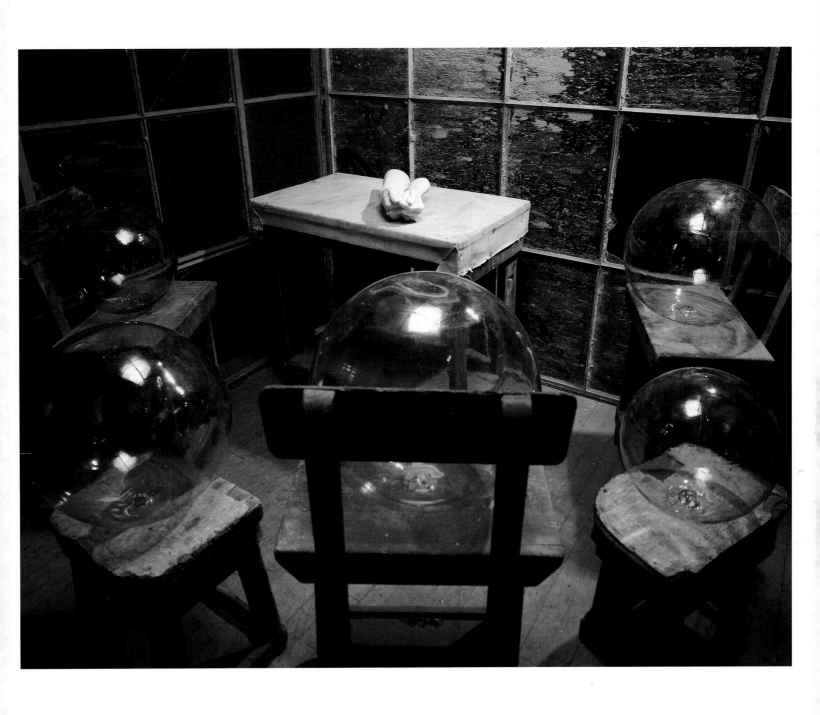

Plate 37. *Cell (Eyes and Mirrors)*. 1989–93. Marble, mirrors, steel, and glass, 93 × 83 × 86 in. (236.2 × 210.8 × 218.5 cm). Tate Gallery, London

Plate 38. *Cell (Glass Spheres and Hands)*. 1990–93. Glass, marble, wood, metal, and fabric, 86 × 86 × 83 in. (218.4 × 218.4 × 210.8 cm). Collection of the artist; courtesy Robert Miller Gallery, New York

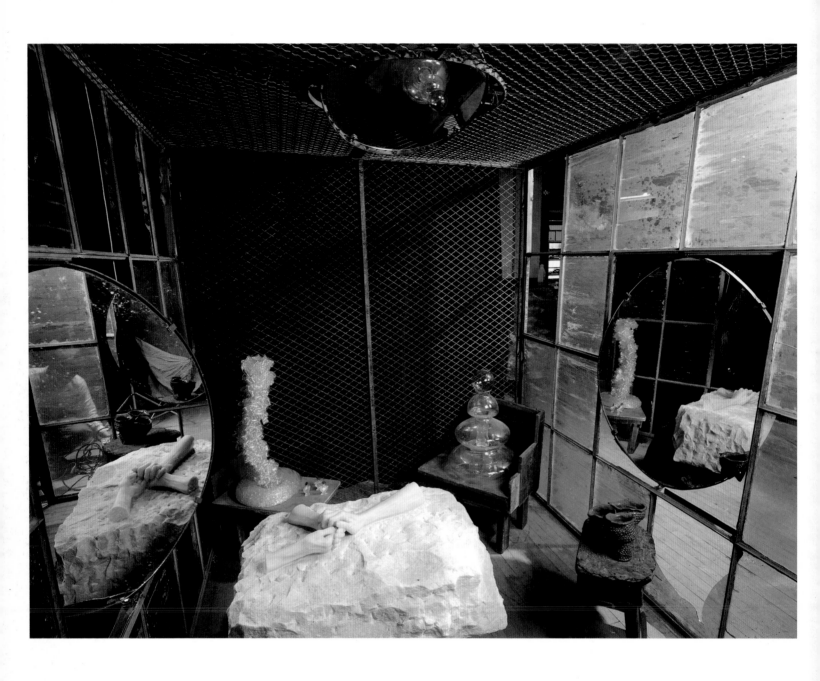

Plate 39. *Cell (You Better Grow
Up).* 1993. Steel, glass,
marble, ceramic, and wood,
83 × 82 × 83½ in.
(210.8 × 208.3 × 212.1 cm).
Collection of the artist;
courtesy Robert Miller Gallery,
New York

OPPOSITE:
Plate 40. *Cell (Three White
Marble Spheres).* 1993. Steel,
glass, marble, and mirror,
84 × 84 × 84 in.
(213.4 × 213.4 × 213.4 cm).
Collection of the artist;
courtesy Robert Miller Gallery,
New York

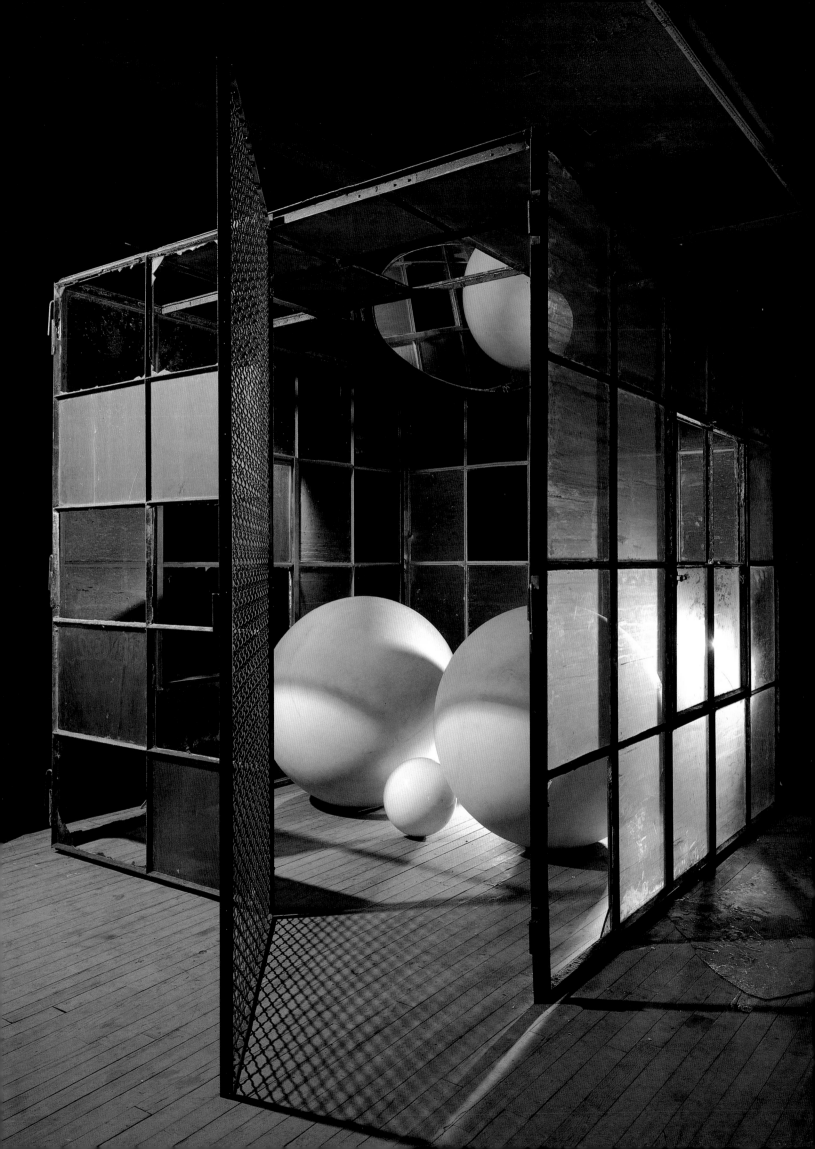

Plate 41. *Untitled*. 1989. Ink
and charcoal on burnt paper,
8½ × 11 in. (21.5 × 27.9 cm).
Collection of the artist;
courtesy Robert Miller Gallery,
New York

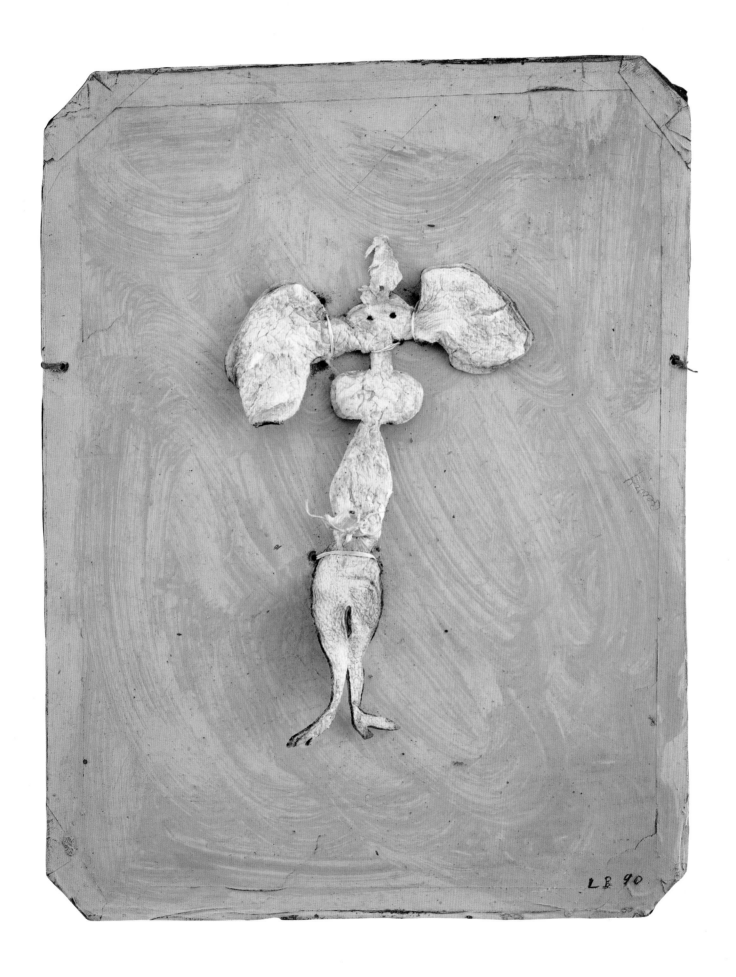

Plate 42. *Orange Episode*.
1990. Oil, gouache, and
orange collage on board,
17 × 13⅛ in. (43.1 × 33.3 cm).
Collection of Jerry Gorovoy,
New York

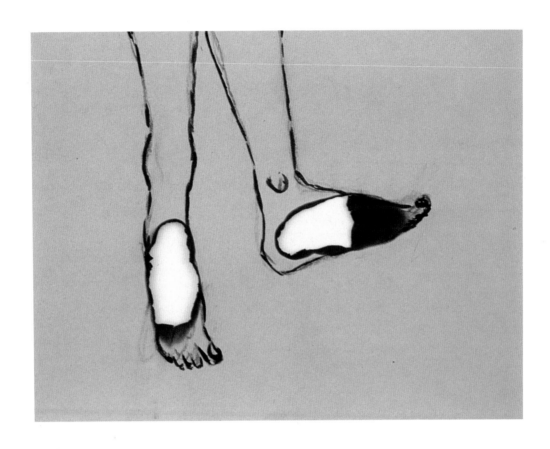

Plate 43. *Untitled*. 1991. Ink
and charcoal on blue paper
with burning, 8½×11 in.
(21.5×27.9 cm). Solomon R.
Guggenheim Museum,
New York 92.4016

Plate 44. *Altered States*. 1992.
Gouache, ink, pen, and pencil
on paper, 19 × 23¾ in.
(48.2 × 60.3 cm). Collection
of the artist; courtesy Robert
Miller Gallery, New York

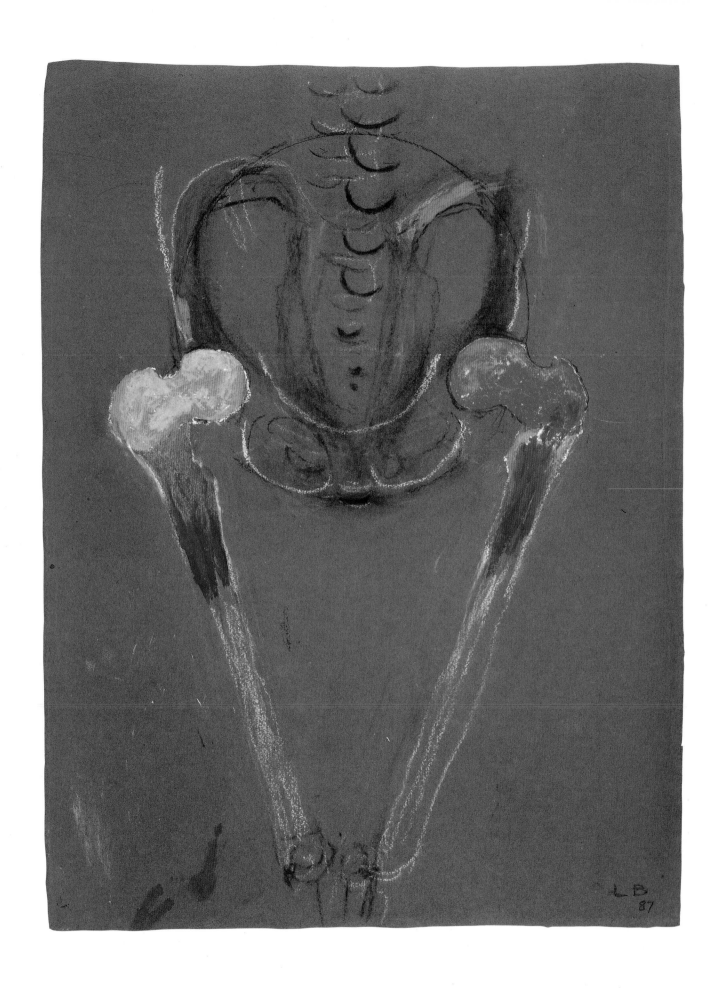

Plate 45. *Untitled*. 1987.
Charcoal, pastel, and
watercolor on paper, 25¾ × 20
in. (65.4 × 50.8 cm).
Collection of the artist;
courtesy Robert Miller Gallery,
New York

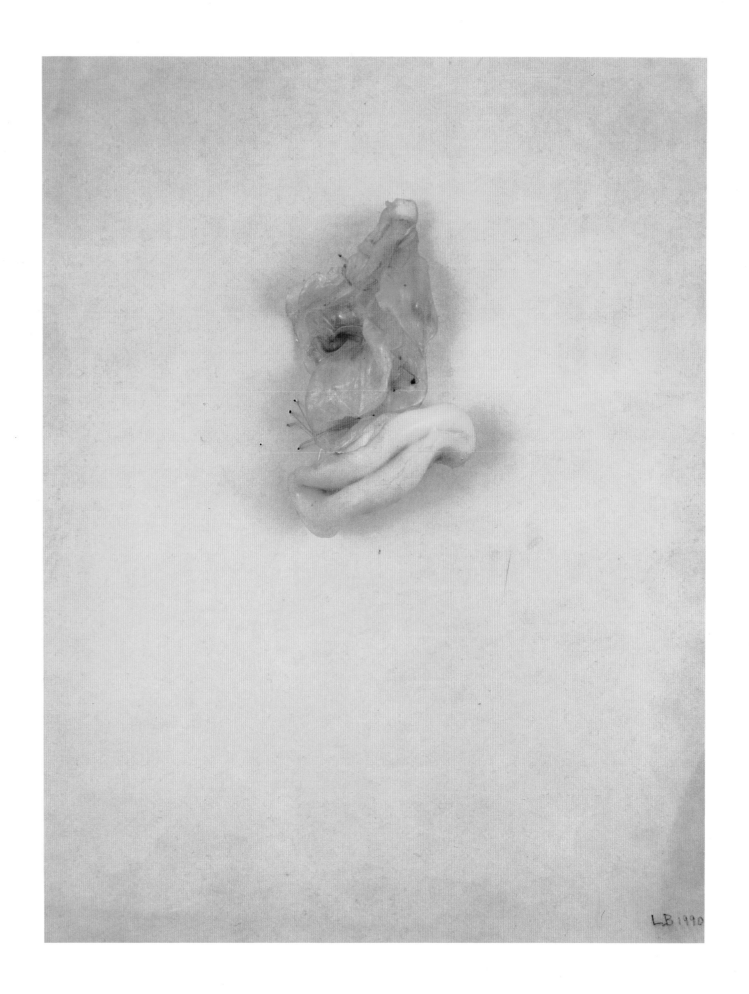

Plate 46. *Untitled*. 1990.
Latex sewn on pink paper,
13 × 10 × 1½ in. (33 ×
25.4 × 3.8 cm). Collection of
Caroline and Dick Anderson;
courtesy Galerie Lelong,
New York

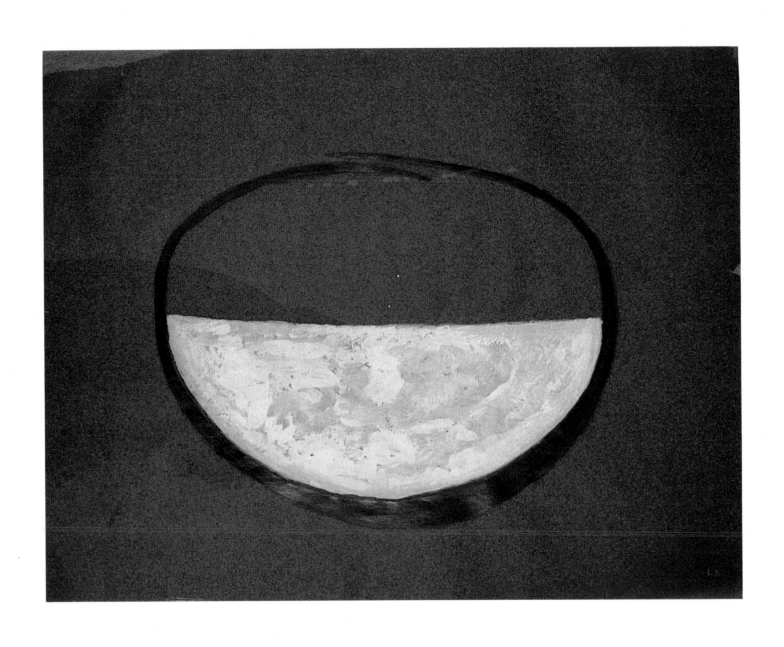

Plate 47. *Untitled*. 1987. Ink
and gouache on blue paper,
26⅛ × 33⅝ in. (66.3 × 85.3
cm). Collection of Jacqueline
Burckhardt, Zurich

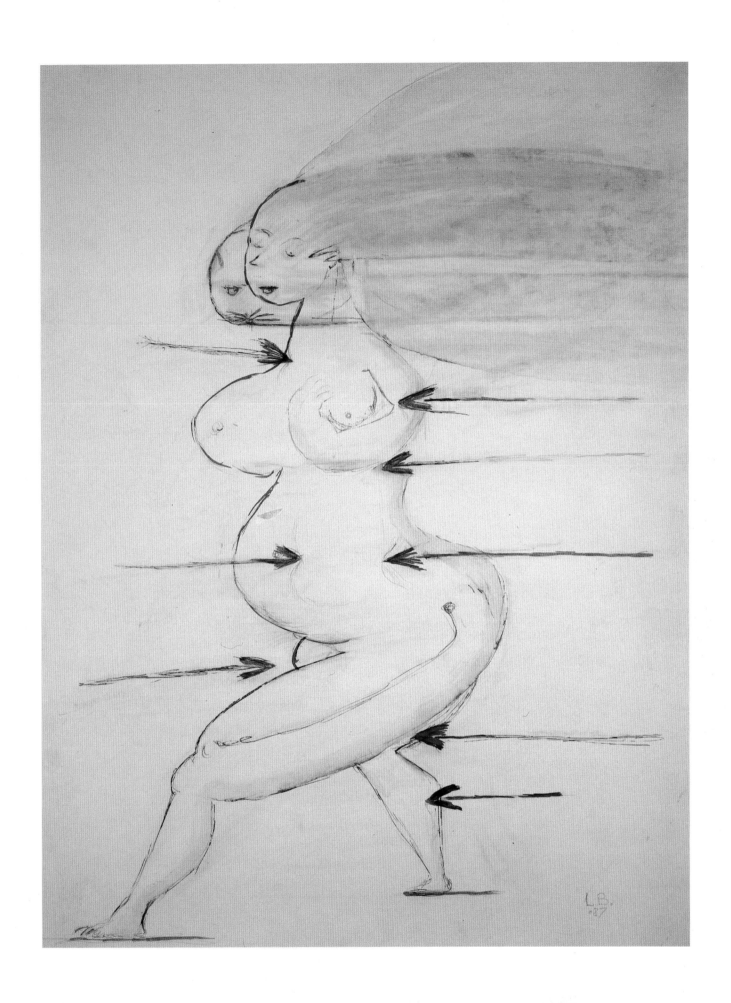

Plate 48. *Untitled (St. Sebastienne)*. 1987. Ink, watercolor, and pencil on paper, 24⅞ × 19 in. (63.1 × 48.2 cm). Collection of Jerry Gorovoy, New York

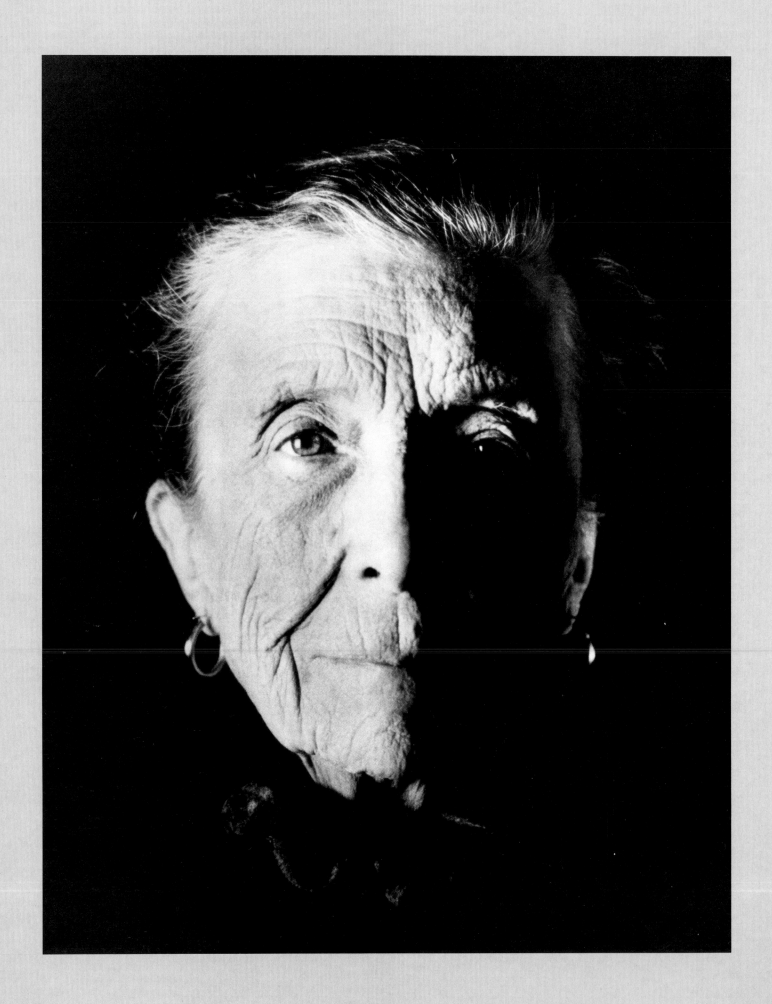

CHRONOLOGY

1911
Louise Bourgeois is born in Paris on December 25, the middle child of three. Parents own a gallery dealing primarily in historical tapestries.

1912
The family moves its residence to Choisy-le-Roi, keeping the gallery in Paris.

1919
The family business is expanded by establishing tapestry restoration workshops in nearby Antony. Louise, who draws well, begins to render fragments of missing imagery, which are used to restore tapestries.

1932
Graduates from the Lycée Fénélon, Paris. Enrolls at the Sorbonne to study mathematics. Mother dies.

1935
Decides to pursue an artistic career and is accepted to the École des Beaux-Arts. Dissatisfied with the strictly academic program, she leaves to study painting at the Académie Ranson, Académie Julian, Académie de la Grande-Chaumière, and the studios of Fernand Léger, Paul Colin, André Lhote, Achille-Émile-Othon Friesz, Roger Bissière, Yves Brayer, and Robert Wlérick. Also takes art history classes at the École du Louvre and works as a lecturer at the Musée du Louvre.

1938
Marries American art historian Robert Goldwater and moves to New York City. Enrolls at the Art Students League, where she studies with Vaclav Vytlacil.

1939
Begins to exhibit in the United States. Submits prints to the *Fine Prints for Mass Production* exhibition at The Brooklyn Museum.

1941
Creates first large-scale sculptures. Takes part in art-world war-effort activities such as the *Artists for Victory* exhibitions.

1945
Has first solo show of paintings at Bertha Schaefer Gallery, New York. Exhibits in the Whitney Museum of American Art's *Annual Exhibition of Painting* and is represented almost yearly until 1962 by paintings, sculpture, or drawings according to the theme of the year.

1946
Begins working in Stanley Hayter's printmaking studio, Atelier 17.

1947
Publishes *He Disappeared into Complete Silence*, a suite of engravings with text made in Hayter's studio.

1949
Has first solo exhibition of sculpture at Peridot Gallery, New York.

1950
Joins group of artists known as the Irascibles to protest the conservative selection for an exhibition of American painting planned at The Metropolitan Museum of Art, New York.

1951
Father dies.
Becomes an American citizen.
The Museum of Modern Art, New York, acquires *Sleeping Figure*, the first of her sculptures to become part of a museum collection.

1950s
Participates in many group exhibitions in museums, commercial galleries, and with fellow members of the American Abstract Artists, the Federation of Modern Painters and Sculptors, and the Sculptors Guild.

1960
Begins to teach art in public schools.

1963
Begins to teach art classes at Brooklyn College and at Pratt Institute, Brooklyn.

1966
Participates in Lucy Lippard's ground-breaking exhibition *Eccentric Abstraction*. Subsequently becomes involved with feminist movement and political activities, which remain concerns throughout the following decades.

1967–72
Visits Pietrasanta marble works yearly. Also uses local bronze foundries.

1973
Receives an Individual Artist's Grant from the National Endowment for the Arts. Exhibits *The No March*, her first work of environmental scale, in the Whitney Museum of American Art's Biennial.
Robert Goldwater dies.

1974
Begins to lecture or act as visiting artist at numerous institutions, including Columbia University, Cooper Union, New York Studio School, and Yale University.

1977
Is awarded an Honorary Doctor of Fine Arts degree by Yale University.

1978
Is commissioned by General Services Administration to create her first outdoor public sculpture, for Norris Cotton Federal Building, Manchester, New Hampshire.

1980
Receives Award for Outstanding Achievement in the Visual Arts from Women's Caucus for Art.

1981
Visits Carrara to continue work in marble. Is elected Fellow of American Academy of Arts and Sciences, New York.

1982
Is given her first major museum retrospective, organized by Deborah Wye at The Museum of Modern Art, New York.

1984
Is named Officier de l'Ordre des Arts et Lettres by French Minister of Culture Jack Lang.

1985
Receives Skowhegan Medal for Sculpture.

1987
Receives Distinguished Artist Award for Lifetime Achievement from the College Art Association of America.

1989
Is given first European retrospective, organized by Peter Weiermair at the Kunstverein, Frankfurt, which travels in Europe.

1990
Receives Award for Distinction in Sculpture 1990 from the Sculpture Center, New York.

1991
Is awarded Grand Prix National de Sculpture by the French Minister of Culture.
Receives the first Lifetime Achievement Award from the International Sculpture Center, Washington, D.C.
Is included in Carnegie International, Pittsburgh.

1992
Participates in *documenta 9*, Kassel, Germany.

1993

Represents the United States at the 1993 Venice Biennale. Wins Honorable Mention.
Participates in Biennale d'art contemporain, Lyons.
Lives in Manhattan and works in her Brooklyn studio with the help of her assistant and friend
Jerry Gorovoy. Currently working on two sculpture commissions, one for the city of Chicago
and one for Choisy-le-Roi.

ONE-PERSON EXHIBITIONS

1945	Bertha Schaefer Gallery, New York
1947	Norlyst Gallery, New York
1949	Peridot Gallery, New York. Also in 1950 and 1953
1953	Allan Frumkin Gallery, Chicago
1959	Andrew D. White Art Museum, Cornell University, Ithaca, New York
1963	Rose Fried Gallery, New York
1964	Stable Gallery, New York
1974	112 Greene Street, New York
1978	Xavier Fourcade Gallery, New York. Also in 1979 and 1980
	Hamilton Gallery, New York (sculpture installation and performance)
1979	Berkeley Art Museum, University of California
1980	Max Hutchinson Gallery, New York
1981	Renaissance Society, University of Chicago
1982	Robert Miller Gallery, New York. Also in 1984, 1986, 1987, 1988, 1989, and 1991
1982–83	The Museum of Modern Art, New York. Traveled
1984	Daniel Weinberg Gallery, Los Angeles and San Francisco
1985	Serpentine Gallery, London
	Galerie Maeght Lelong, Paris and Zurich
1986	Doris Freedman Plaza, New York
	Texas Gallery, Houston
1987	The Art Museum of Florida, International University, Miami
	The Taft Museum, Cincinnati. Traveled
1988	Laguna Gloria Art Museum, Austin, Texas
	Museum Overholland, Amsterdam
1989	Galerie Lelong, New York, Paris, and Zurich
	Sperone-Westwater Gallery, New York
	Rhona Hoffman Gallery, Chicago
	Dia Art Foundation, Bridgehampton, New York
	Art Gallery of York University, North York, Ontario
	Frankfurter Kunstverein. Traveled
1990	Linda Cathcart Gallery, Santa Monica, California
	Barbara Gross Galerie, Munich
	Karsten Schubert Ltd., London
	Galerie Krinzinger Wien
	Ginny Williams Gallery, Denver
	Galerie Karsten Greve, Cologne
1990–91	Monika Sprüthe Galerie, Cologne
1991	Ydessa Hendeles Art Foundation, Toronto. Also in 1992
	Galerie Lelong, Zurich
1992	Galerie Karsten Greve, Paris
	The Milwaukee Art Museum, Wisconsin
	Second Floor, Reykjavik, Iceland
	Fabric Workshop, Philadelphia (sculpture installation and performance)
1993	Linda Cathcart Gallery, Santa Monica
	Laura Carpenter Fine Art, Santa Fe
	United States Pavilion, 45th Venice Biennale

SELECTED PUBLIC COLLECTIONS

Albright-Knox Art Gallery, Buffalo, New York
Australian National Gallery, Canberra
British Museum, London
Centre National d'Art et de Culture Georges Pompidou, Paris
The Denver Art Museum, Colorado
Des Moines Art Center, Iowa
The Detroit Institute of Arts, Michigan
Fogg Art Museum, Cambridge, Massachusetts
Graphische Sammlung Albertina, Vienna
Solomon R. Guggenheim Museum, New York
Hirshhorn Museum and Sculpture Garden, Smithsonian Institution,
 Washington, D.C.
Ydessa Hendeles Art Foundation, Toronto
Kunstmuseum Bern
Kunstmuseum Luzern
The Metropolitan Museum of Art, New York
The Museum of Fine Arts, Houston
The Museum of Modern Art, New York
Museum Moderner Kunst, Vienna
New Orleans Museum of Art, Louisiana
The New York Public Library
Olympic Park, Seoul
Philadelphia Museum of Art, Pennsylvania
Portland Museum of Art, Maine
Museum of Art, Rhode Island School of Design, Providence
Sheldon Memorial Art Gallery, University of Nebraska, Lincoln
Storm King Art Center, Mountainville, New York
Ulmer Museum, Ulm, Germany
Walker Art Center, Minneapolis
Whitney Museum of American Art, New York

SELECTED BIBLIOGRAPHY

Bourgeois, Louise. "Louise Bourgeois." *Balcon* (Madrid), issue 8–9 (1992), pp. 44–50.

Bourgeois, Louise, with Robert Gober. *Parkett* (New York and Zurich), no. 27 (March 1991).

Cheim, John, and Jerry Gorovoy, eds. *Louise Bourgeois Drawings*. Exhibition catalogue. New York: Robert Miller Gallery, and Paris: Galerie Lelong, 1988. Introduction by Robert Storr.

Cooke, Lynne, and Mark Francis. *Carnegie International*. Exhibition catalogue. Pittsburgh: The Carnegie Museum of Art, 1991.

Gorovoy, Jerry. *Louise Bourgeois and the Nature of Abstraction*. Exhibition catalogue. New York: Robert Miller Gallery/Bellport Press, 1986.

———. *The Iconography of Louise Bourgeois*. Exhibition catalogue. New York: Max Hutchinson Gallery, 1980.

Kuspit, Donald. *Bourgeois (An Interview with Louise Bourgeois)*. New York: Elizabeth Avendon Editions/Vintage Contemporary Artists (a division of Random House), 1988.

Leigh, Christian. "Rooms, Doors, Windows: Making Entrances & Exits (When Necessary). Louise Bourgeois's Theatre of the Body." *Balcon* (Madrid), issue 8–9 (1992), pp. 142–55.

Lippard, Lucy R. "Louise Bourgeois: From the Inside Out." In *In from the Center, Feminist Essays on Women's Art*. New York: E.P. Dutton, 1976, pp. 238–49.

Louise Bourgeois. L'Oeuvre gravée. Exhibition catalogue. Zurich: Galerie Lelong, 1991.

Louise Bourgeois: Rétrospective 1947–1984. Exhibition catalogue. Paris: Galerie Maeght Lelong, 1985.

Marandel, Patrice J. "Louise Bourgeois: From the Inside." In *Louise Bourgeois: Femme maison*. Exhibition catalogue. Chicago: The Renaissance Society at the University of Chicago, 1981.

Meyer-Thoss, Christiane. *Louise Bourgeois: Designing for Free Fall*. Zurich: Ammann Verlag, 1992.

Morgan, Stuart. *Louise Bourgeois: Recent Work 1984–89*. Exhibition catalogue. London: Riverside Studios, 1990.

————. *Louise Bourgeois*. Exhibition catalogue. Cincinnati: The Taft Museum, 1987.

Pincus-Witten, Robert. *Bourgeois Truth*. Exhibition catalogue. New York: Robert Miller Gallery, 1982.

Storr, Robert. *Dislocations*. Exhibition catalogue. New York: The Museum of Modern Art, 1991.

————. "Louise Bourgeois: Gender and Possession." *Art in America*, vol. 71, April 1983, pp. 128–37.

Weiermair, Peter, Lucy Lippard, Rosalind Krauss, et al. *Louise Bourgeois*. Retrospective exhibition catalogue. Frankfurt: Frankfurter Kunstverein, 1989.

Wye, Deborah. *Louise Bourgeois*. Retrospective exhibition catalogue. New York: The Museum of Modern Art, 1982.

PHOTOGRAPH CREDITS

INDEX

Numbers in *italic* indicate pages
bearing illustrations.